LIVING IN SCOTLAND

Lesley Astaire Roddy Martine

Fritz von der Schulenburg

with 287 color illustrations

Thames and Hudson

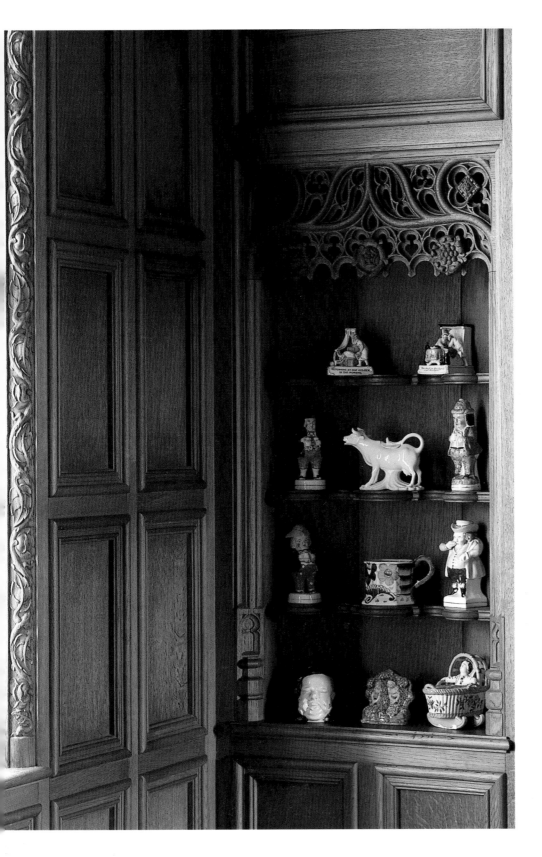

Frontispiece:
Evening at Traquair House,
Innerleithen.

Left:
China ornaments in an
alcove in the drawing-room
at Manderston.

Opposite:
A row of Georgian servant
bells in Traquair House.

Overleaf:
Crossed spears and stags'
antlers line the long
corridors in Blair Castle.

© 1987 Thames and Hudson Ltd, London

*Published in paperback in the United States of
America in 1997 by Thames and Hudson Inc.,
500 Fifth Avenue, New York, New York 10110*

*Library of Congress Catalog Card
Number 96-61190*
ISBN *0-500-27934-9*

Printed and bound in Hong Kong

FOR MARK

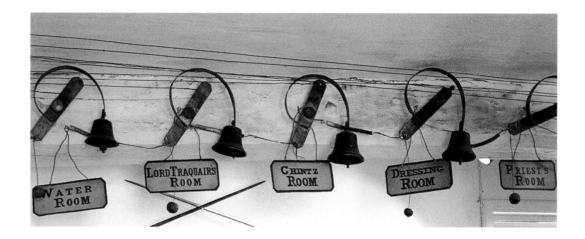

ACKNOWLEDGMENTS

The authors would like to thank all those who allowed them to photograph their homes and gardens, in particular Lady Shaw Stewart, Keith Schellenberg and Angus Grossart, who were so helpful in advising on locations. This book is as much a tribute to the owners and their way of life as it is to the splendour and variety of their Scottish homes. The authors wish also to thank the following for their assistance, suggestions, information and enthusiasm: Sam Beazley, Lawrence Black, Andrew Brown, Emilio Coia, Catriona Clark, Hugh Dodd, Ronny Grimaldi, Col. T.D. Lloyd Jones, Sheena McDonald, Sir Norman MacFarlane, Mark Magowan, David Maitland, Patty Martine, The National Trust for Scotland, Brian Nodes, Johnny Shand Kydd, Sue Tranter. We are particularly indebted to Karen Howes, who, as Fritz von der Schulenburg's assistant, so patiently chauffeured us to the far corners of Scotland. We would also like to register our immense debt of gratitude to the staff of publishers Thames and Hudson.

LIVING IN SCOTLAND was first published in 1987 and sadly since then Peter Maxwell Stuart, Sir Nicholas Fairbairn, Pam Elliott, the 10th Duke of Atholl, and Brodrick Haldane have died. Over the same period, several of the houses have changed ownership. At the time of writing and photography, the authors were anxious to create an insight into existing taste and style in Scotland. The subsequent demand for copies has proved that this was achieved, and although LIVING IN SCOTLAND is now, to some extent, an historic record, the houses featured remain timeless and a tribute to those remarkable individuals who created them.

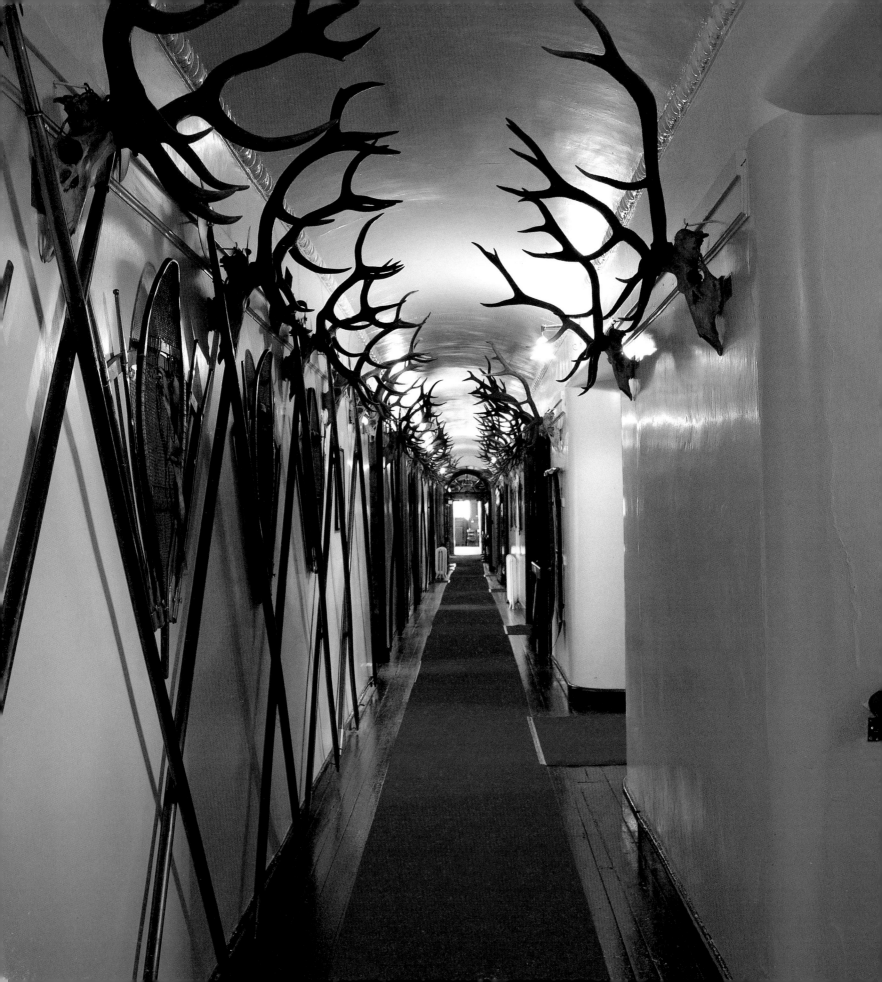

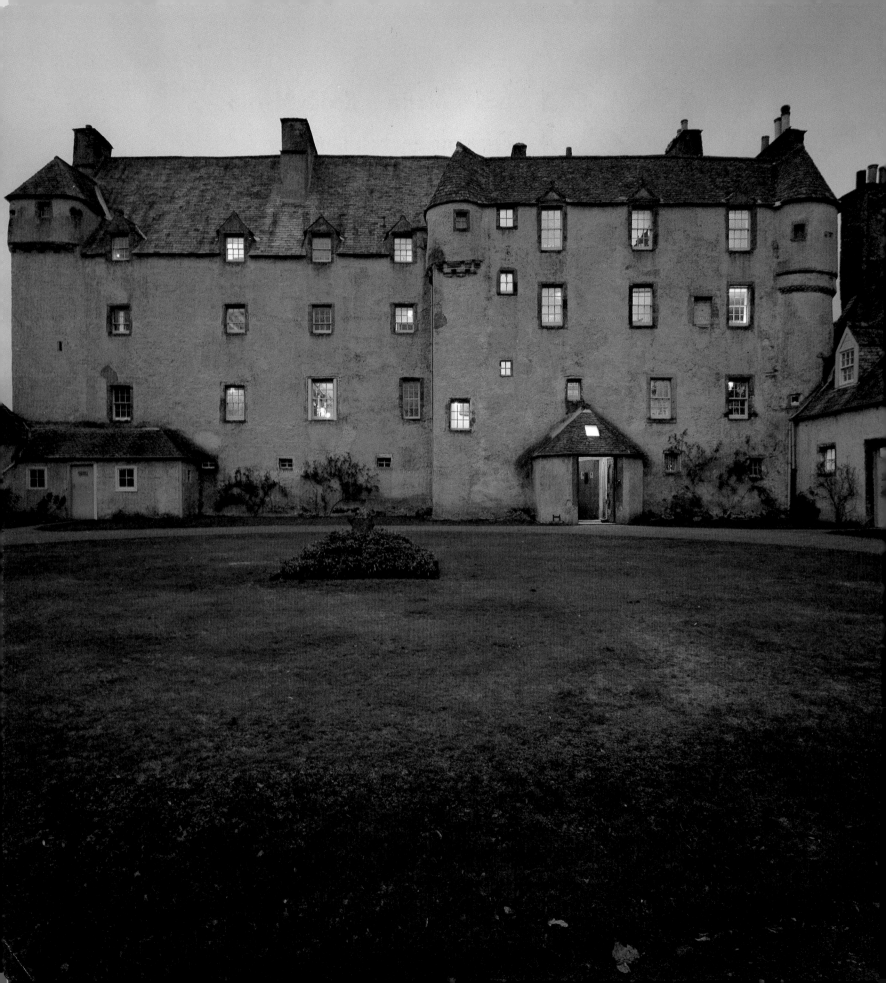

CONTENTS

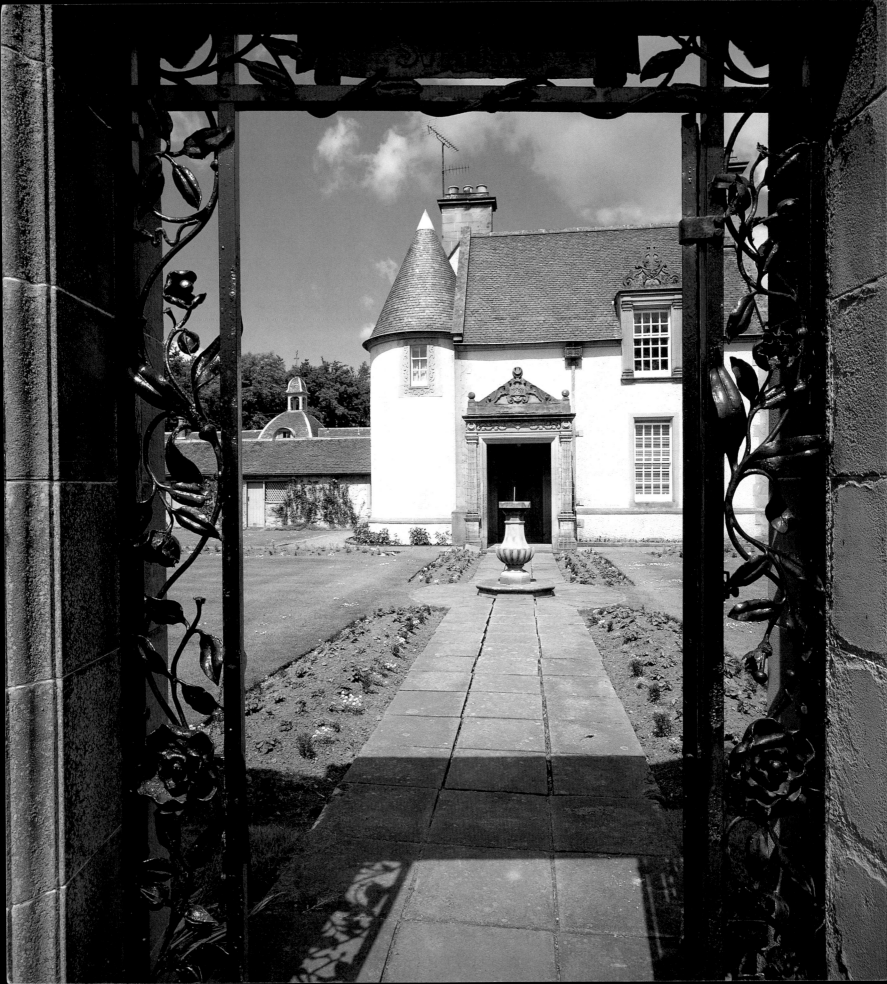

Outside of Scotland, there is an altogether too widely held belief that *all* Scots inhabit gloomy, stone-built castles tucked impregnably into heather-carpeted glens shrouded in the ubiquitous and romantic Highland mist. As in every generalization, there are elements of truth in this view; indeed, apart from the ancient keeps and fortresses thrown up for protection by the various landed clans of the North and families of the South in more primitive times, Victorian Scotland indulged those fantasies of a turbulent history with a proliferation of extravagantly patriotic homes conceived to flatter the egos and social ambitions of those whose fortunes derived from the Industrial Revolution. Queen Victoria herself set the pace with the purchase of her beloved Castle of Balmoral, her private celebration of the tartan and thistle, symbols of her Northern Realm.

Local materials were abundant, and demand produced the craftsmen and the collective genius of architects such as James Stuart, William Burn, Thomas Hamilton, William Henry Playfair, Archibald Simpson, Alexander "Greek" Thompson and, of course, the spectacular family of Adam. Thereafter came Sir Robert Lorimer and the innovatory Charles Rennie Mackintosh at the turn of the century. The Scots have been well served by their indigenous talent. Over the centuries, they have been intrepid travellers – voluntary and involuntary. The Grand Tour surreptitiously implanted aspirations towards classical grandeur; periods of military or diplomatic service in Europe, India, the Far East and the Americas, reaped rich rewards. The accumulated treasures from far-off lands have endured through the generations to stand side by side with locally made ornaments and furniture, porcelain, silver and paintings from the Scottish School, ranging from Sir Henry Raeburn and Allan Ramsay to William McTaggart, F.C.B. Cadell, S.J. Peploe, Joan Eardley and, more recently, Sir Robin Philipson, Elizabeth Blackadder and Fionna Carlyle. A distinct style emerges, necessarily individual

but following various parallels of refined ethnic taste. The armouries and stag's antlers of Blair and Inveraray acknowledge a way of life close to the hearts of all Highlanders, and one which can still be experienced in the shooting and stalking lodges of the north-east and north-west. The more opulent palaces of the Borders enshrine the triumphs and marriages of ancestors, while the New Town of Edinburgh can boast that at the time of its inception no less an authority than Thomas Jefferson was inspired to refer to it as a city that "no place in the world can pretend to compete with."

And then there was that late-19th-century, early 20th-century flowering of what has come to be known as the Glasgow Style, aspects of which evolved from traditional Celtic imagery, although it was too closely linked with Continental Art Nouveau to be claimed as a national concept. Nevertheless, its idiosyncratic influence is undeniable, and as Scotland's largest city emerges from the near catastrophic decline of a heavy industrial legacy to find a thriving technological base for the future, those remarkable designers, artists and craftsmen are being re-appraised.

It would be too easy to put together yet another book of Scotland's great houses – there are so many, and they have been written about and photographed so often before. It is also impossible in a book of this kind to ignore them altogether. Therefore, alongside the lesser known and the more eccentric, we have chosen a selection of those we consider to be classic examples, but with the requirement that they be lived in. The one exception to this prerequisite has been Hill House, Helensburgh, which is now owned by the National Trust for Scotland, but is the unique total work of Charles Rennie Mackintosh that survives.

Scotland is a small country with a population fluctuating around 5,000,000. There are large areas of land still owned by individuals. And there are large areas in the Highlands, abandoned by the crofting communities of the 18th and 19th centuries, which have not been re-populated and which today serve solely as playgrounds for the sportsman and the tourist. There are five major cities and, as is often the case in small territories, marked contrasts exist between the cultural influences of north, south, east and west. These might not be obvious to the outsider, but they are vividly apparent to the local mind. It would therefore be dangerously pretentious to assume, when looking at Scotland, that a typical pattern emerges. What does materialize, however, is the imaginative adaptation of the past to enhance the future. Despite the ravages of the planners and architects of the 1950s, there are fine examples of characteristic architecture still to be found in the city centres of Edinburgh, Glasgow, Aberdeen, Inverness and even Dundee. And it is pleasing to note that city centres are once again enjoying a revival, as inhabitants move inwards from the suburbs.

Like the English, the Scots have acquired a confidence in their past which they have pre-served, in tangible form, all around them. And as Scotland, despite its frequent inclemency, is

an "outdoors" country, abundant in sport for all seasons, gardens also have a special quality – not the refinement of England's manicured enlosures, but often a bold confrontation with nature. No more sublimely has this been achieved than in Wester Ross, at Inverewe, the famous National Trust for Scotland garden created by Osgood Mackenzie at the turn of this century. His inspiration showed that the hand of man can blend in perfect harmony with landscape even in the remotest and wildest context. It is his example which has profoundly directed the approach to Scottish gardens where, particularly on the west coast warmed by the offshore Gulf Stream, exotic plants and rhododendrons are found in all their glory. And therefore, although this is essentially a book of interiors, we have selected some gardens, for in an "outdoors" country the policies of a house are as much a part of the whole as the insides.

This book sets out to provide a personal sojourn into a cross-section of Scottish homes, to capture their atmosphere and to offer an insight into the personalities and tastes of their owners, without being unfairly intrusive. The appearance of the owners themselves within each series of photographs provides an added intimacy, although in certain cases they have chosen not to be pictured and this is entirely for their own reasons. Some of the houses illustrated are grand, some are masterpieces of understatement, some are erratic and others are relatively modest, but made special by the inventiveness of their owners. There are properties which have been devotedly restored and maintained, and others which have weathered the passing of years with magnificent defiance. Whether they be country mansion, historic tower house or town flat, they are all individual, exciting and a joy to explore.

COUNTRY LIVING

Mansion, fortified castle or cottage, country living in
Scotland is dictated by climate. In a land where
distances are not great but the terrain is often
impassable or inaccessible, the elements dominate. Turbulent
seas can cut off a Hebridean island for weeks on end. A winter
storm can still isolate communities despite the most immediate
attempts at snow clearance.

Dramatic contrast is offered by the wild splendour of the
Western Highlands, the richly forested tranquillity of the east,
and the undulating, controlled farmland of the Lowlands. But
not surprisingly, the majority of Scots prefer to locate themselves
in close commuting distance to the centres of commerce.

The Lowlands of Scotland therefore comprise one-tenth of
the land area and accommodate three-quarters of the
population. In consequence, there remain large areas of
remoteness, particularly in the far north where moorland meets
mountain, forest and sea. And the dwellings of the Highlands
blend into that landscape in homage to a way of life governed by
the weather. In the south, where the climate is less extreme, the
theme is more showy.

Overall, however, there is a timelessness in Scotland where
ancient and modern inter-relate. This could only be achieved in
a country with a strong self-knowledge, where the past is
unchallenged, an influential, ever-present common denominator
which consciously and unconsciously touches all aspects of living.
Scottish homes reveal more than a mere succession of decorating
trends. Individually, each discloses a distinctly personal story.

The south door at
Drumlanrig Castle,
Dumfriesshire, leads to steps
with magnificent wrought-
iron work, incorporating the
"Douglas Heart" emblem of
the Dukes of Buccleuch and
Queensberry, by James
Horn, Kirkcaldy (c.1680).
The sundial is by Henry
Wynne.

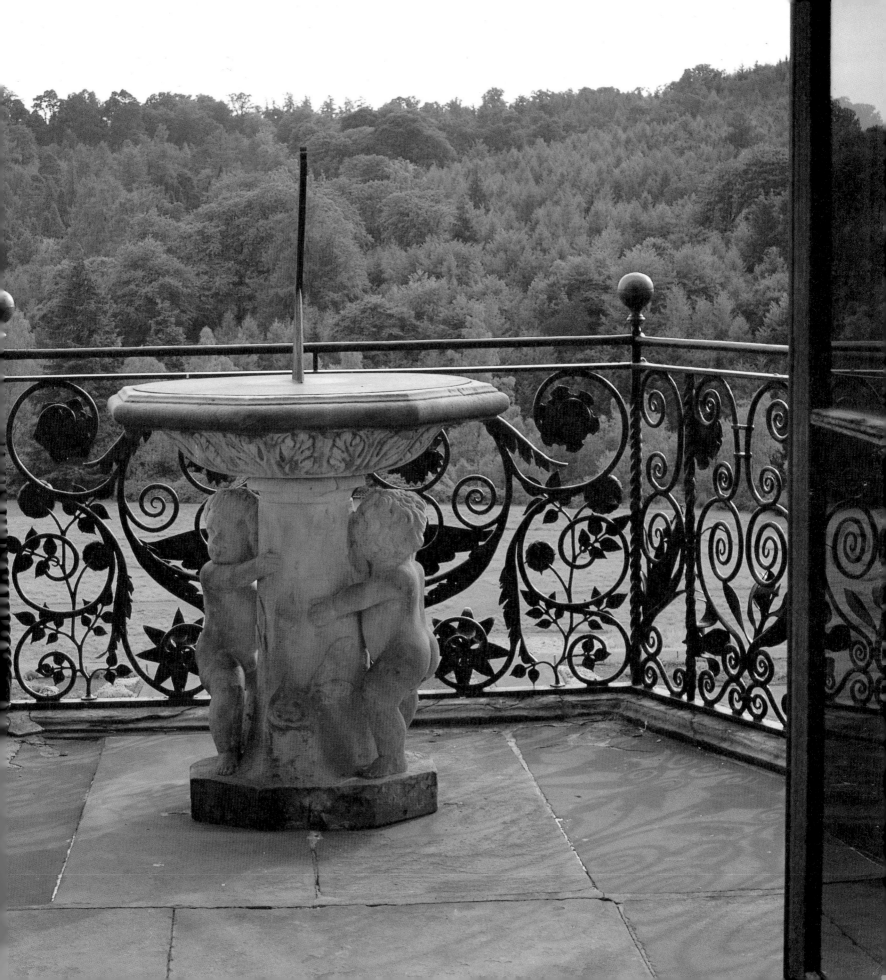

A Castle of Haunting Shadows

It was King Robert II of Scotland who granted the thaneage of Glamis to Sir Robert Lyon in 1372, and four years later this undoubtedly noble knight married the King's daughter, Princess Joanna. Throughout the centuries that followed, the castle, originally a royal hunting lodge, was to witness a fair share of happy and tragic events.

Mention Glamis Castle and it conjures up images of Shakespeare's Macbeth and the legend of a haunted secret room somewhere behind those pink sandstone walls. To most, however, Glamis, set in the expansive countryside of Angus, is best known as the childhood home of the much-loved Queen Elizabeth the Queen Mother, whose family have lived there for six hundred years.

Although the Queen Mother was not herself born there, it was her personal decision that her younger daughter, Princess Margaret Rose, should be, and the Princess is thus the first Royal baby in direct line to the throne of England to have been born in Scotland for three hundred years. As Her Royal Highness the Princess Margaret, Countess of Snowdon, she returns to Glamis frequently as a guest of the Strathmore family to sleep in the same room where she was born.

In 1972, Fergus Bowes Lyon, then an Edinburgh stockbroker, became 17th Earl of Strathmore and Kinghorne, inheriting Glamis Castle and estates from his first cousin. Although the family had been aware of this possibility for some time, Lady Strathmore confesses that when she was first married, the castle did not charm her at all. She remembers secretly thinking how glad she was that her first home would be an army quarter rather than a massive castle.

Now, she says, her attitude has changed completely. Aside from becoming a deeply loved family home for the Strathmores and all their family, it has become a way of life for them. Lady Strathmore's cheerful presence spreads through the entire building, and under her influence Glamis becomes an enchanted place.

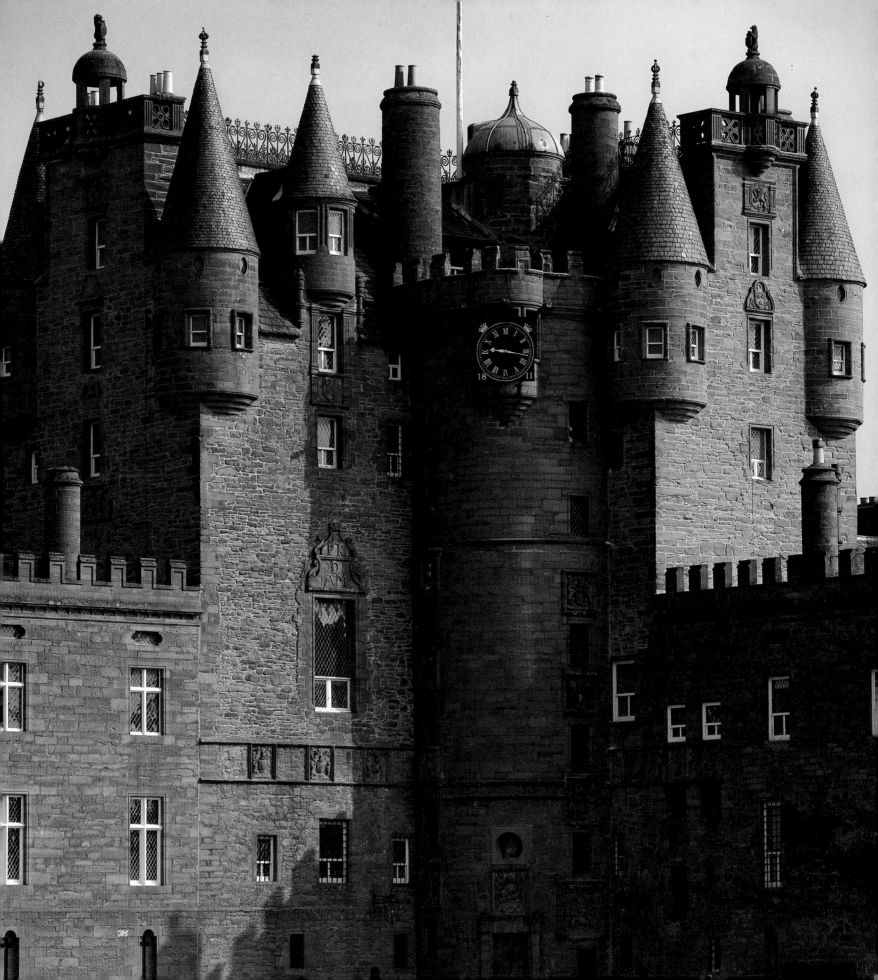

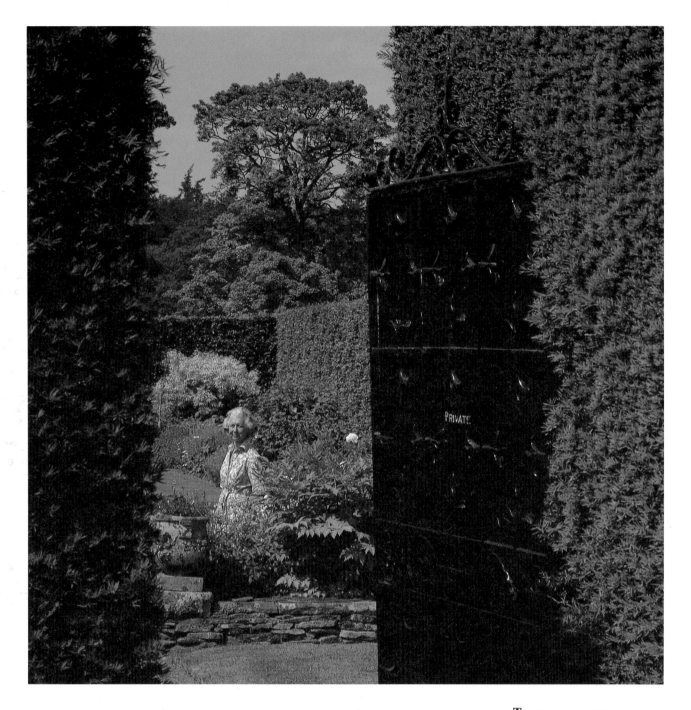

The Countess of Strathmore
and Kinghorne in her
private garden.

Opposite:
A wide avenue of trees
sweeps up to the dramatic
frontage of Glamis Castle.

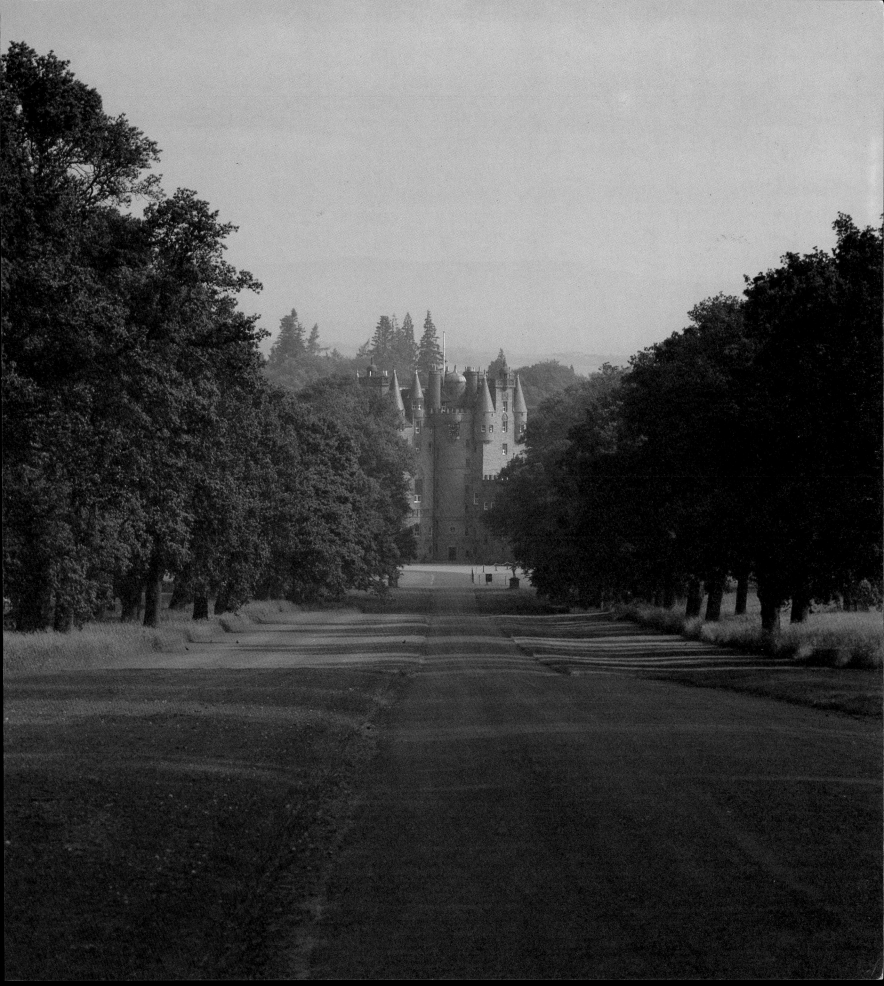

Left:
A conversation piece by
Fred Elwell of the Queen
Mother's parents in the
drawing-room hangs in the
dining-room.

Below:
The staircase leading from
the drawing-room. The
screen is believed to have
been created out of a
painting by an old master.

Opposite:
The drawing-room, 60 feet
long by 22 feet broad. The
fine arched ceiling bears the
monograms of John, 2nd
Earl of Kinghorne, and his
Countess, and the date,
1621. The painting on the far
wall is of the 3rd Earl and his
sons and hunting dogs.
Below are portraits of Queen
Elizabeth I, King Charles I,
and Lady Arabella Stuart.
On the left of the fireplace is
a painting of Elizabeth
Lyon, Countess of Aboyne.

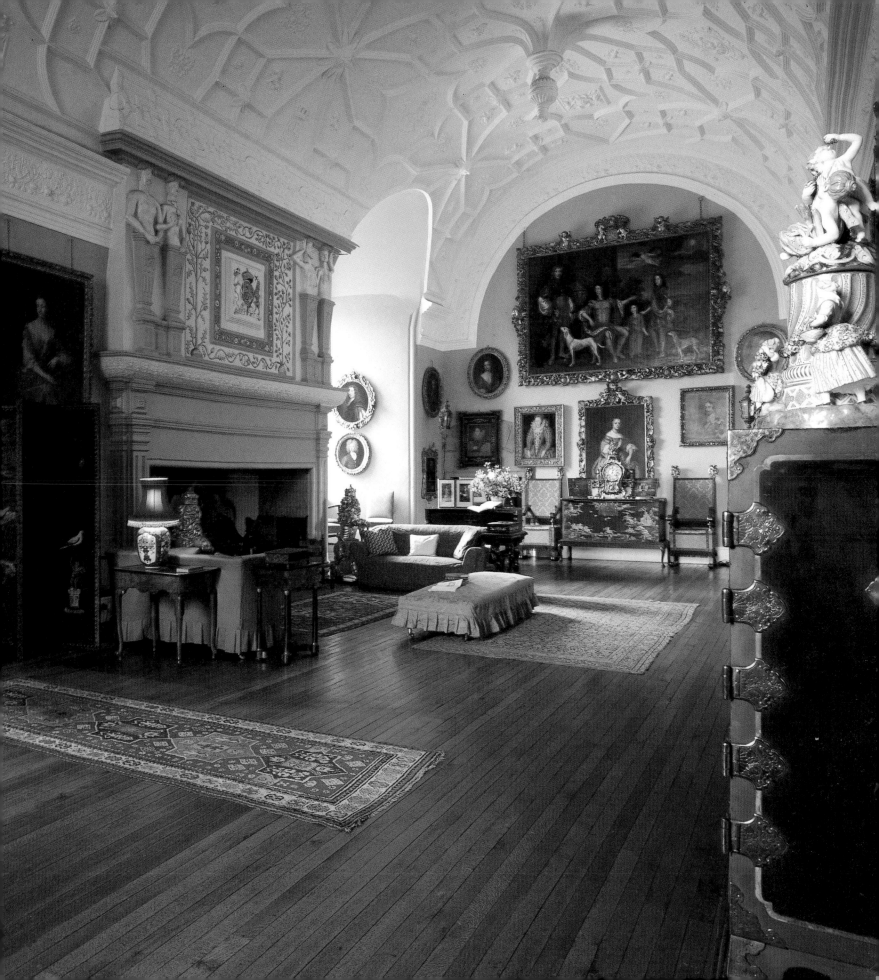

A raised sofa for watching the game of billiards. The cut-out wooden soldier holds an ashtray.

An elaborately decorated 17th-century Flemish cabinet has ornate and unusual legs.

Opposite:
The dining-room with table laid for a dinner party. The silver ship centrepiece was presented by estate workers to the 13th Earl and Countess to celebrate their golden wedding in 1903. On the far wall are portraits of the present Earl and Countess.

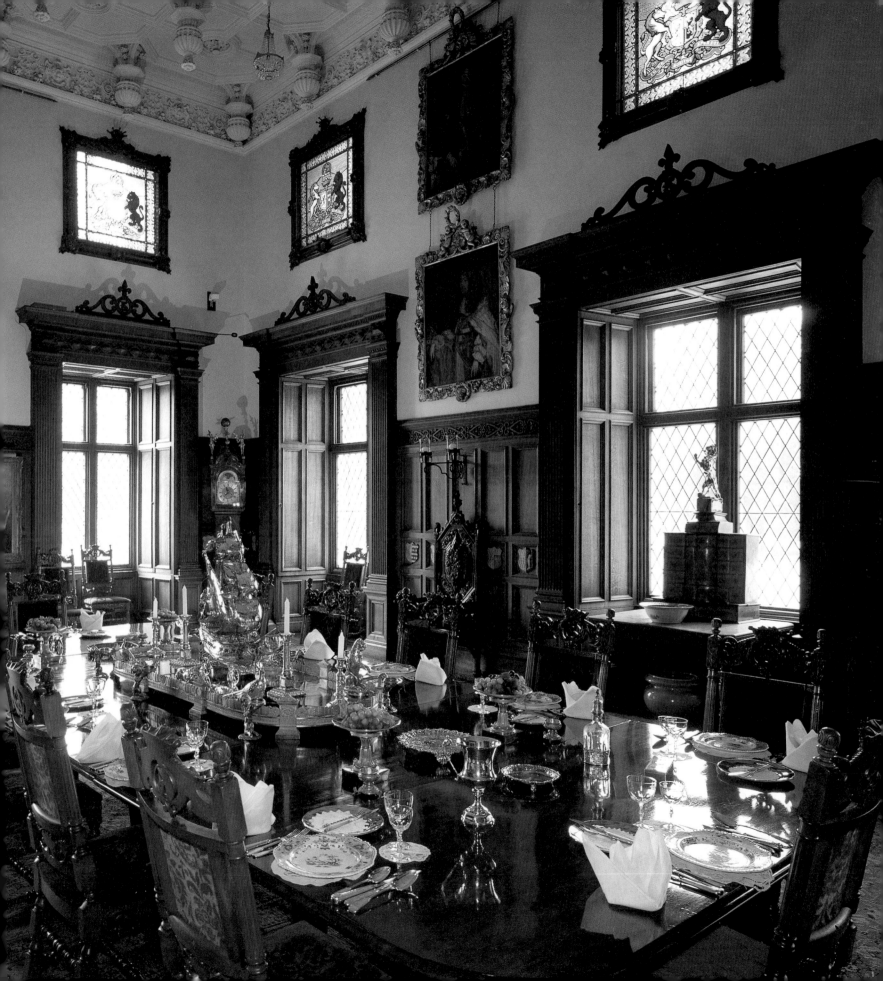

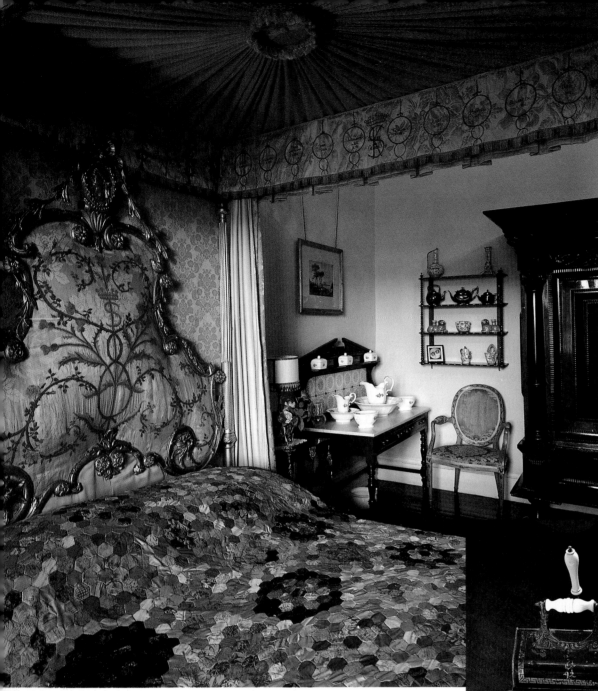

The canopy of the bed in the Queen Mother's bedroom incorporates the embroidered names of the children of the 14th Earl and Countess and includes "Elizabeth 1900" and "Michael 1893", the father of the present earl.

Opposite:
The 14th-century lower hall known as the Crypt. A secret chamber is thought to be located deep in the thickness of the walls. In this room a Lord of Glamis and the "Tiger" Earl of Crawford played cards with the Devil on the Sabbath. So great were the resulting disturbances that the room was eventually bricked up and permanently sealed.

Paintings of the Castle adorn a coal scuttle and bellows.

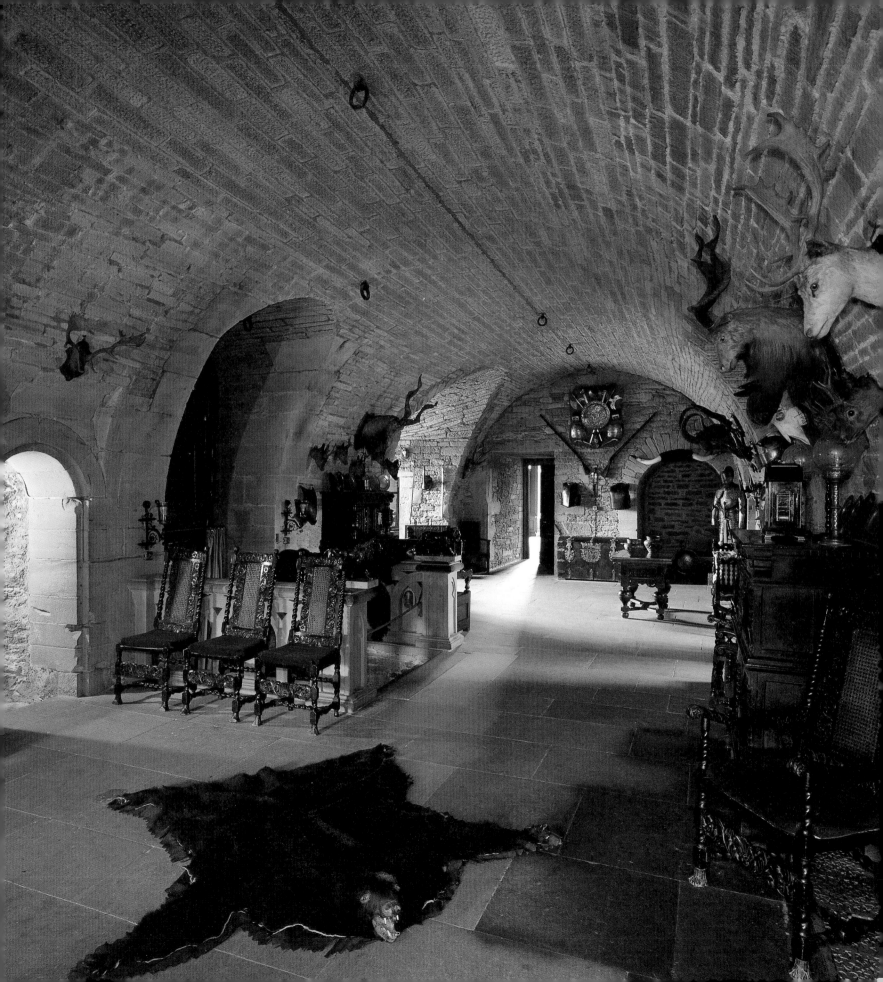

A view from the top of the walled garden situated half a mile from the house.

Opposite:
A distant view of the north front. The obelisk on the far hill commemorates James Hunter Blair's great-great-uncle, killed in the Crimean War.

A Loyal House in Ayrshire

The Laird of Blairquhan is a robust, jovial bachelor who some years ago exchanged his own smaller house with his father for this imposing Tudor-style family mansion and has since completely restored the building. A great party-goer and -giver, James Hunter Blair lives in a house which expresses its owner's insatiable zest for life and fun. At the same time it has been thoughtfully converted in an ingenious and sympathetic manner to meet the needs of modern living.

Blairquhan is considered one of William Burn's most successful commissions. The building cost James's ancestor, Sir David, £16,371. 14s with a further £3,866 for furnishings in 1798. The masonry work was undertaken by Alexander Ramsay and Archibald Johnston and the carpentry by James Patton and Hugh Govan, all under the strict supervision of Burn. Every detail was masterminded from Edinburgh and Burn's drawings, now in the National Monuments Record for Scotland, confirm that all his specifications were carried out exactly.

The result is that one enters a neo-Greek masterpiece, stepping into the saloon to be confronted by a series of apartments, all in the Gothic style. The drawing-room and billiard-room, situated on the west side, have bright bay windows which look over the garden and the park, and down to where the Water of Girvan snakes off towards Maybole. The dining-room and Sir David's Room, now a library and cosy sitting-room, are across the saloon on the east side, with a corridor between them which connects with the new kitchen. Above the saloon, bedrooms open off the gallery in the tower. At the end of a passage to the east is the modern estate office, which has been incorporated in the former kitchen court; on the outside walls here can be seen the only remaining details of an original castle, the oldest part of which dates from the 14th century.

There is no argument that Blairquhan is a very welcoming house; containing the original furniture bought from Thomas Newbiggin of London and from James and Matthew Morrison of Ayr, it projects an enduring sense of all being as it should be. James Hunter Blair now opens the house to the public and plays the role of landowner and Scottish laird with enthusiasm.

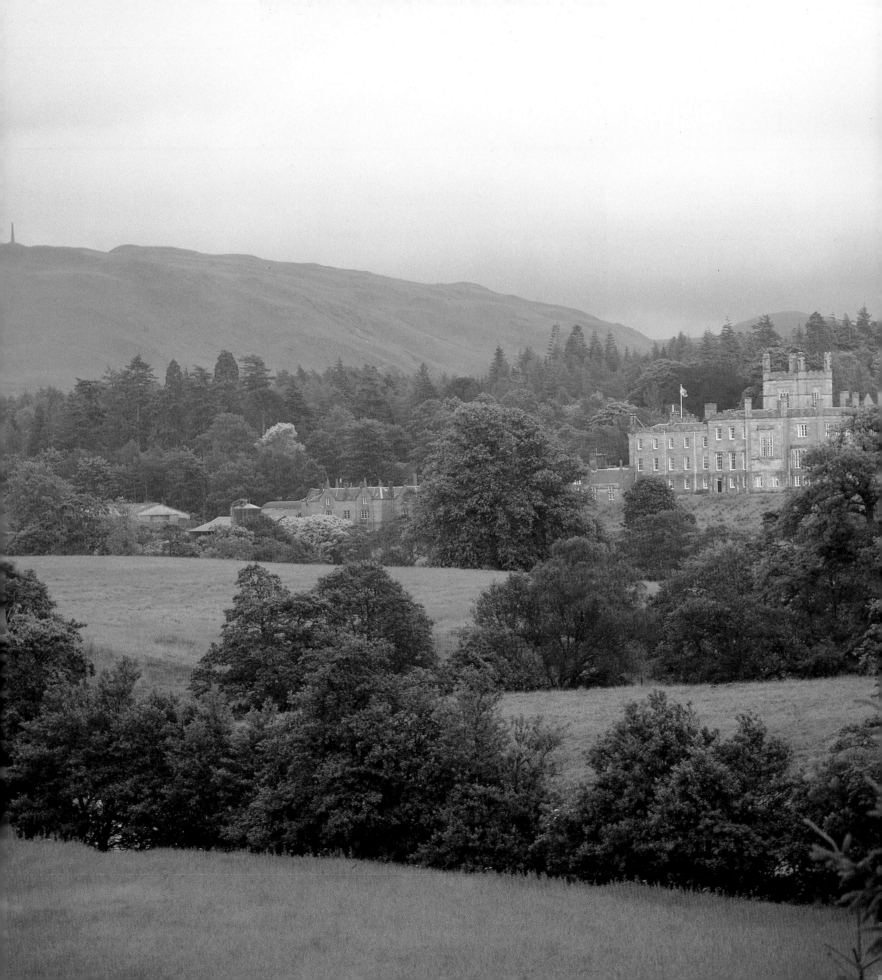

James Hunter Blair is particularly proud of the *c.* 1810 mechanical organ made in Edinburgh, which he purchased at a Christie's sale. It has five rolls and each plays ten tunes, one of which is named after his ancestor, Sir David Hunter Blair.

The principal staircase. The painting on the far wall is attributed to Spierinox.

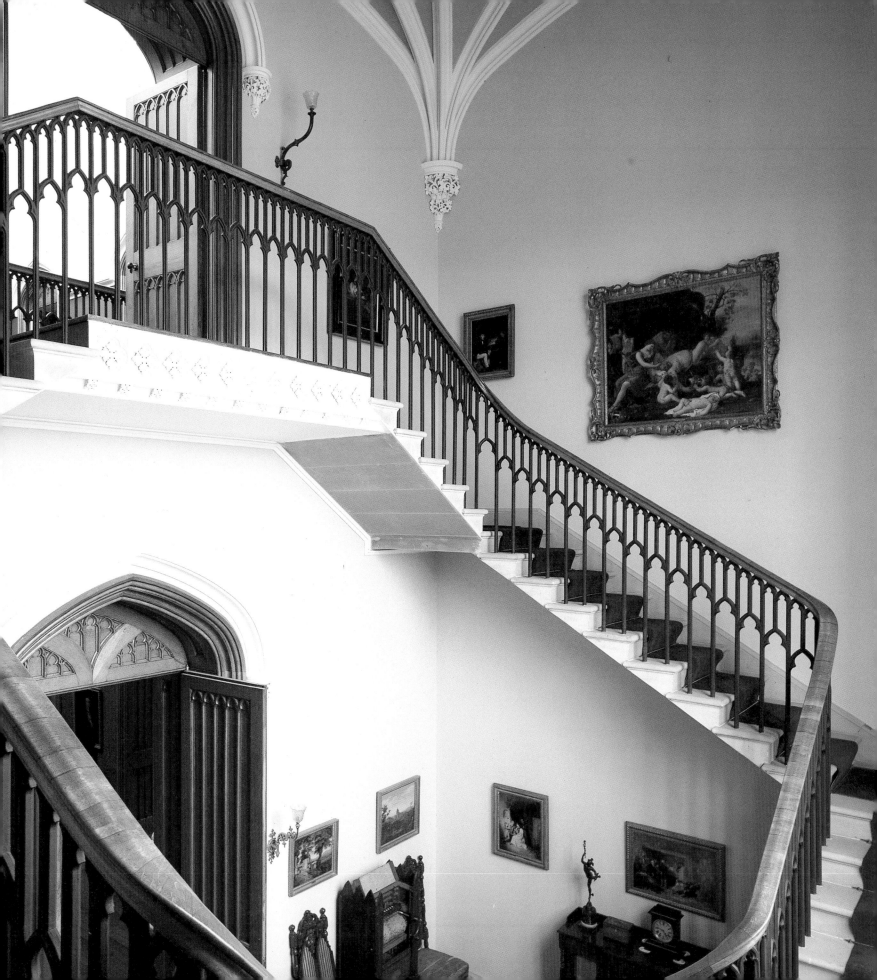

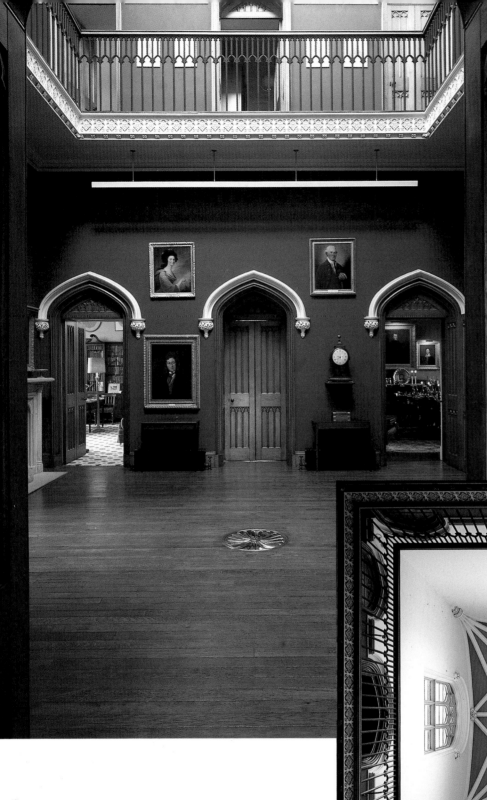

A view across to the east side of the saloon. The brass rose in the centre of the floor is a central heating duct. The portraits are of Lt Col James Hunter Blair, MP (1817-54), Margaret Elizabeth Hunter by David Martin, and Robert Hunter of Thurston (died 1810).

Opposite:
A painting of Robert Hunter of Thurston hangs above two doors on the east side of the saloon. The door on the right opens into the dining-room recently vacated by forty dinner guests.

The vaulting in the interior of the saloon tower is picked out in white and blue.

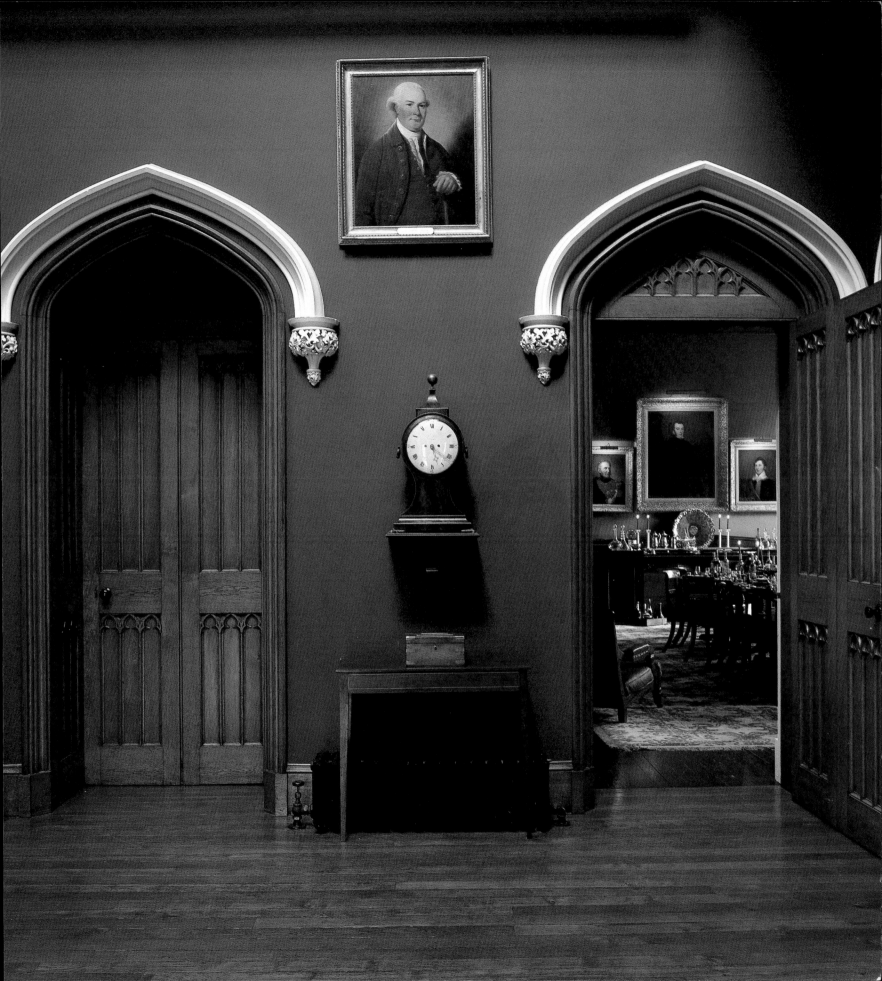

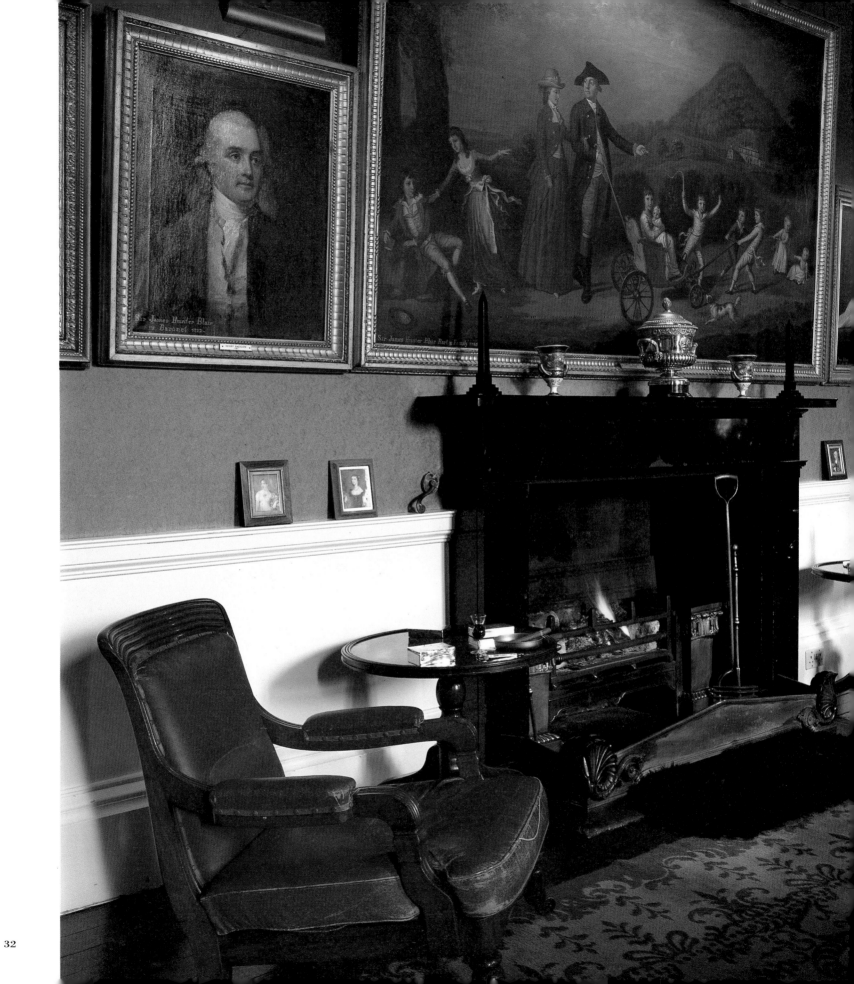

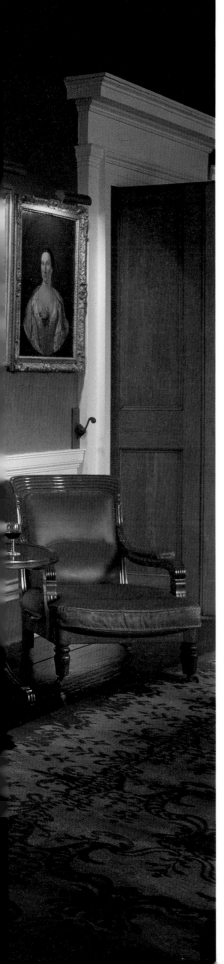

Left:
The dining-room. The magnificent painting above the mantelpiece is of James and Jean Hunter Blair with their children at Dunskey, painted by David Allan in 1785.

Curling stones sit on shelves under a window at the far end of a passage.

Overleaf:
At the end of the basement corridor a moose's skull, antlers and feet are suspended above a sleigh acquired by a travelling member of the family. Coloured ribbons decorate the central heating pipes.

The gun room.

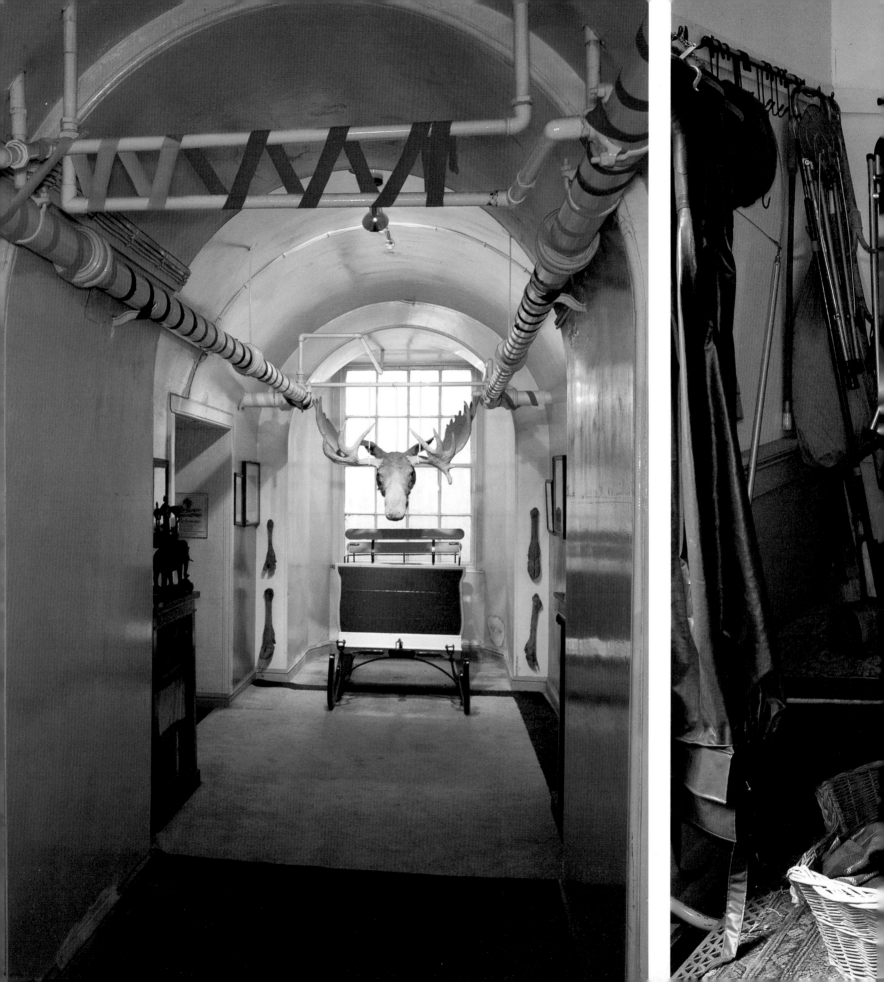

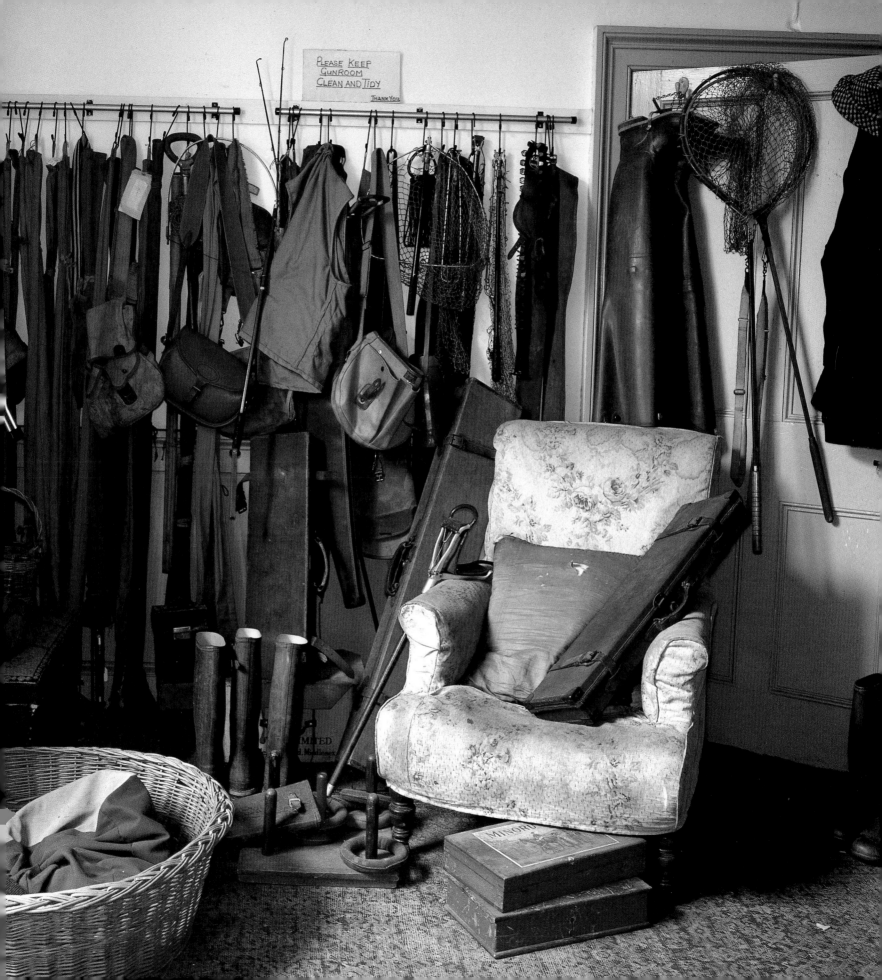

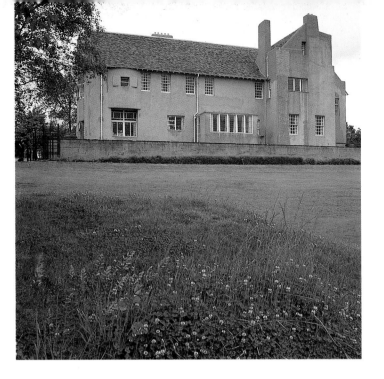

A simple harled exterior to withstand the extremes of the Scottish climate.

Opposite:
A tiled overmantel in the dining-room. In front are a pair of steel poker and tongs. The wall lights are brass with white glass panels.

Created for an Art Lover

In 1902, the publisher Walter Blackie purchased a plot of land at the top of a hill in Helensburgh which overlooks the Gareloch and the Firth of Clyde. Blackie was a notable patron of the evolving Glasgow Style and had been introduced to the controversial 33-year-old designer and architect, Charles Rennie Mackintosh, who by then had established a reputation with his design for the new building for Glasgow's School of Art. Blackie and Mackintosh discovered that they both held similar views – they disliked pastiche Tudor, Gothic and Classical details which ignored the overall setting of a building and, in particular, the climate. Both men preferred a "plain" style.

Mackintosh's dream was to create an entirely new style for the 20th century which, in line with the aspirations of his colleagues involved in the Glasgow Style movement, would be identifiably Scottish. Hill House, a simple harled building, cost Walter Blackie £5,000, a large sum in those days. But if the house might appear austere on the outside, reflecting a Scottish protestant ethic, by contrast the interiors are charming.

The Blackie family confirm that Mackintosh visited them regularly at their Dunblane home in order to see how the family lived, and Hill House was entirely conceived to meet their needs.

Hill House was sold in 1953 and in 1972 it was acquired by the Royal Incorporation of Architects in Scotland, on the understanding that the character of the house would be preserved for posterity with the furniture specifically designed for it. In 1982, the National Trust for Scotland, aided by a generous grant from the National Heritage Memorial Fund, accepted Hill House as a gift.

Mackintosh never achieved his dream of a continuing school of uniquely Scottish architectural style, but what he created at Helensburgh is a domestic masterpiece which survives as a memorial to his original inventive genius.

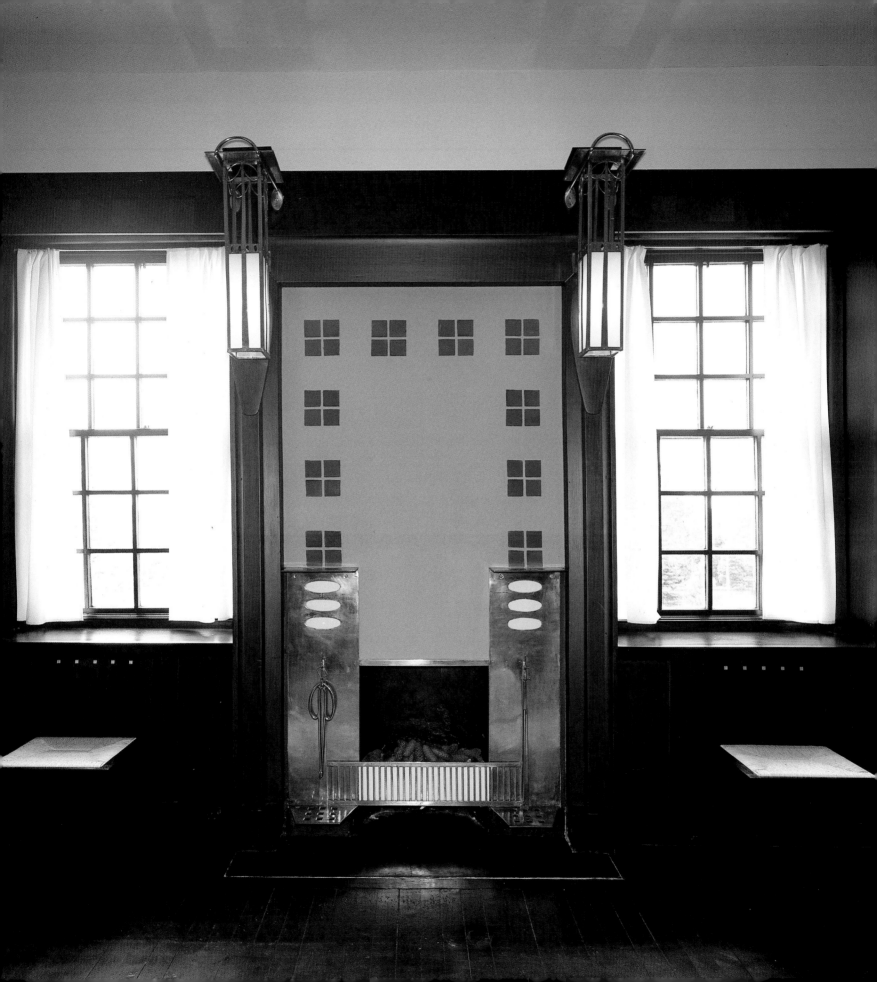

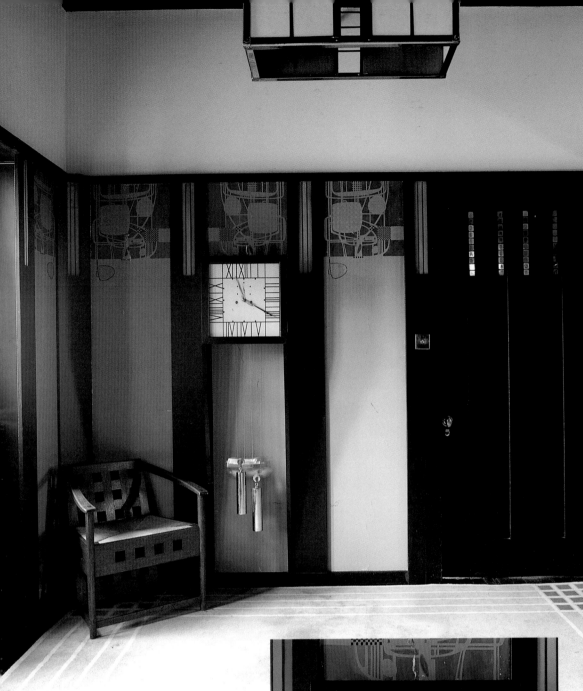

In the hall, a carved wooden chair with rush seat stands next to the clock which is built into the wall as a permanent fixture.

Opposite:
The hall with Mackintosh furniture and carpet, and stencilled designs on the walls.

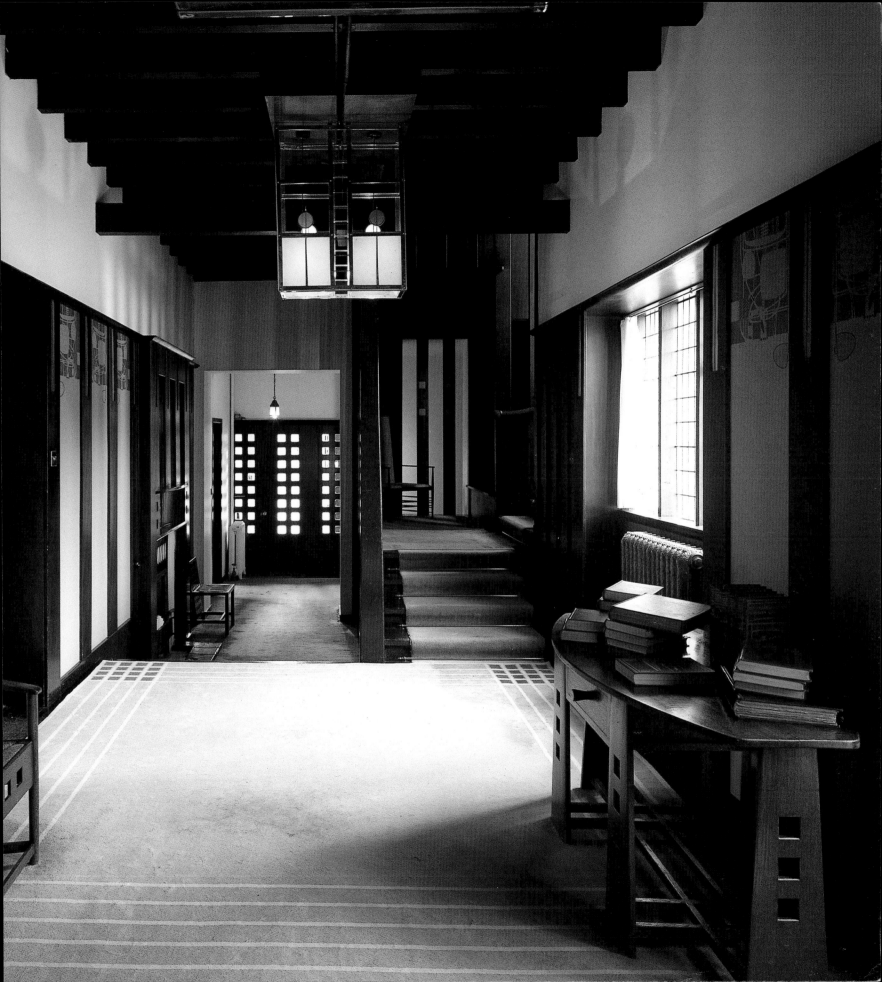

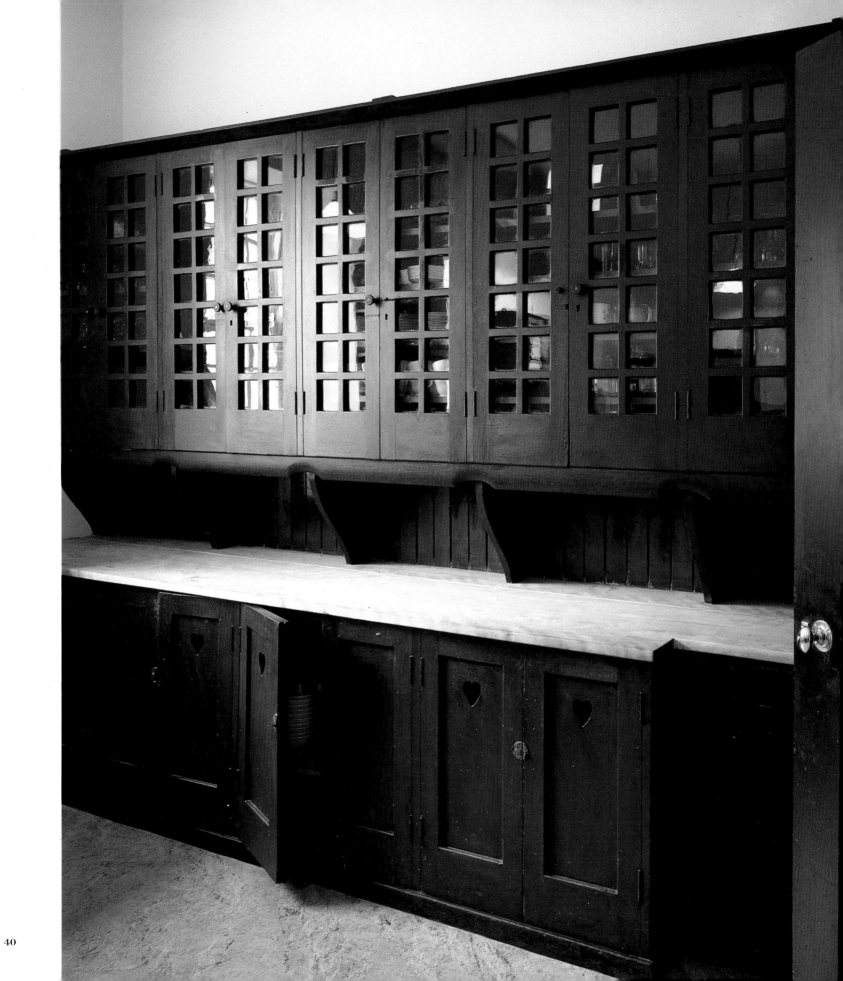

Purple glass insets and
stencilled designs are a
theme throughout the house.

Left:
Functional cupboards and
worktop in the kitchen.

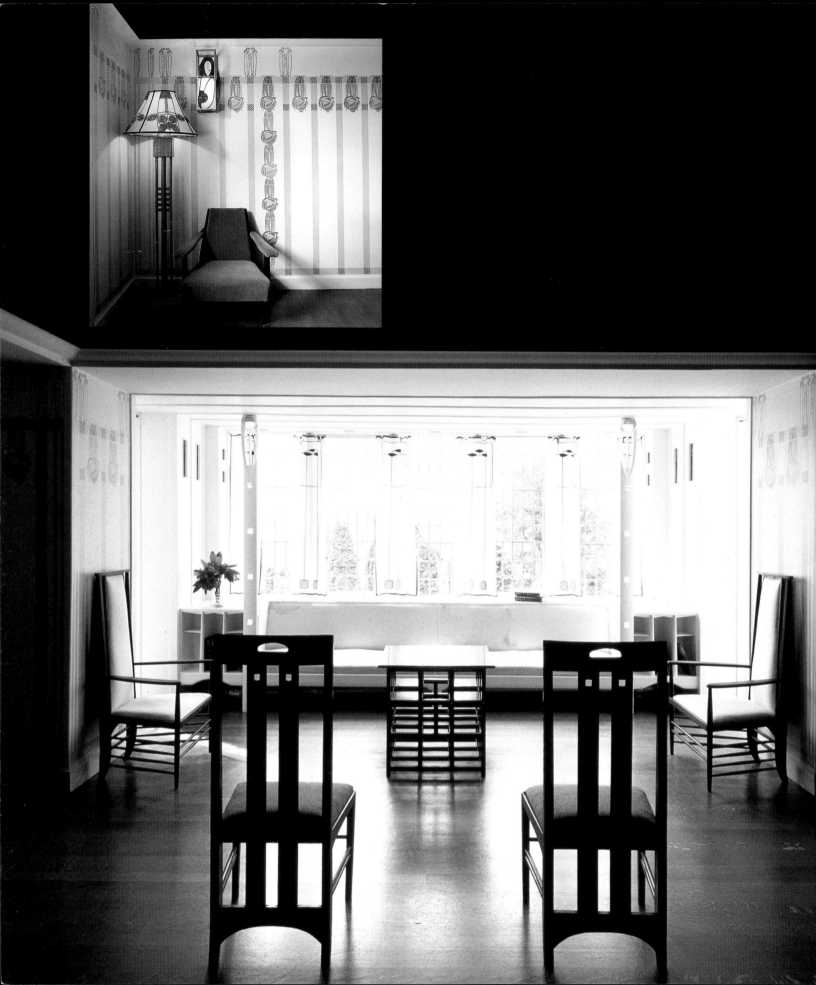

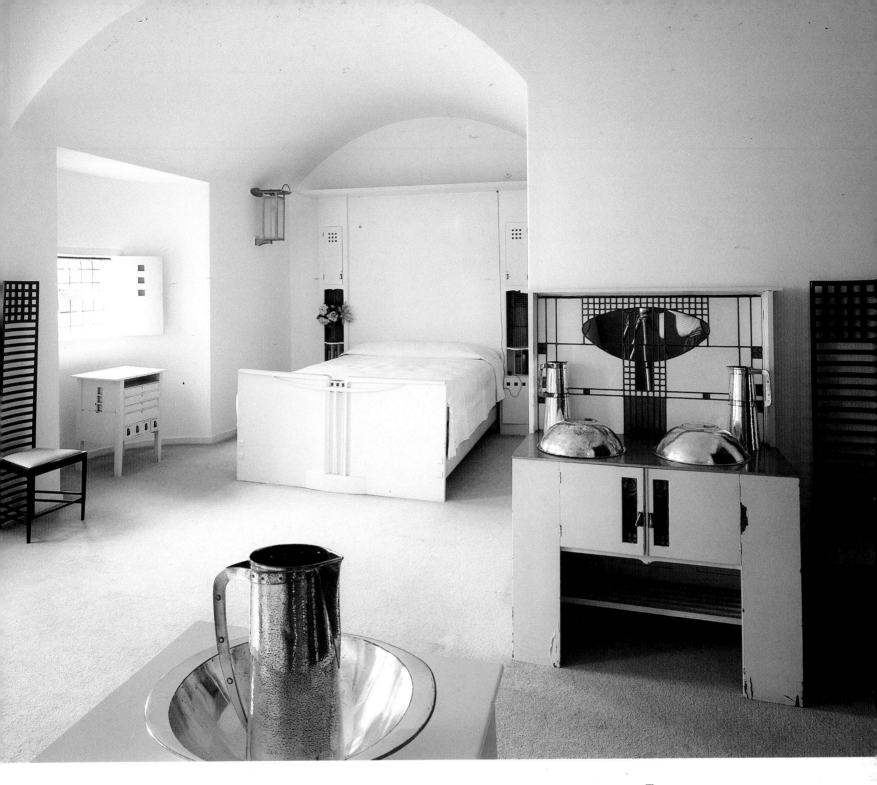

Opposite, below:
The drawing-room, its walls decorated with an elaborate pattern of roses supported by trellis work, which forms a repetitive pattern around the room. The wide window seat is flanked by book- and magazine-racks.

Opposite, above:
In the drawing-room a sycamore standard lamp with mother-of-pearl base stands against a stencilled wall. This is complemented by a brass wall-lantern painted with decorative glass panels in a similar design.

The white bedroom, which could also be used as a morning room. The windows and shutters are curved to follow a curve in the outside wall.

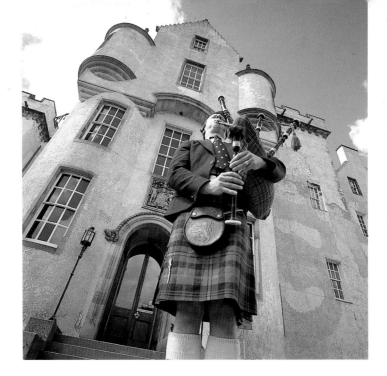

The Duke of Atholl's personal piper welcomes visitors to the castle.

Opposite:
Blair Castle from the north-east.

Overleaf:
Blair Castle, seen from the west, sparkles white in the evening sunlight.

A Ducal Fortress in the Highlands

From the A9 Blair Atholl-to-Inverness highway, Blair Castle gleams white and imposing against a rich backdrop of forest and the distant Grampian mountains. From close to the village of Blair Atholl, an avenue flanked with limes leads to the gravelled east entrance of the castle where, in summer, the tourist coaches bank together to give Blair the largest annual visitor figures for any property open to the public in Scotland. And when the Duke of Atholl's personal standard flutters from the ramparts, one knows that His Grace is in residence.

The earliest record of a castle at Blair dates from 1269 and probably refers to the section which is known as Cumming's Tower at the north end of the castle group. The hall range is believed to have been built in the 16th century, but most of what we see today was built in the 18th, when a neo-Gothic face lift was imposed by David Bryce.

The interiors of Blair have survived intact from that time. Much of the plasterwork was created by the Scottish stuccoist Clayton and the chimneypieces by the London stonemason, Thomas Carter. The rooms are filled with magnificent furniture, for the most part Georgian English. There are superb collections of china, valuable books and displays of pottery, embroidery and lace. The corridors lined with stags' antlers taken from the estate are a reminder that one is in the heart of Highland sporting land.

George Iain Murray, 10th Duke of Atholl and chief of Clan Murray, is a descendant of the 3rd Duke. As Chairman of Westminster Press he spends much of his time in London, but as a keen sportsman he takes every possible opportunity to enjoy his 135,000 Scottish acres.

The Murray Earls and Dukes of Atholl have lived at Blair Castle since the 15th century and successive owners have influenced the overall picture of today. This is a classic Highland home where, despite the magnificence of the surroundings and treasures, there is evidence of a traditional integrity unsurpassed anywhere in the world.

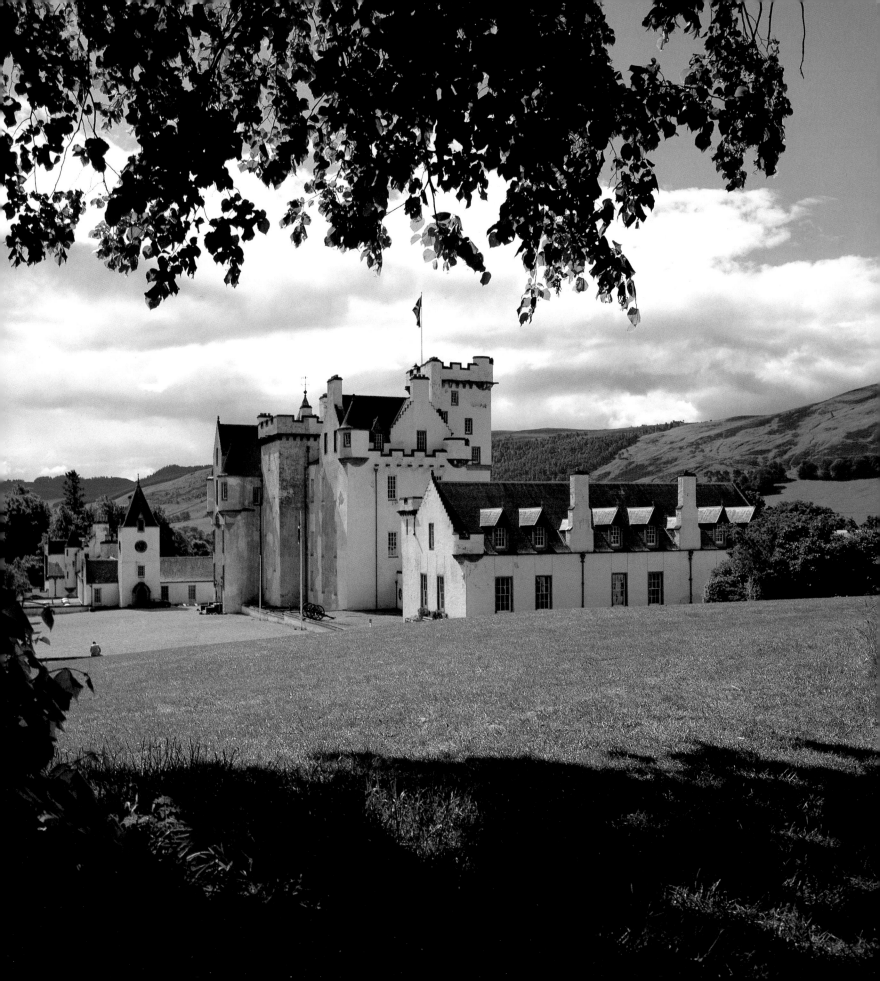

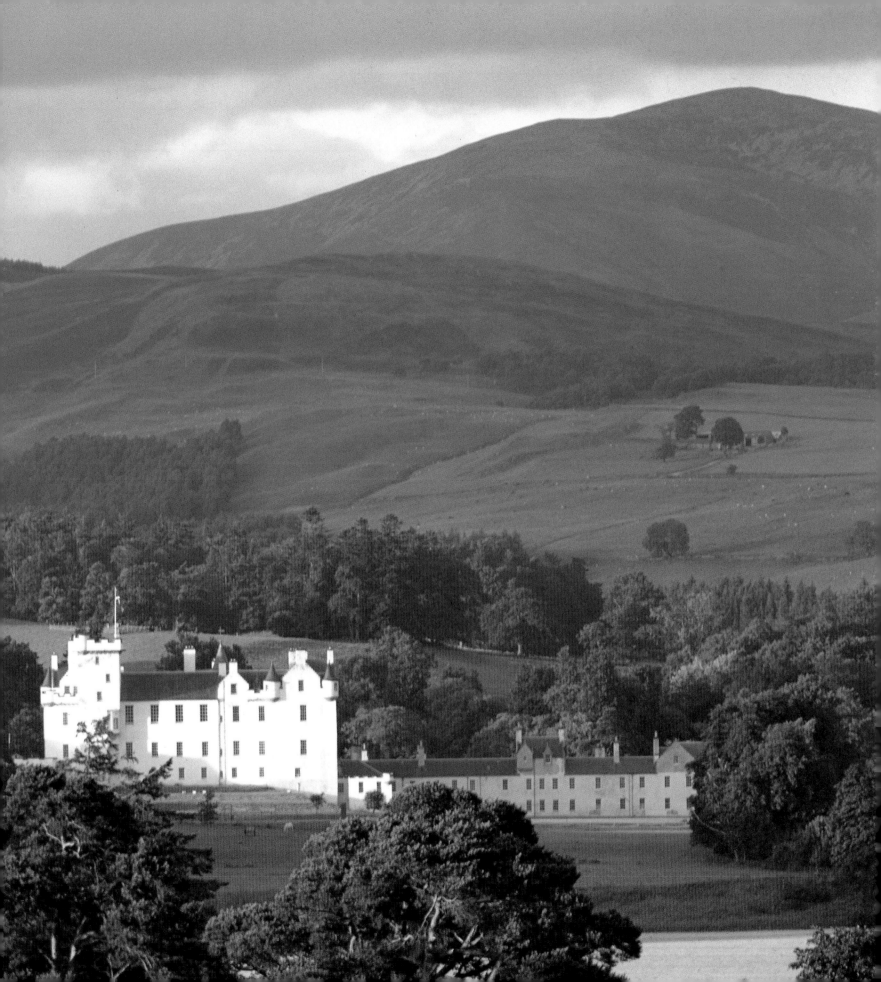

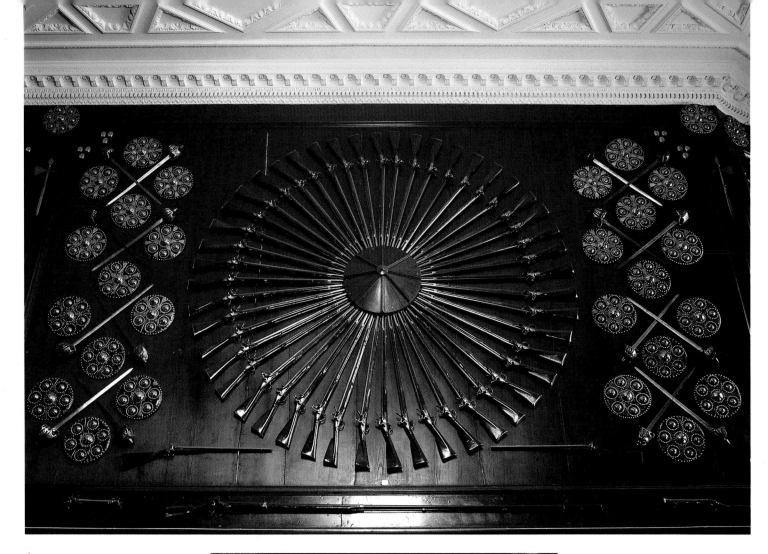

Armoury decorates the walls of the entrance hall.

Three curling stones made of Glen Tilt marble, one bearing the Duke's crest. The Turkish cooking pot, strainer ladle and stirrer were taken at the Battle of Romani by the Scottish Horse in 1816.

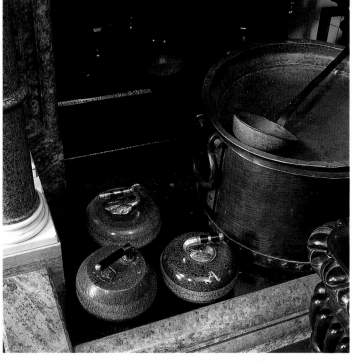

Opposite:
The great panelled entrance hall decorated with arms and stags' antlers. The portrait of Iain, 10th Duke of Atholl, was presented by tenants, friends and employees to celebrate his 25 years as Duke in 1982.

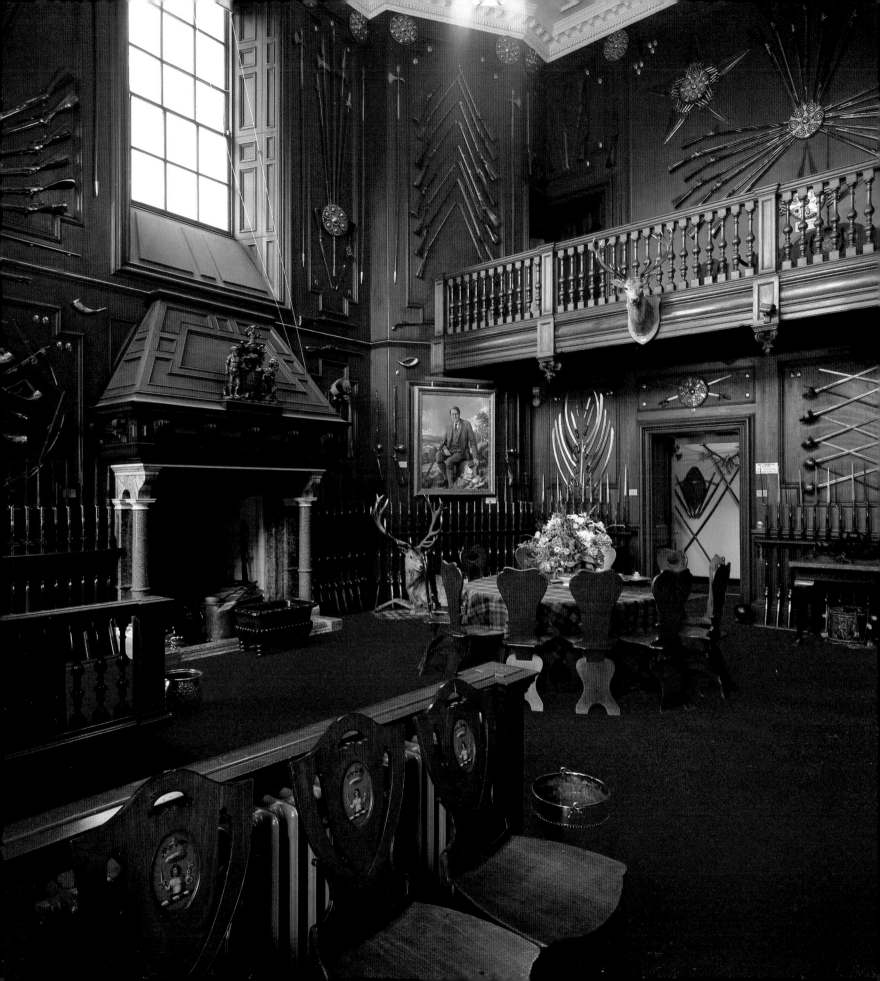

Elaborate plasterwork by Clayton over a door in the dining-room. The ceiling collapsed in 1985 and the plasterwork has been completely restored.

The silver stag was presented to the 7th Duke and Duchess on their silver wedding in 1888.

Opposite:

The dining-room, looking across to the carved marble chimney-piece with head of Apollo by Thomas Carter the elder (1756) and the plaster overmantel of a Trophy of Arms, the work of the Scottish stuccoist, Clayton. The mahogany table set dates from 1805.

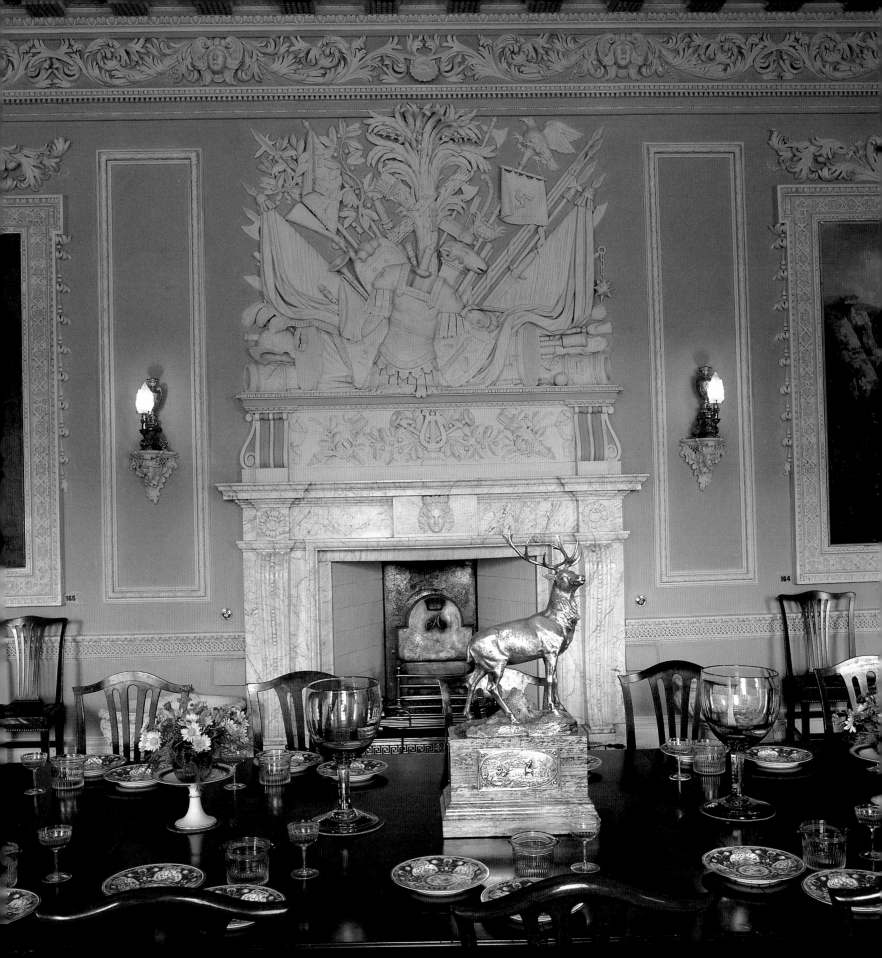

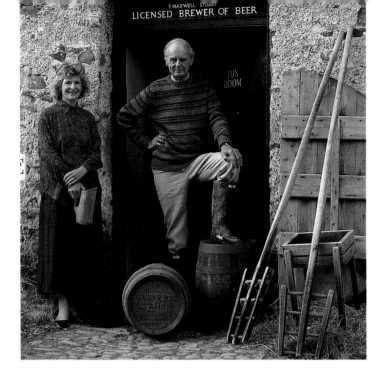

Peter and Flora Maxwell Stuart outside the Traquair Brew House where in 1966 the Laird revived the ancient tradition of brewing Traquair ale.

Opposite:
Traquair House nestles into the woodland of the Tweed Valley.

A Peeblesshire Hunting Lodge

Peter and Flora Maxwell Stuart are a dedicated couple who are determined to keep what one visiting writer described as their "careworn fortress" intact. When Peter, the 20th Laird, inherited Traquair, there was no electric light. Now, apart from welcoming some 60,000 visitors a year, Peter, Flora and their daughter Catherine have managed to create a sympathetic balance between the past and the present.

Traquair House has played host to twenty-seven kings. In the early days, when it was the focal point of sporting excursions into the forests of Ettrick and Lauderdale, King James III of Scotland gifted the house and lands to a series of his favourites, and eventually to his half-brother, the Earl of Buchan. Buchan bequeathed it to his natural son, James Stuart, ancestor of the present owner.

Located in lush rolling hills, this old fortress stands ¼ mile back from where the River Tweed winds a leisurely course through pastoral meadowland. Once that lovely river passed so close to the house itself that the Laird could fish from his windows, but in the 17th century the Laird decreed that the river's course should be altered.

Enlargements to the old keep had already begun when James Stuart fell, with his king, at the Battle of Flodden against the English in 1531. In 1599, Sir William Stuart created the main house as we see it today, extending the existing buildings southwards and adding the steep slated roof and dormer windows. It was he who had the river re-routed.

The low two-storey wings, ornamental wrought-iron gateway and screen which enclose the court-yard date from the 17th century. The story goes that the "Steekit yetts" or Bear Gates were permanently closed after the departure of Prince Charles Edward Stuart, who had called on his cousins to solicit help on his march south to York in 1745. They are not to be reopened until a Stuart once again sits on the throne of Scotland.

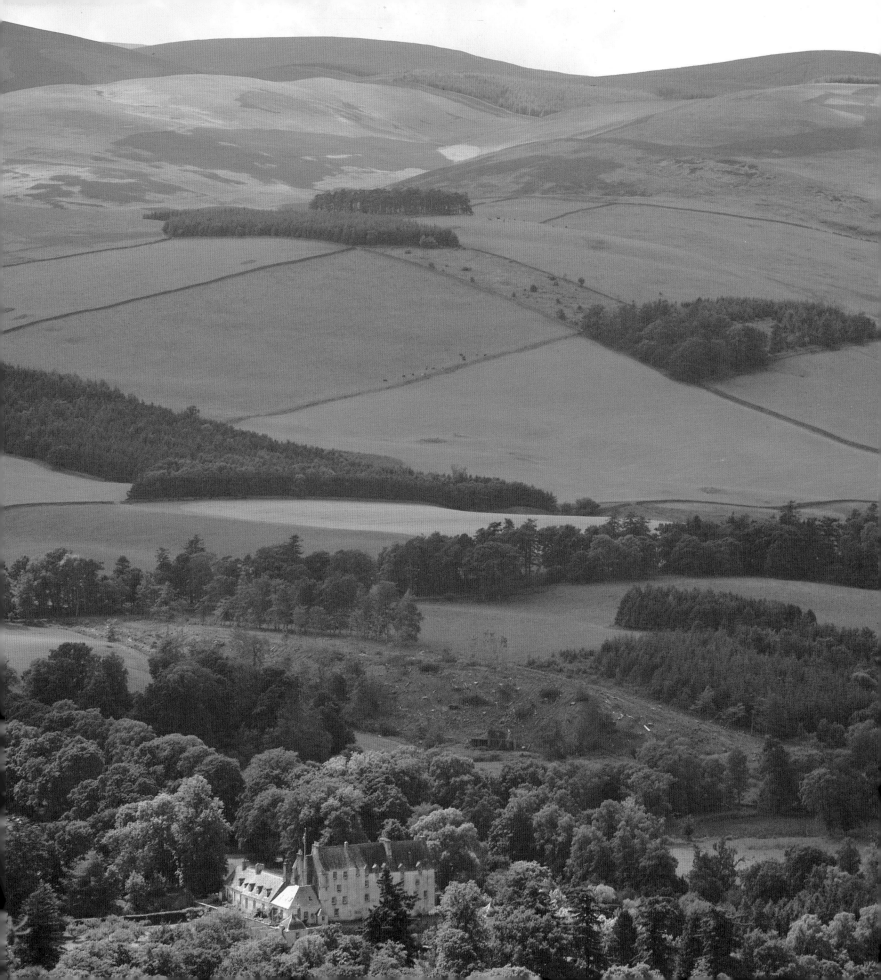

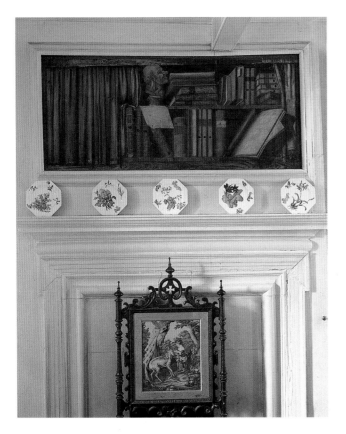

Over the fireplace in the sitting room is a *trompe l'oeil* still-life painting on wood by Egbert van Heemskerk.

Right:
The 18th-century library contains some 3,000 volumes. Each book carries the Traquair bookplate and has printed on its spine an exact indication of its corresponding shelf and place number. The two globes, celestial and terrestrial, are 18th century. The ceiling cove contains paintings of busts of classical authors, repainted by Edinburgh artist James West in 1823.

Far right:
The seascape over the fireplace in the high drawing-room is a curiosity, as it does not belong to the original painted decoration surrounds and may be a fragment of an early drawn wall-covering, painted on paper and applied to canvas.

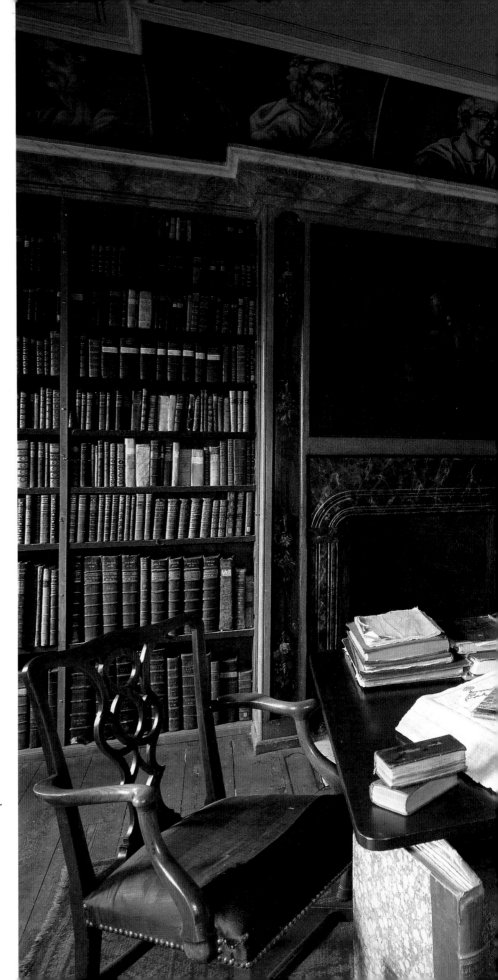

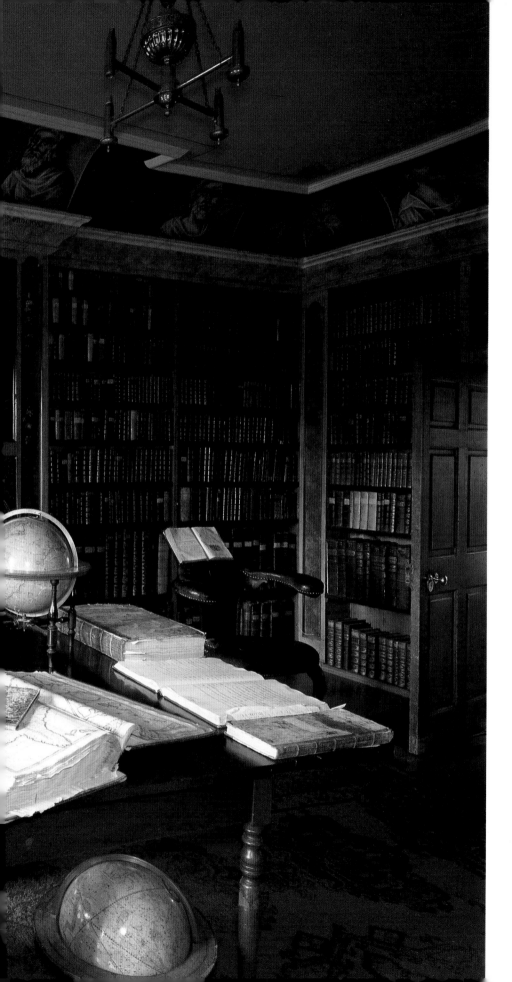

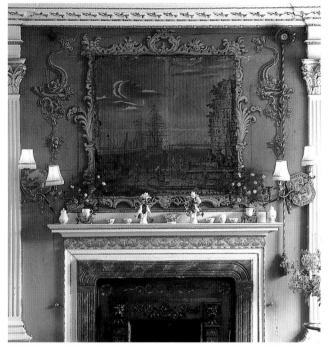

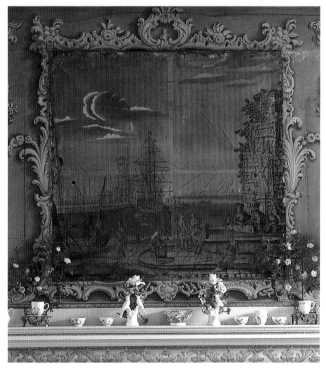

The staircase leading to the upper floor. The door on the right is of carved oak and came from the Maxwell family's Dumfriesshire home, Terregles House. The design incorporates two animals locked in combat – the Scottish unicorn and the English lion – and the door dates from 1630.

Right:
The old laundry. Until the 1930s, washing was done in the now ruined wash-house about 200 yards from the house and then taken by pony and trap to the laundry, where it was pressed and ironed. The old box mangle dates from 1840.

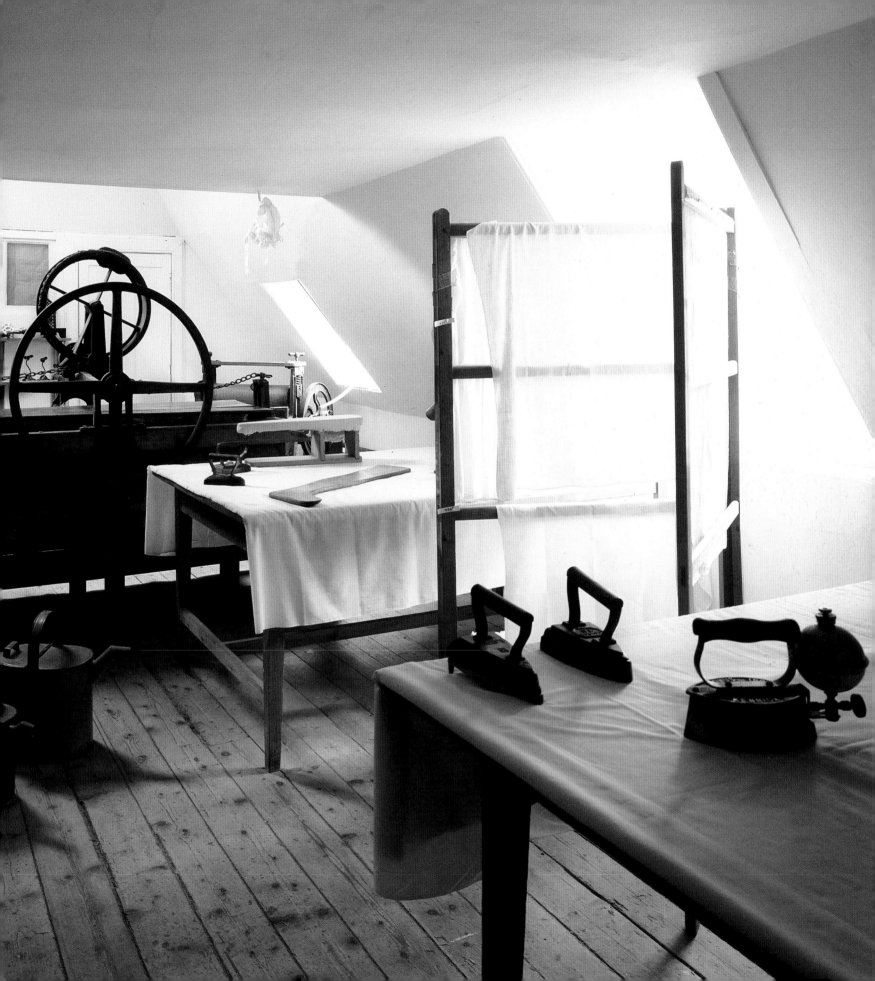

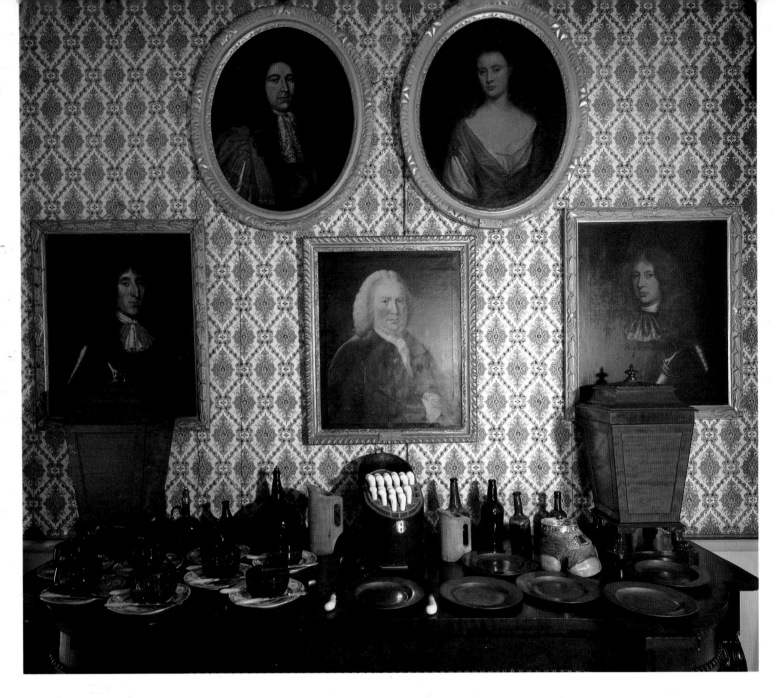

In the dining-room, the two oval portraits are of the 4th Earl and Countess of Traquair. In the centre is the 6th Earl. On the sideboard is a knife-box with a full complement of Bow porcelain knives (*c.* 1720) and a collection of pewter plates and mugs (17th century).

Opposite:

In the front hall, a row of Georgian servant bells above an oak armorial commemorates the visit of Mary Queen of Scots to Traquair in 1566 and displays the Royal Arms of Scotland. Below this hangs a copy of the warrant to execute Mary in 1587. On the floor are three curling stones.

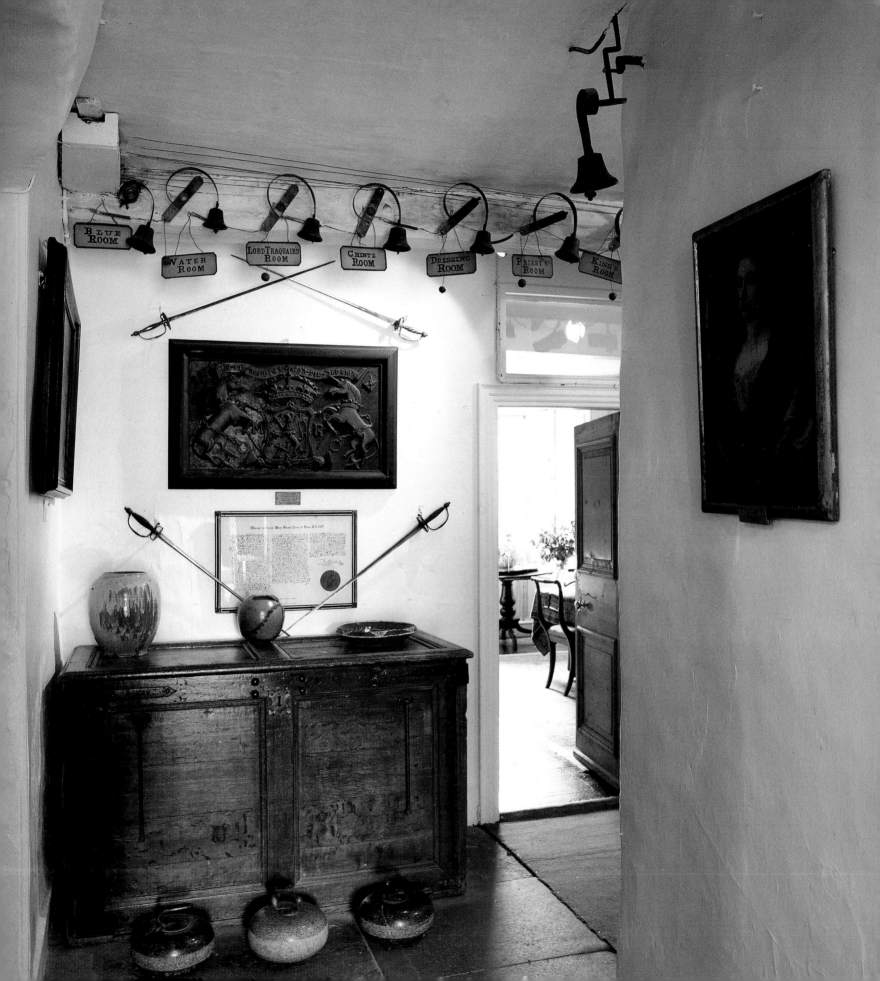

The white bedroom. On the wall to the left of the window is a picture of the same view painted recently by a member of the family.

Right:

In this room, known as the King's Room, there is a magnificent state bed with yellow hangings, which is said to have been used by Mary Queen of Scots. The portrait on the far wall is of Lady Anne Seton, wife of the 2nd Earl of Traquair. At the foot of the bed is the cradle used by Mary Queen of Scots for her infant son, later King James VI of Scotland and I of England.

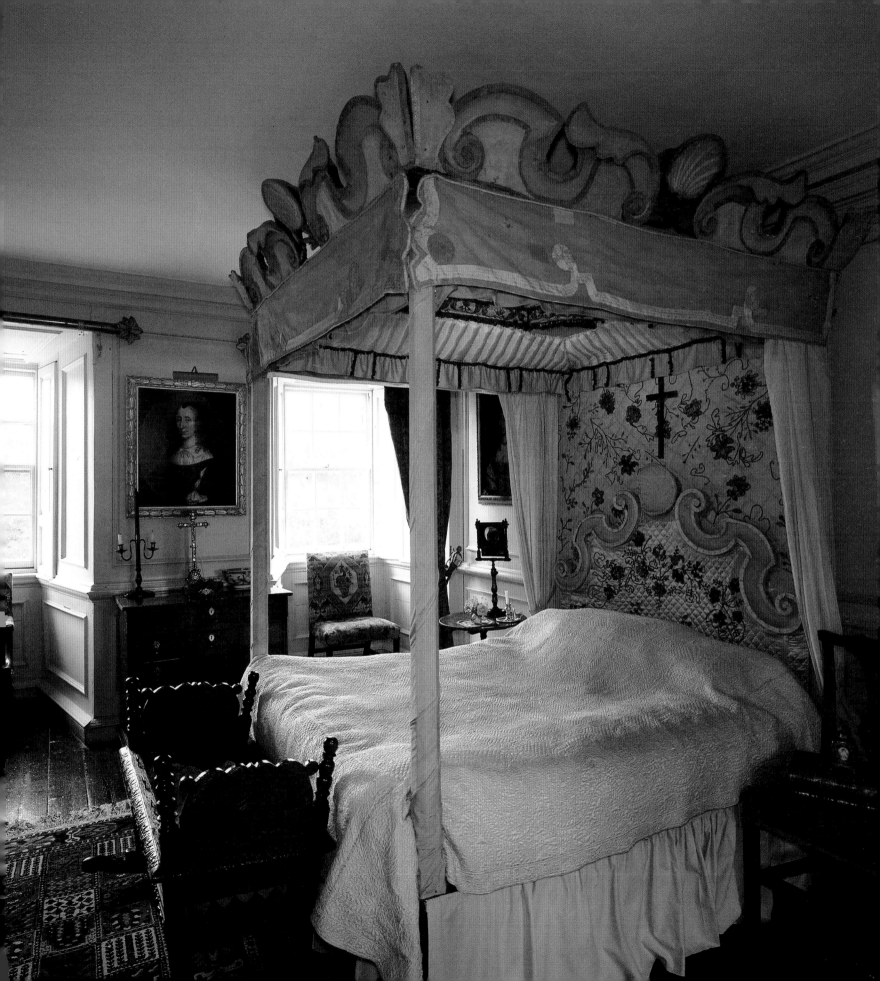

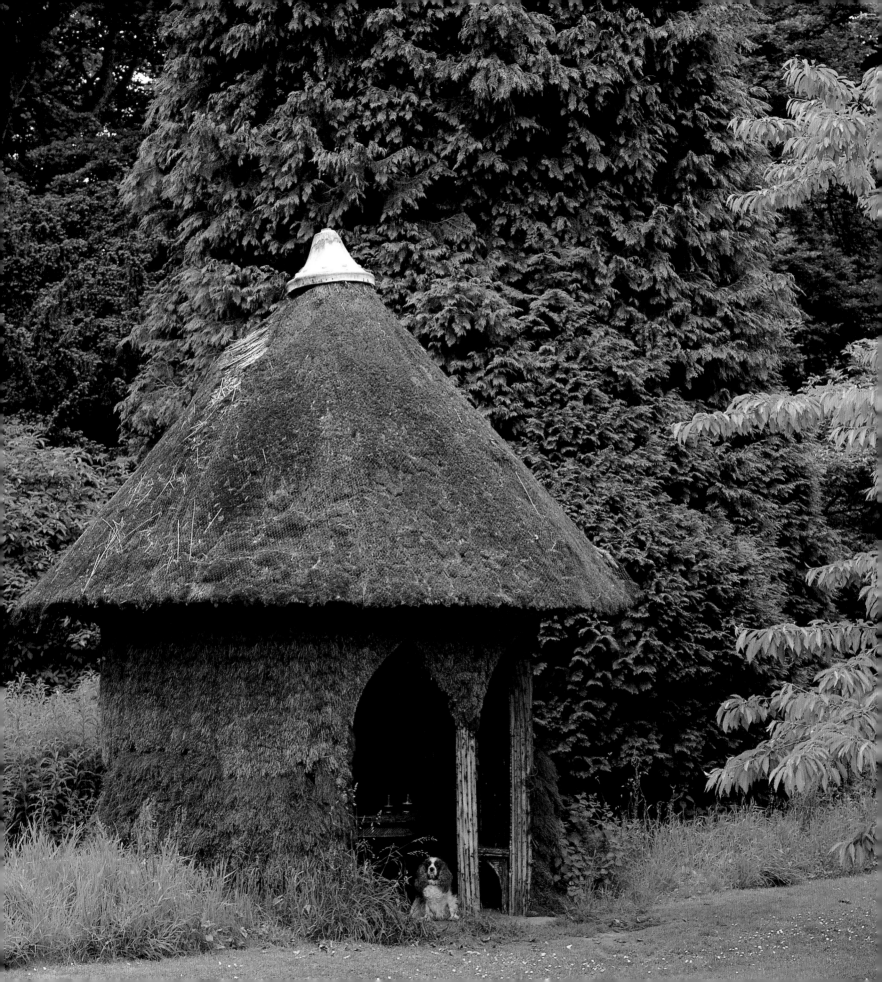

Left:

Sophie poses in the doorway of the heather hut which stands in the grounds close to the house.

Right:

On the wall of the terrace, overgrown with wild plants, is the bust of a young girl.

Below left:

On the little gate leading to the woodland walk is one of the bears of Traquair, recalling the time when bears were hunted in the woods here.

Below right:

In the museum room there is a wall painting discovered in 1900 under wallpaper and dated around 1530. It shows a hound and a dromedary, probably copied from contemporary book illustrations and accompanied by quotations from the Acts of the Apostles.

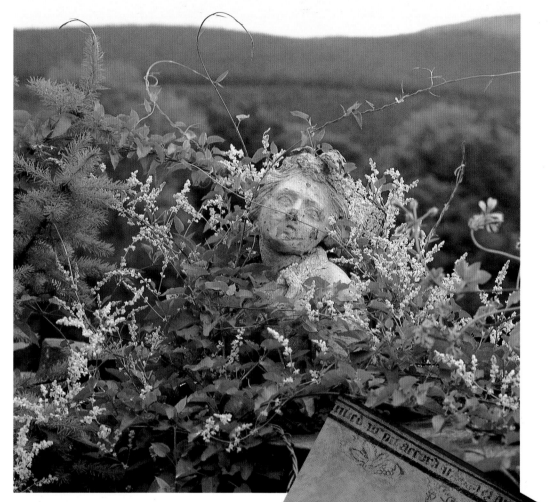

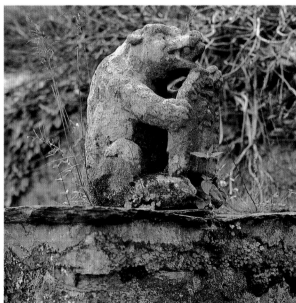

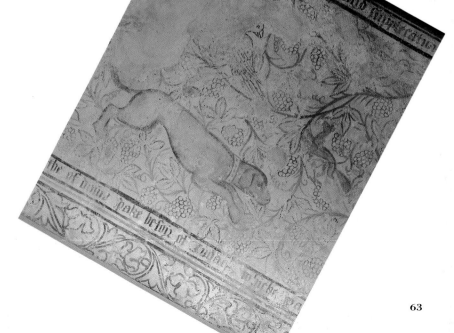

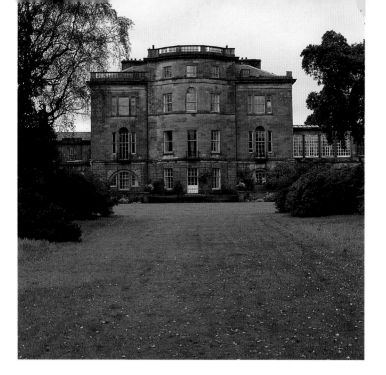

Ardgowan House from the south-west.

Opposite:
Sir Houston and Lady Shaw Stewart with their pony and trap and their two springers, Malcolm and Sammy.

Forgotten Chintz

The Shaw Stewarts of Ardgowan descend from a natural son of King Robert III of Scotland, who was granted the family seat in the 14th century. The present large, rambling house was built in 1791 and looks out over the Firth of Clyde towards Cowal. When Sir Houston Shaw Stewart, 10th Baronet, brought his bride Lucinda home to live there in 1982, the property had fallen into some disrepair.

Like many families with large houses in Scotland, the Shaw Stewarts frequently have groups of Americans to stay, and a chance discovery of a trunk full of old chintzes in an attic led to an amusing sequence of events. It happened that one of the guests at the time was Ronnie Grimaldi of the New York interior decorators, Rose Cummings; he was so thrilled with these surprisingly modern-looking designs dating from 1822, that he suggested they should be copied and packaged and launched as The Ardgowan Collection. This has now been done with considerable success, and in the meantime Lady Shaw Stewart has been steadily restoring and redecorating the old house, making good use of the reproduction chintz originally designed for the house.

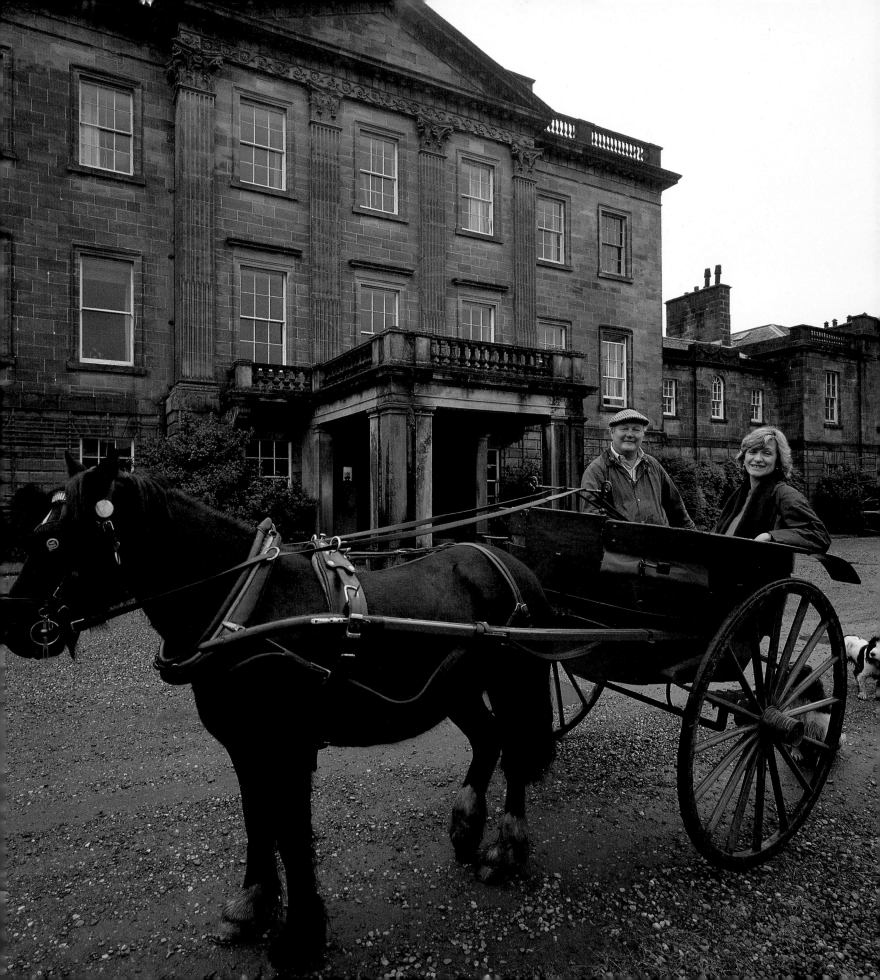

A view of the pale blue washed hall taken from the top of the house.

Below:
On one of the landings, a Venetian commode and a pair of chairs.

Opposite:
The hall was decorated by Alec Cobb. The details of border and swags were repainted from original designs discovered under the old paint. The tiled floor is Victorian.

Opposite below:
The hat Napoleon wore at the Battle of Friedland was bought by Sir Michael Shaw Stewart, 6th Baronet, in 1814. In the wicker container is a bottle of Napoleon brandy purchased at the same time. At Ardgowan there is a picture of Napoleon given to Sir Michael by the Emperor's mother.

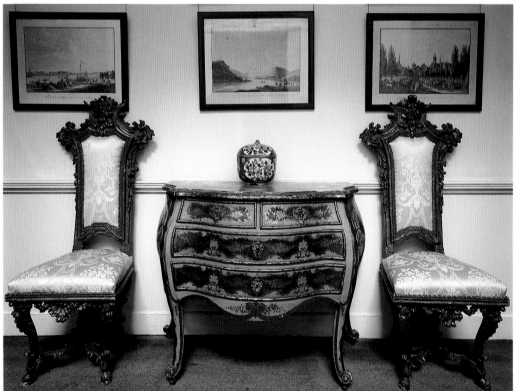

In the library, yet to be restored, sits this trunk full of the original chintz curtains made for the house.

Left:
A general view of the drawing-room. The 19th-century painted chairs are by Gillow of Lancaster. The damask walls are covered from ceiling to floor with a varied collection of paintings. To the left of the fireplace is a portrait of an earlier Houston Shaw Stewart and, to the right, Sir Michael, 5th Baronet, wearing a Caledonian hunting coat, both paintings by Sir Henry Raeburn.

A painting by Franz Snyders in the drawing-room.

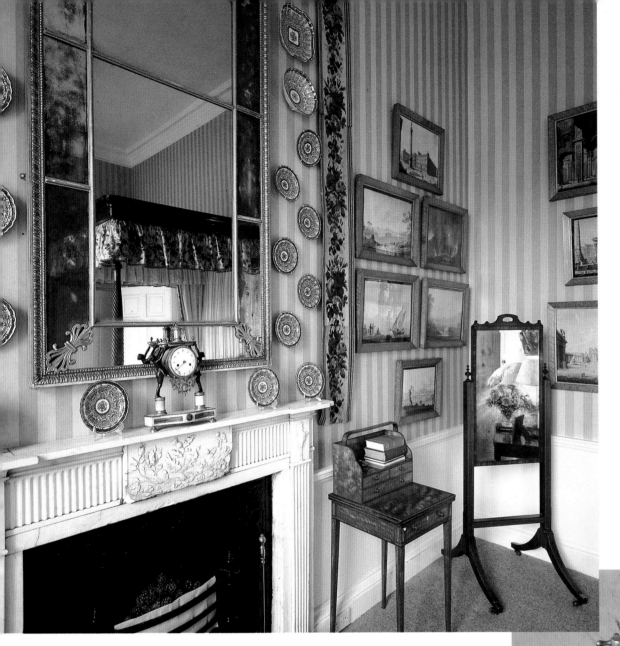

In the principal bedroom there is an impressive collection of Worcester plate, as well as a fine, small *bonheur du jour*.

Opposite:
Seen through the four-poster bed, which is hung with chintz curtains, is the set of 1800 Worcester plate displayed around a mirror.

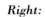

Right:
A detail of one of the marble basins in the bathroom.

Ewan and Sandra Macpherson of Glentruim on the tower of Glentruim House.

Opposite:
Looking across to Glentruim House over the ancient battlefield of Invernahavon. Macphersons have lived in this part of Scotland for 1,000 years.

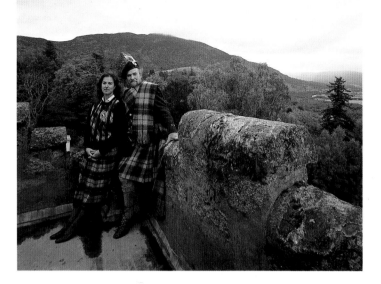

The Highland Chieftain

Within a few hundred yards of Glentruim House there is a stone which marks the point in the Highlands of Scotland furthest from the sea in every direction. In the truest sense, therefore, this is the very heart of the Highlands.

The Macphersons of Glentruim, a branch of the family of the ancient chiefs of Clan Macpherson, have lived in this area of Badenoch for almost 1,000 years. Glentruim House, formerly a ruin, was rebuilt by the great-grandfather of the present Laird. It faces north across the field of Invernahavon where, in 1486, a great battle took place between Clan Cameron and Clan Chattan, the powerful tribal confederation to which the Macphersons gave allegiance. That battle was bloody but indecisive, and the sequel was fought the following year in Perth at the Battle of North Inch, stirringly described by Sir Walter Scott in his novel *The Fair Maid of Perth*.

But clan battles, if not forgotten, are long past and Glentruim, in this fertile corner of the Valley of the Spey, is today a place of great tranquillity, close to the Highland capital Inverness, and within easy reach of the winter sports playground of Aviemore.

Until Ewan and Sandra Macpherson came to live at Glentruim House, no woman had ever set foot in this room, known as the smoking-room. When Sandra first went into the room, the family housekeeper packed her bags and departed in protest.

On the mantelpiece, the two cannonballs used for candlesticks came from the siege of Paris in 1871. On the walls are black-and-white prints of Highland scenes. Macpherson tartan rugs are used as chair covers. On the left of the fireplace is a pipe-rack.

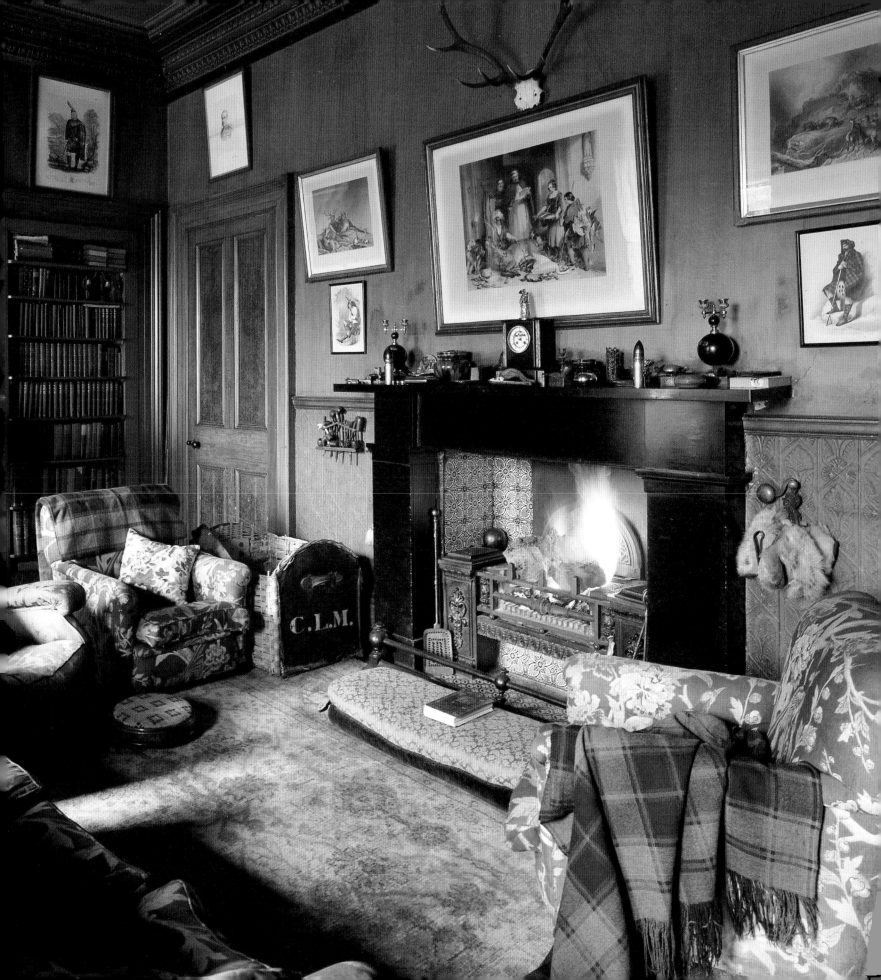

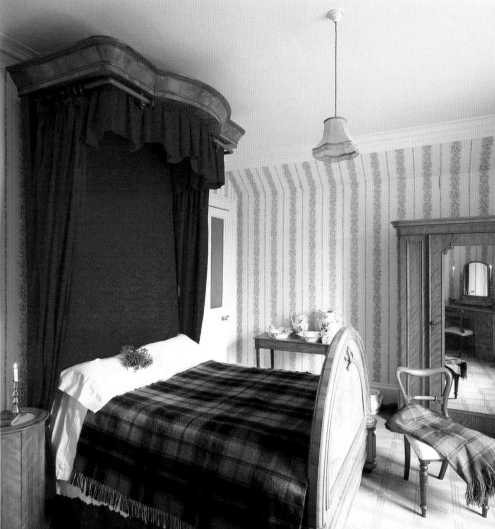

A Macpherson tartan rug covers the half-tester bed in a guest bedroom. On the side-table are jugs and bowls for washing.

Opposite:
Stags' heads look down on the front hall and staircase.

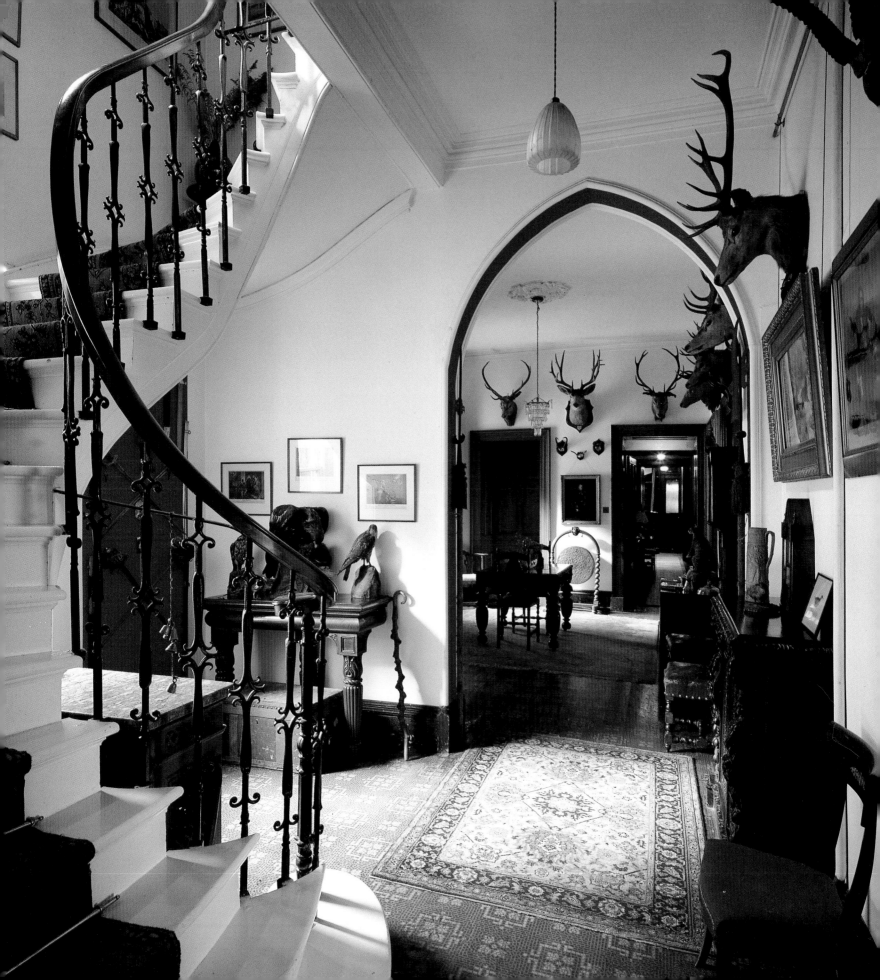

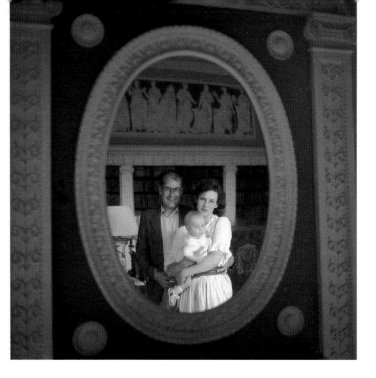

The 13th Earl and Countess of Haddington and Lord Binning reflected in one of the mirrors in the library at Mellerstain.

Opposite:
The front entrance to Mellerstain, showing the large central block built by Robert Adam between 1770 and 1778.

The Glory of Adam

It is widely considered that the library at Mellerstain is the finest surviving example of Robert Adam's work. It contains one of the best decorated ceilings in the original colours (1773).

Mellerstain is the home of the 13th Earl of Haddington and his family, the estate having been acquired in 1642 by his ancestor George Baillie of Jerviswood, the son of a flourishing merchant. Through marriage, the property passed to two earls of Haddington who employed first William Adam to build the two wings in 1725, and then his son Robert to design the central block and subsequently the magnificent interior decoration.

The heroine of Mellerstain is Grisell Hume, daughter of Sir Patrick Hume, later Earl of Marchmont. It was she who, at the age of 12, carried her father's message to his friend George Baillie, imprisoned in the Edinburgh Tolbooth, accused of treason. In exile in Holland, Grisell was courted by George's son, another George, penniless and also exiled after his father's execution in 1684. But when William of Orange assumed the English throne, the situation changed. Estates were restored and Grisell Hume became Grisell Baillie. She kept a Household Book which has survived as a classic of social history, and her portrait welcomes visitors in the Front Hall.

George Baillie's youngest daughter Rachel married Charles Lord Binning in 1717, and while his eldest son ultimately succeeded his grandfather as 7th Earl of Haddington, his youngest, George, who took the name of Baillie, succeeded to the estates of Mellerstain. This George's grandson was to succeed as 10th Earl.

The great house has not changed much since that time. But on the south side are the spectacular terrace and loggia added in 1909 by Sir Reginald Blomfield, who also enlarged the lake. Lord Haddington's mother, who lives at the family's other fine home, Tyningham in East Lothian, is responsible for the glorious display of countless species of rose which bloom on the terraces in the summer months.

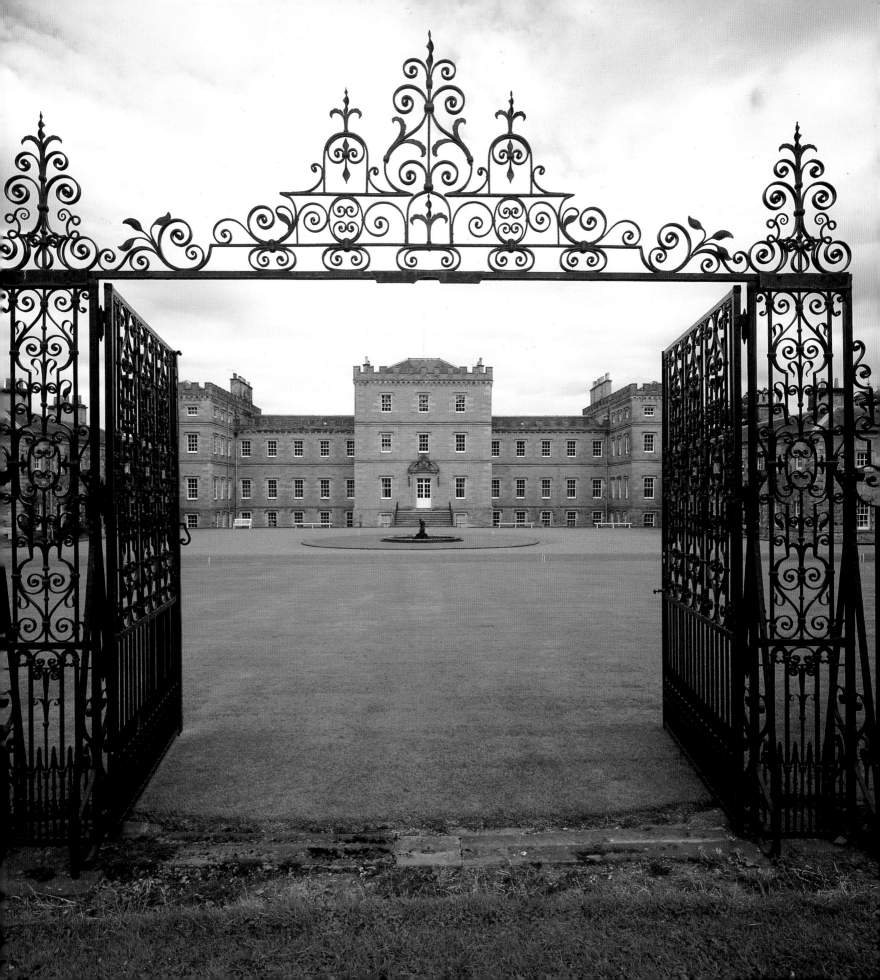

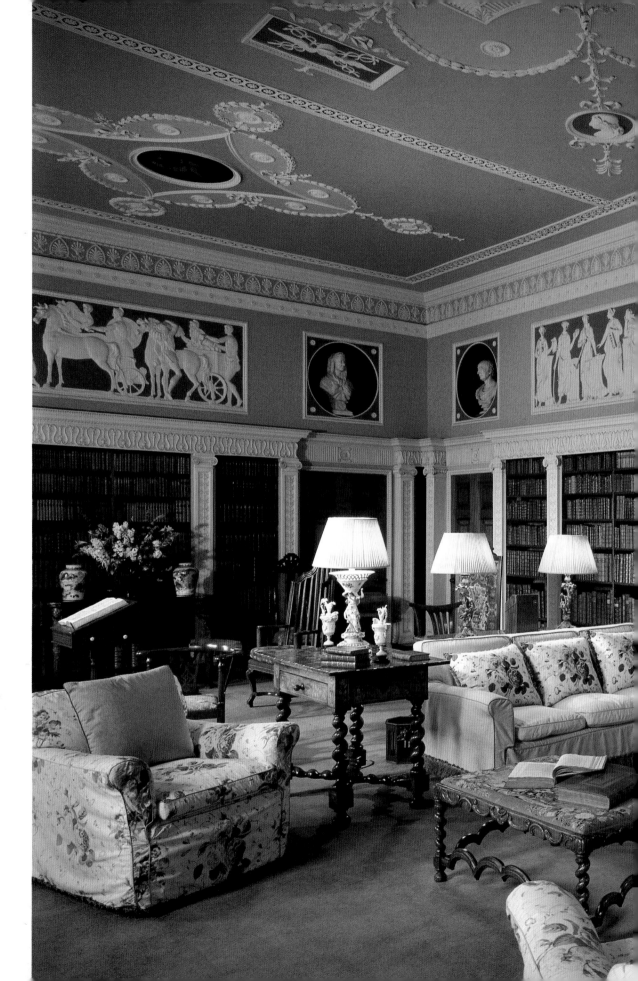

The library at Mellerstain is considered by many to be the finest Adam room in Scotland. The bold plaques along the bookcases show Roman and other antique scenes. The collection of books, mostly collected by the Hon. George Baillie, bear his bookplate (1724) as one of the Lords of Treasury. The painting above the fireplace is a landscape by R. Norrie (1725).

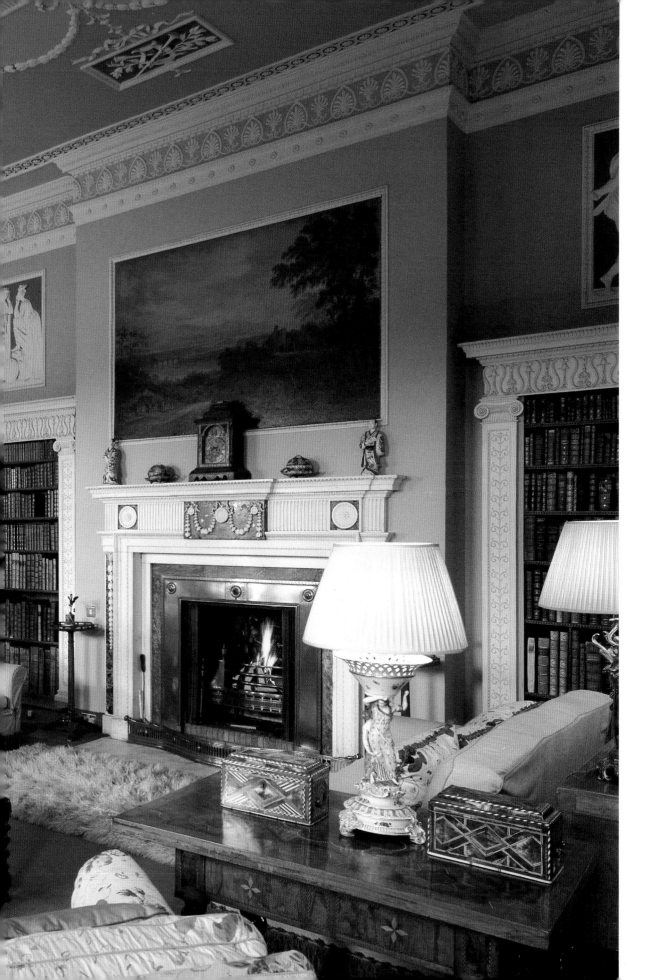

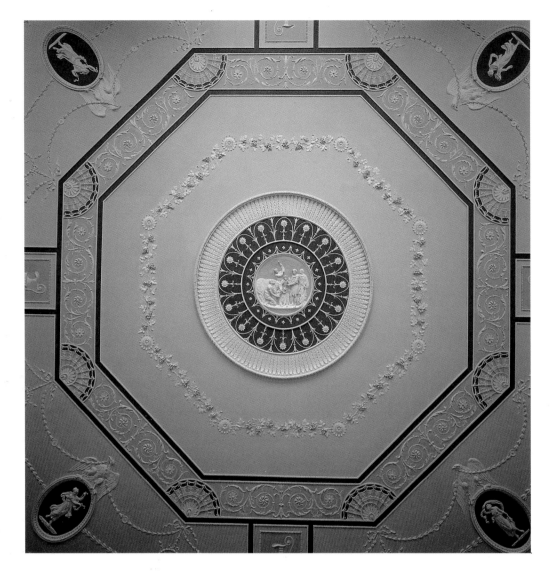

The ceiling of the music room is decorated with eagles and sphinxes. The colour scheme is the original of 1733.

Below:
A marble bust, one of six situated in recesses above the library doors.

Right:
Looking south over the gardens towards the Cheviots. The terrace and loggia were added by Sir Reginald Blomfield, who also enlarged the lake in 1909.

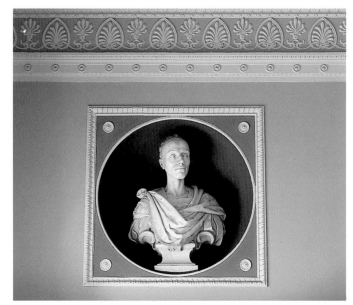

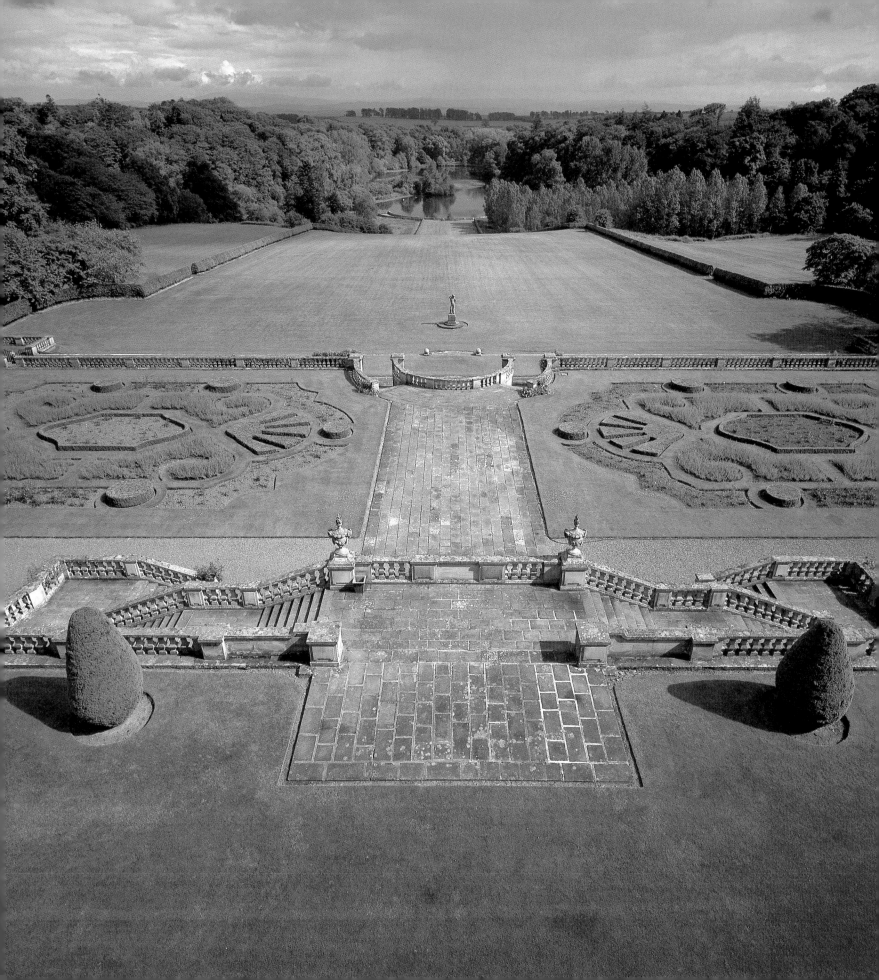

Captain the Hon. Gerald
Maitland Carew at
Thirlestane Castle.

Opposite:
Imposing stone steps lead to
the west entrance.

A Baroque Palace

It was no accident that so many of Scotland's prosperous families chose to locate their homes close to England. The Borders of Scotland, as they are known, abound in great houses supported by some of the richest, rolling farmland in the country. To begin with, Edinburgh, where the Scottish Court and Legislature were located, was within riding distance. Later, when the Court moved to London, the Borders were as near to it as could be afforded without being absorbed into England.

The fine castle of Thirlestane stands on the outskirts of Lauder, gleaming rose-pink on a sunny summer's day. When Captain the Hon. Gerald Maitland Carew, younger son of the 6th Baron Carew, inherited the estate from his mother's family, he was faced with daunting repair problems and formidably entrenched dry rot.

The Maitland family have been established in Berwickshire for centuries. William Maitland had been secretary to Mary Queen of Scots, and his brother became Lord Chancellor of Scotland and 1st Baron Thirlestane. His son was created 1st Earl of Lauderdale in 1642, and the 2nd Earl, who became the 1st and only Duke of Lauderdale, was a confidant of King Charles II and Secretary of State for Scotland. It was he who instructed Sir William Bruce to build on to the old castle, creating the imposing mass which now exists and reflecting the magniloquent Baroque taste of the time. The rich plasterwork ceilings designed by Robert Mylne and manufactured by Dutch craftsmen are unique of their kind.

Most young couples of today would have considered the problems of restoring Thirlestane in the latter half of the 20th century insurmountable. The Maitland Carews, however, sought and found generous grant support amounting to over £1,000,000. When the castle was opened to the public in 1981, a Country Life Museum was added. Captain Maitland Carew shows no lack of innovatory ideas and his latest is to amass a major collection of toys for display in brilliantly designed period children's rooms. The stately home business might not be entirely welcome to the owner, but at least it can be fun.

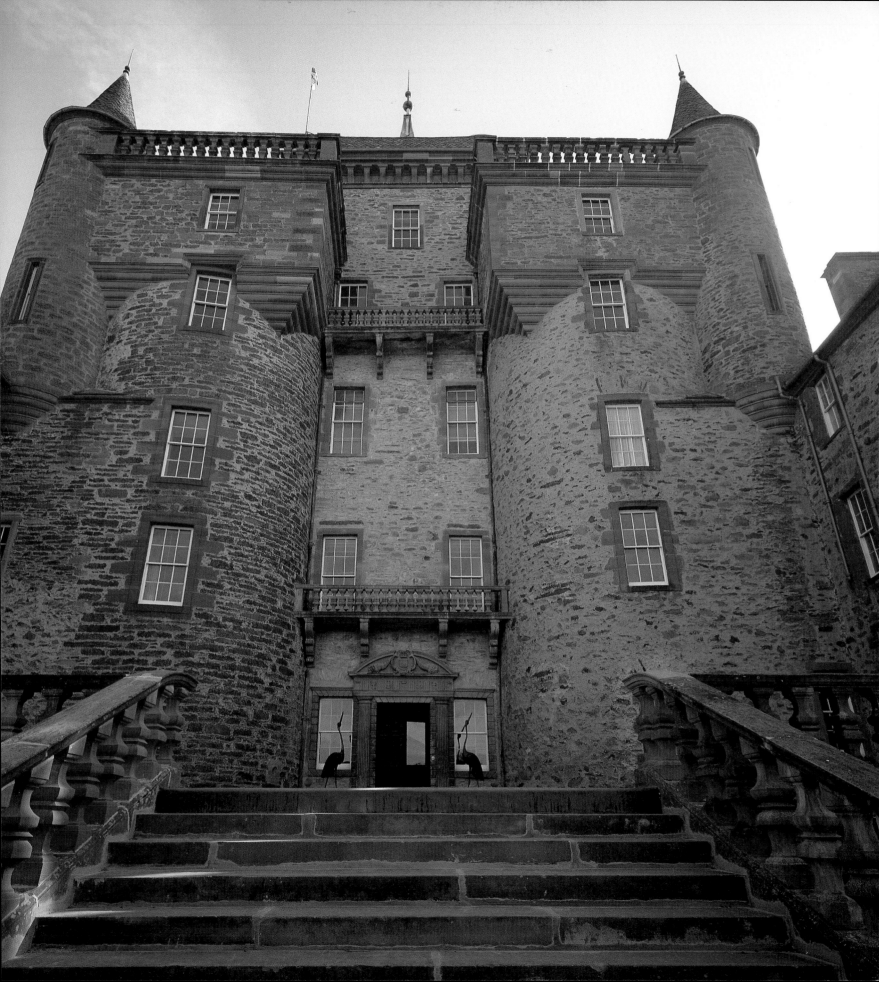

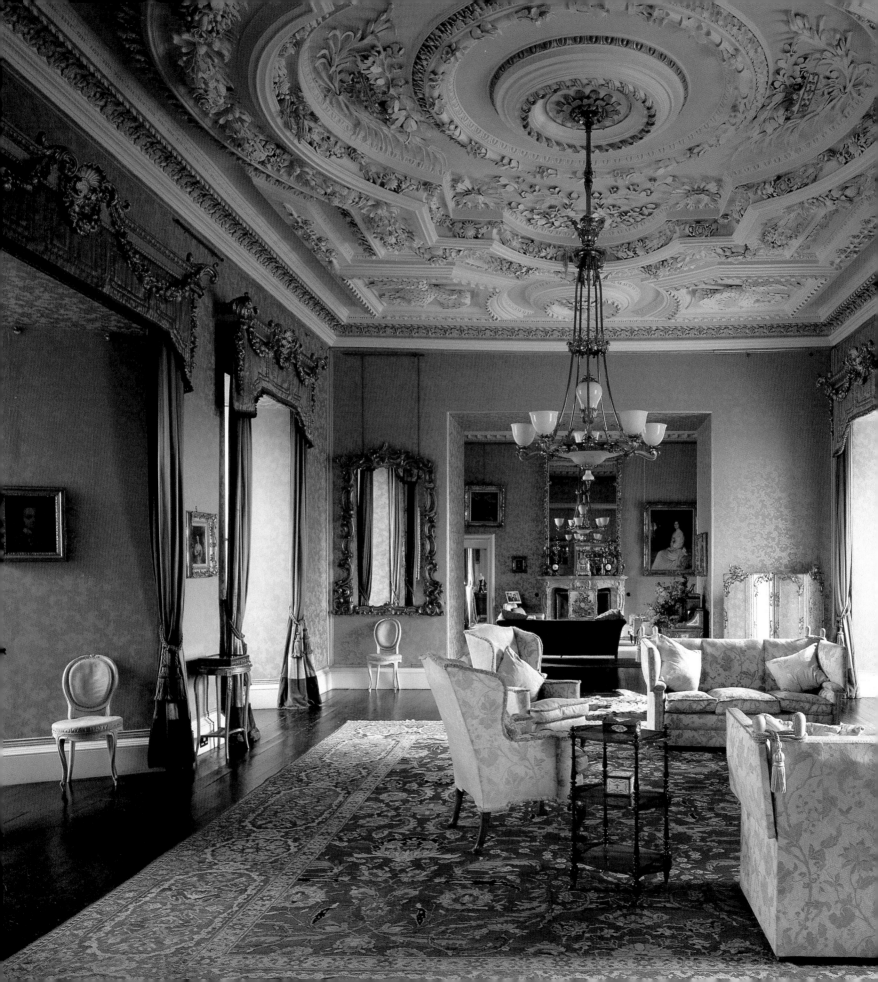

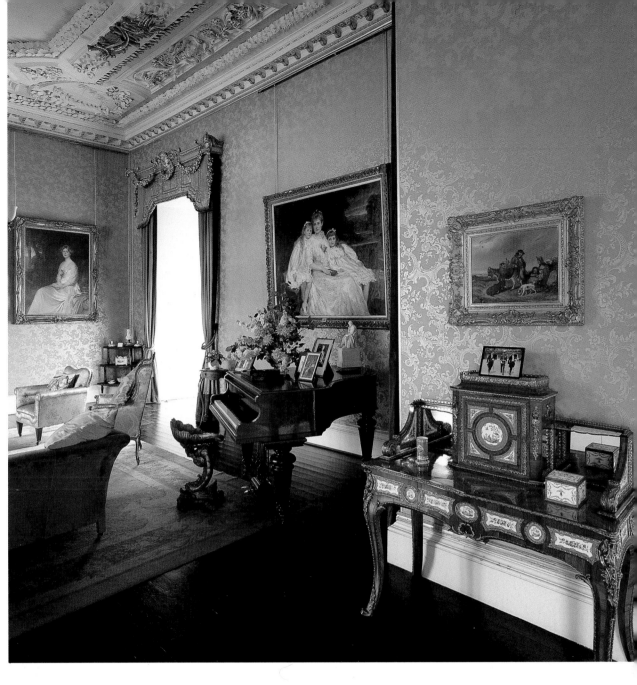

The long drawing-room was decorated in Restoration style for the first and only Duke of Lauderdale. The rich plaster ceilings are unique of their kind.

A corner of the drawing-room in which can be seen a portrait of Ethel Mary, wife of the 15th Earl of Lauderdale, and a family group portrait of Ethel Mary with her mother, Mrs Bell Irving, and her sister Marda.

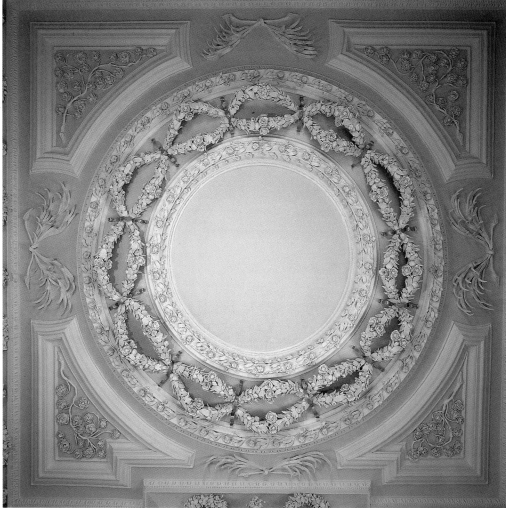

The plasterwork ceilings were created by Dutch craftsmen brought from Holland by the Duke of Lauderdale in 1675.

Opposite:
This fine high-fronted bed stands in a guest bedroom.

Bonnie Prince Charlie slept in this room after the Battle of Prestonpans (1745).

An unidentified, but nonetheless charming, marble bust believed to be of a member of the Maitland family.

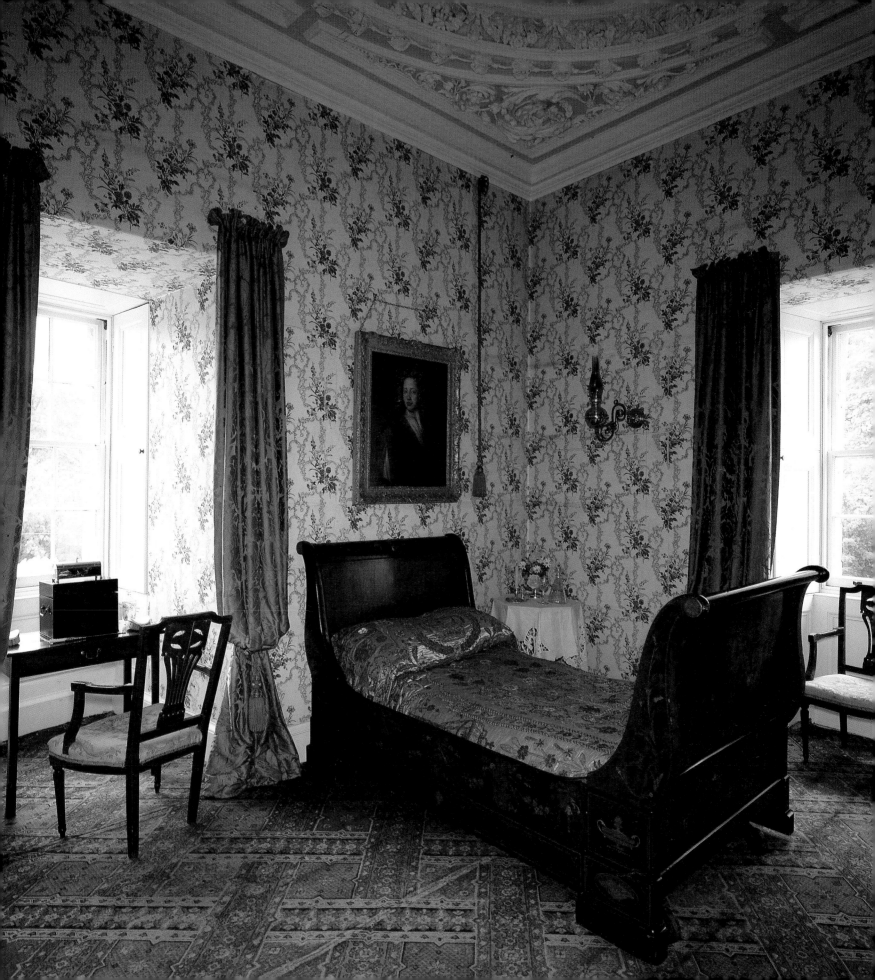

Newhailes House.

Opposite:
Lady Antonia Dalrymple in her drawing-room.

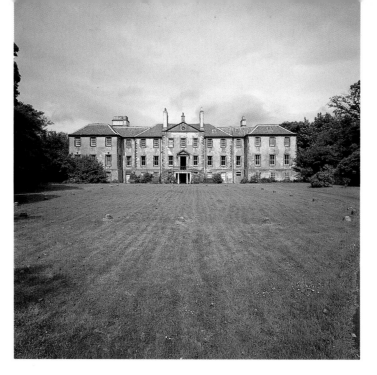

Cherished by Time

The first impression of this house is that it is far too beautiful to have survived so long unscathed. Then one discovers that the Trustees who look after such things for the family have recently spent a fortune on the roof and on the eradication of dry rot, and that the National Library of Scotland, on the instructions of H.M. Treasury, has outrageously removed the contents of what the worthy Dr Samuel Johnson described as one of the finest libraries in the land. And yet Newhailes transcends such intrusions.

Newhailes is at present cared for by the widow of Sir Mark Dalrymple, 3rd UK Baronet of Newhailes. Only daughter of the 12th Earl of Galloway, Lady Antonia is petite and shy, although an impish smile suggests a guarded sense of mischief. The house passed to the Dalrymple family in 1709. Although the original building dates from 1686, a partial refit by William Adam took place in 1720 and additional interiors were added in 1757. The exterior is two storeys high with a basement. An elegant Roman Doric porch shelters a basement entrance, and over it a double stair mounts to the front door. A doorpiece with a Janus consisting of the double head of an old and a young man has the inscription "Laudo Menentem" which means "I honour the stranger". One cannot help feeling that this is a friendly house.

The most celebrated of Newhailes' owners was the lawyer, antiquary and historian Lord Hailes of the Scottish Court of Session in 1766. His opposition to the fashionable enlightenment views of his time won him great favour with Dr Johnson who visited Newhailes on his famous tour of Scotland in 1773.

From Lord Hailes the estate passed through the Fergusson of Kilkerran family to a great-grandson, who took the Dalrymple surname as well as acquiring a UK baronetcy in 1887.

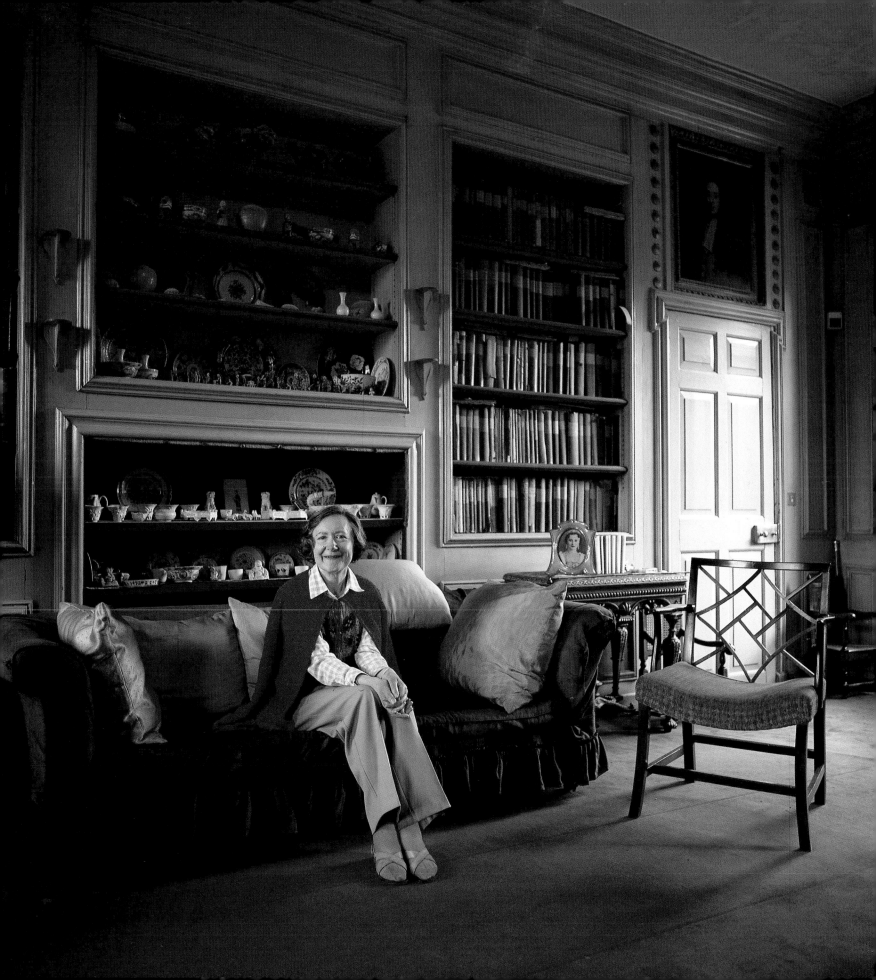

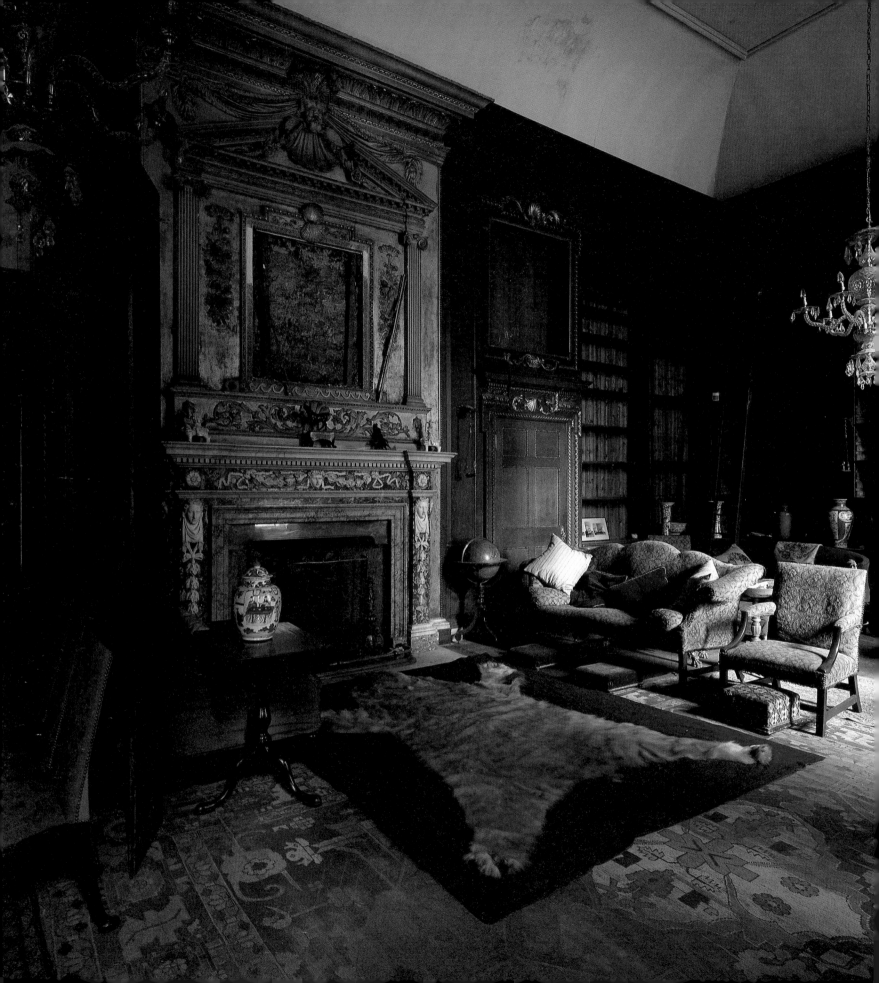

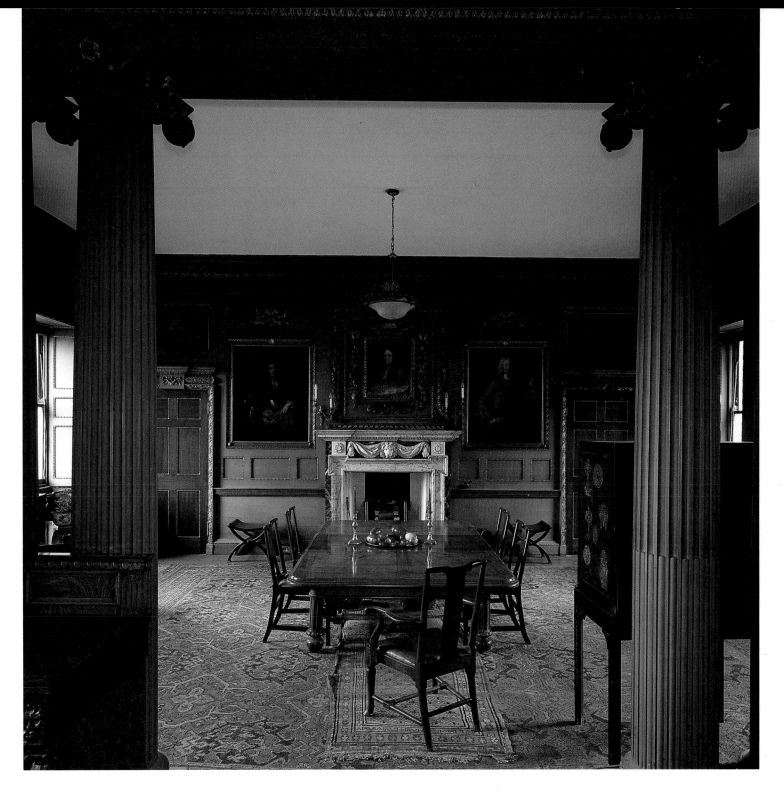

A general view of the dining-
room decorated in green and
gold.

Left:
The magnificent library.
Samuel Calderwood created
the exquisite plasterwork.

A detail of the splendid green-and-gold decoration in the dining-room.

Opposite:
Elaborate Roman Doric doorpieces are a feature of the house. Over the door of the dining-room is a painting showing one of four prospects from the house.

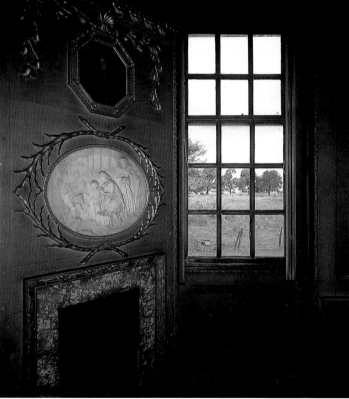

Detail of the plasterwork in one of the bedrooms.

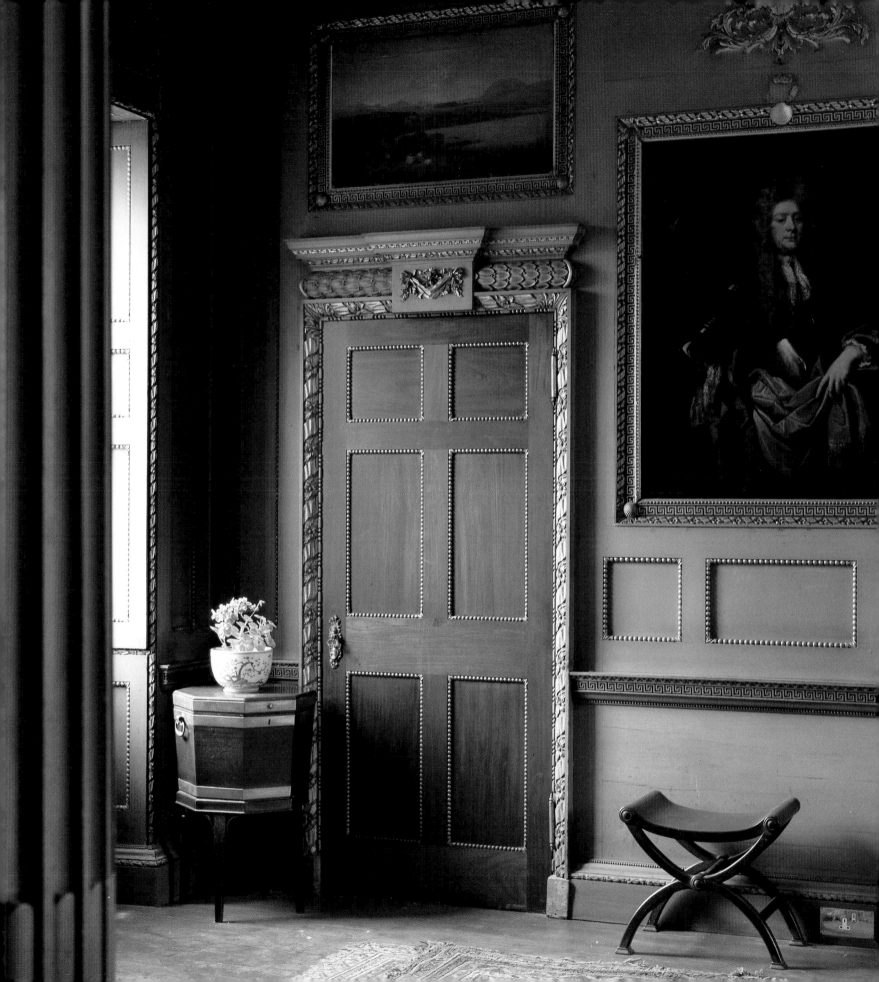

A passageway in an upper
storey is hung with black-
and-white prints showing
distinguished 18th-century
local personalities.

The opulent decoration is
continued into the upstairs
bedrooms.

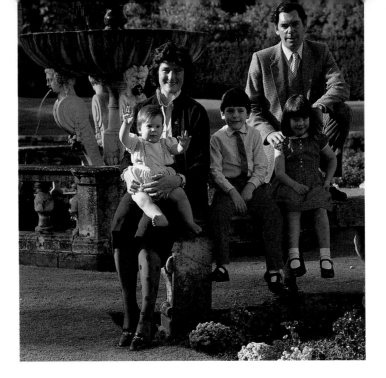

The Palmer family.

Opposite:
A view of Manderston from the formal gardens.

Built to Impress Lord Curzon

When Adrian and Cornelia Palmer moved to the family home of Manderston, near Duns, it involved a complete change in their lifestyle. Adrian, who had been an executive with the family business of Huntley & Palmers in Belgium, was now confronted with the prospect of farming 1,200 acres and with the restoration of an extraordinary mansion built by his great-great-uncle at the turn of the century.

Sir James Miller, son of Sir William Miller of Leith in Edinburgh, inherited a great fortune amassed from the Russian trade in the late 19th century. His bride, Eveline, was a daughter of Lord Scarsdale of Kedleston Hall in Derbyshire, and it was her brother George who became the famous first Marquess of Kedleston and Viceroy of India. Anxious to win favour with his father-in-law and to impress his brother-in-law, Sir James set about turning a modest Berwickshire estate into a showplace of extravagance and beauty.

The interiors of Manderston are sensationally opulent. The staircase is a replica of the Petit Trianon at Versailles, and the rails are plated in silver. Everywhere are silk damask wall coverings and drapes, exquisite frescoes and fine ceilings. All the floors are marble and all the furnishings reproduction but nonetheless beautiful. There is a silver bathtub in a setting of Italian marble.

Adrian and Cornelia Palmer open their home to the public. They have found that many who visit return regularly, because they feel that Manderston is very much a family home and that, despite the splendour, the house is truly lived in. It has been described as the finest Edwardian country house in Britain, and the Palmers have determinedly and courageously set out to maintain it for posterity.

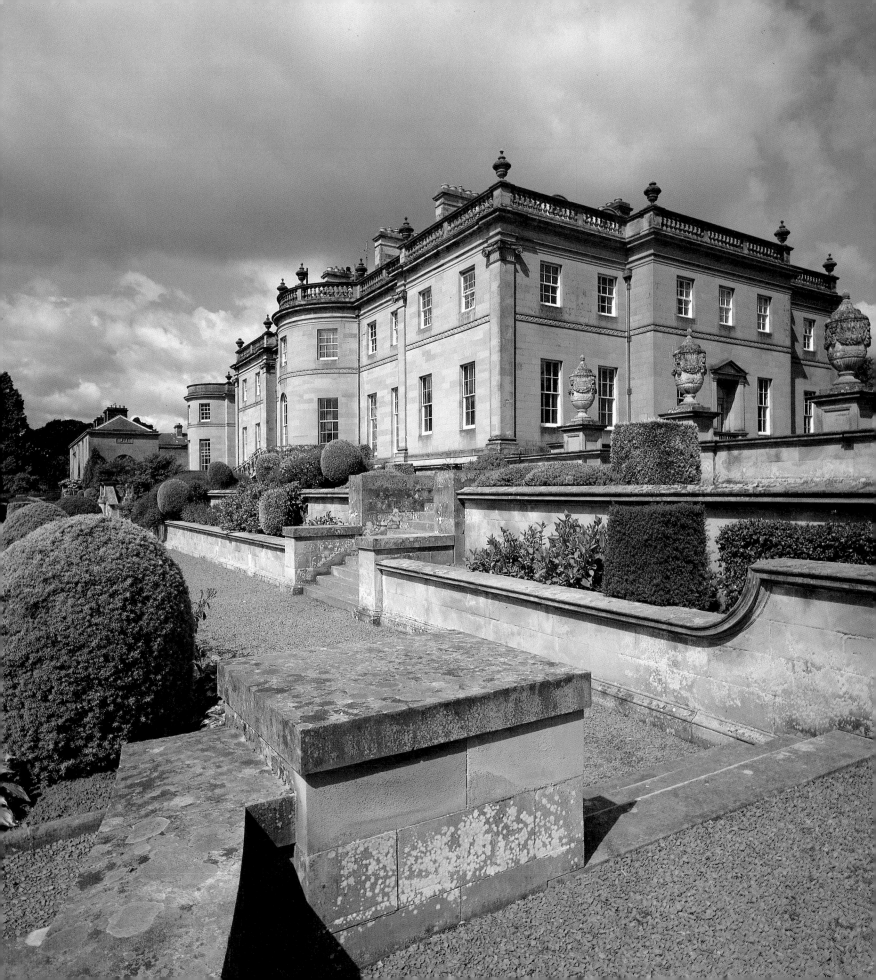

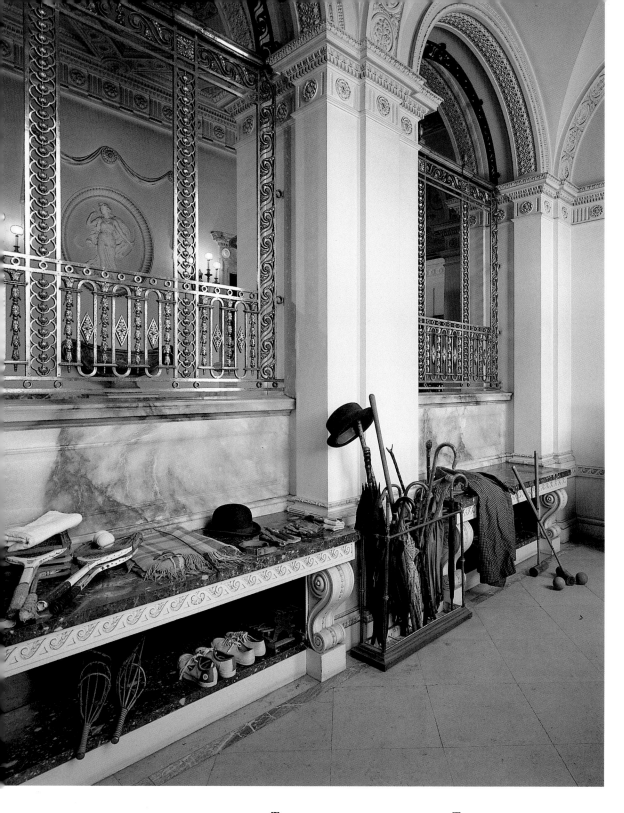

The vestibule has beautiful silver grills on top of the translucent alabaster panels. Adrian Palmer's brother Mark still refers to this area as "The shed by the front door."

The silver staircase has been lovingly restored. It is closely modelled on the one in the Petit Trianon at Versailles. The balustrade is silver-plated and the rail is solid brass.

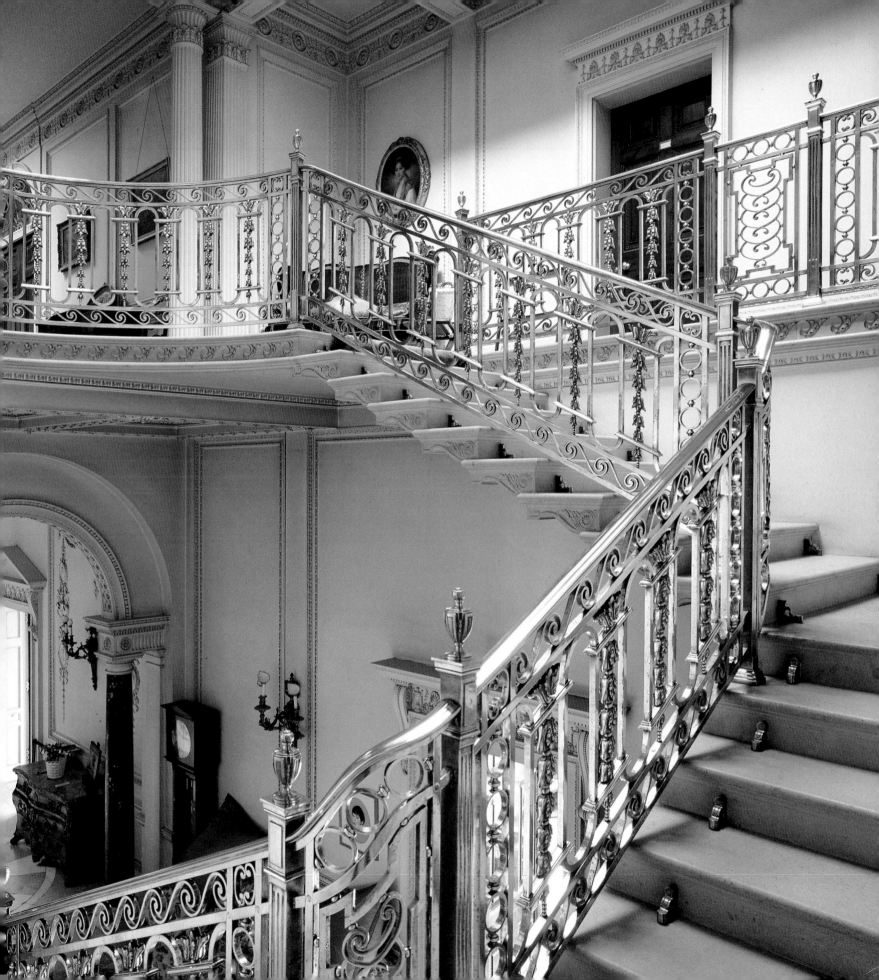

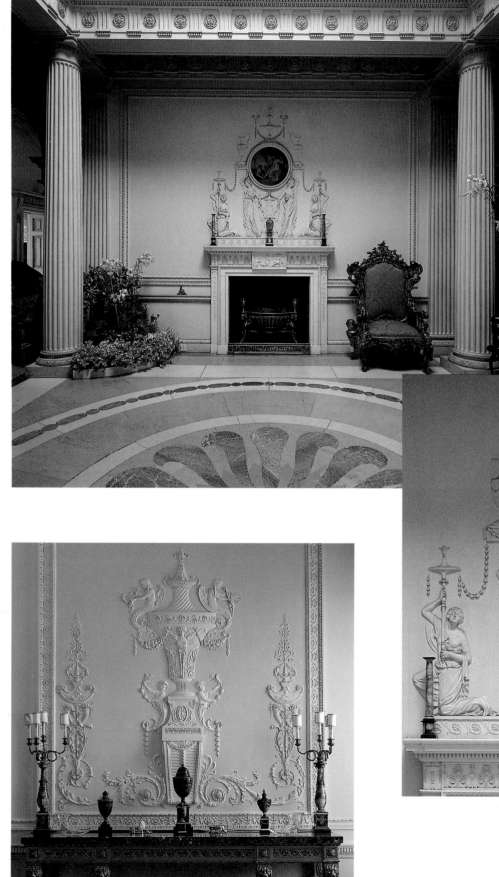

The fireplace in the marble hall is an exact replica of one at Kedleston, Lord Curzon's home near Derby.

Below left:
The alcove in the dining-room, with blue john candelabra, urns and obelisk.

Right:
The ante-room to the library, looking west towards the organ.

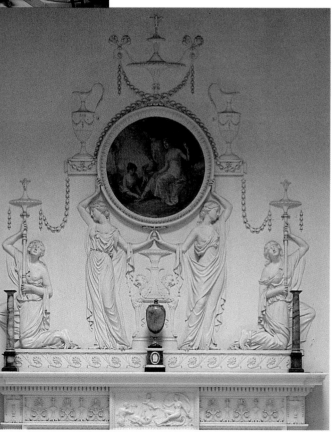

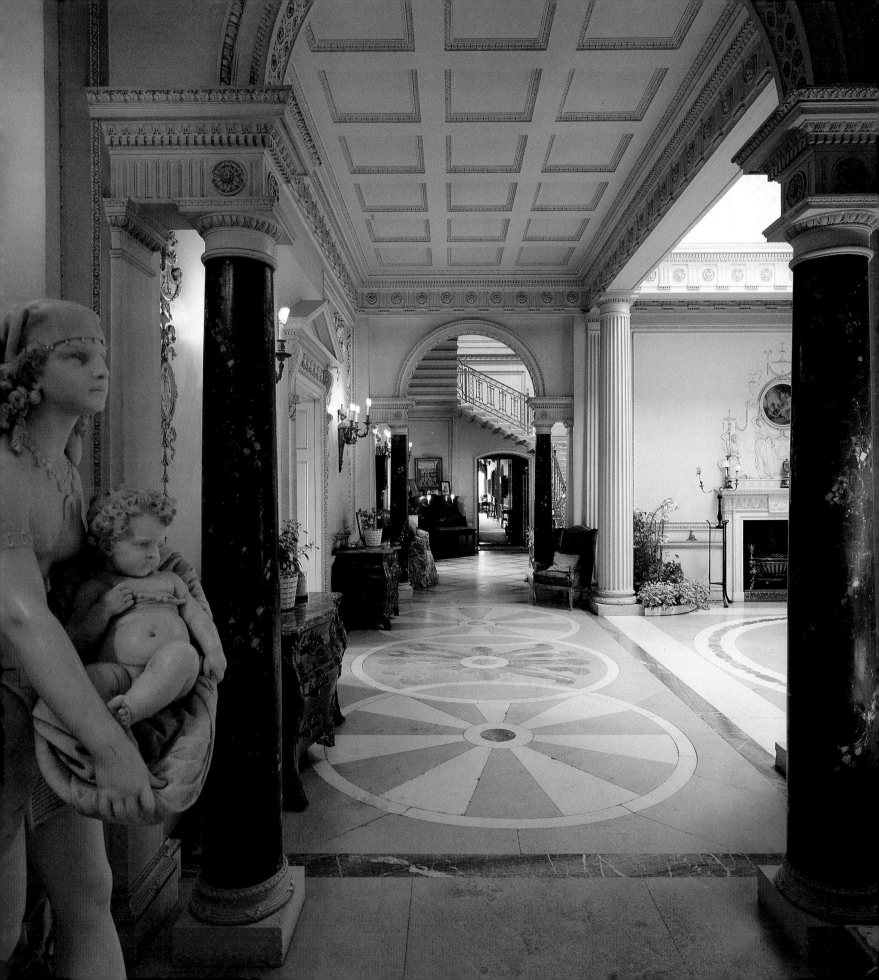

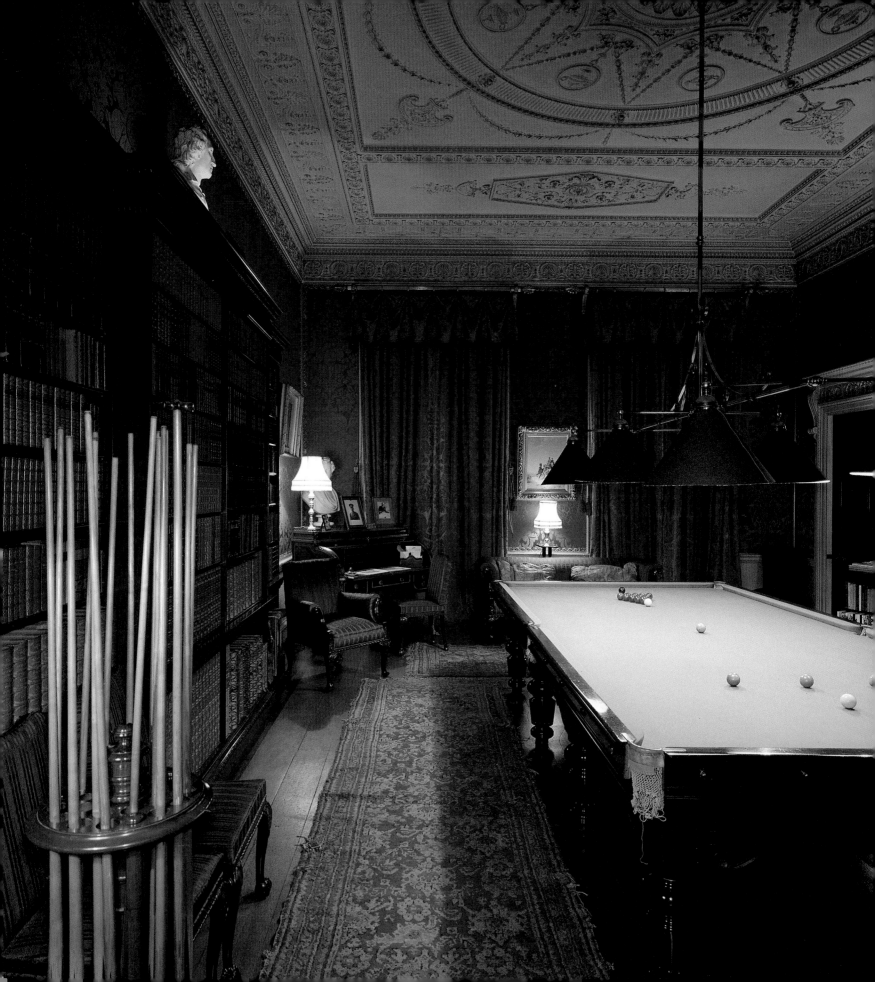

Opposite:

The library. The centre panel in the bookcase is, in fact, a false door which leads back into the hall.

Right:

The harness room in the stables which *Horse and Hound* magazine described as the "finest in the world". It is still regularly in use.

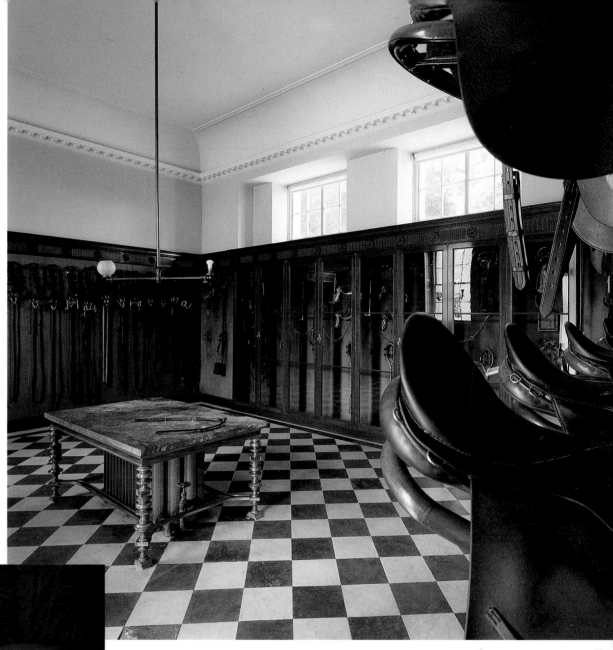

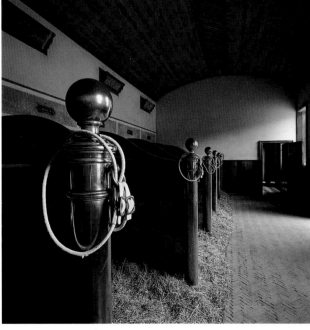

The stalls in the stables have marble plaques – each horse's name began with an "M".

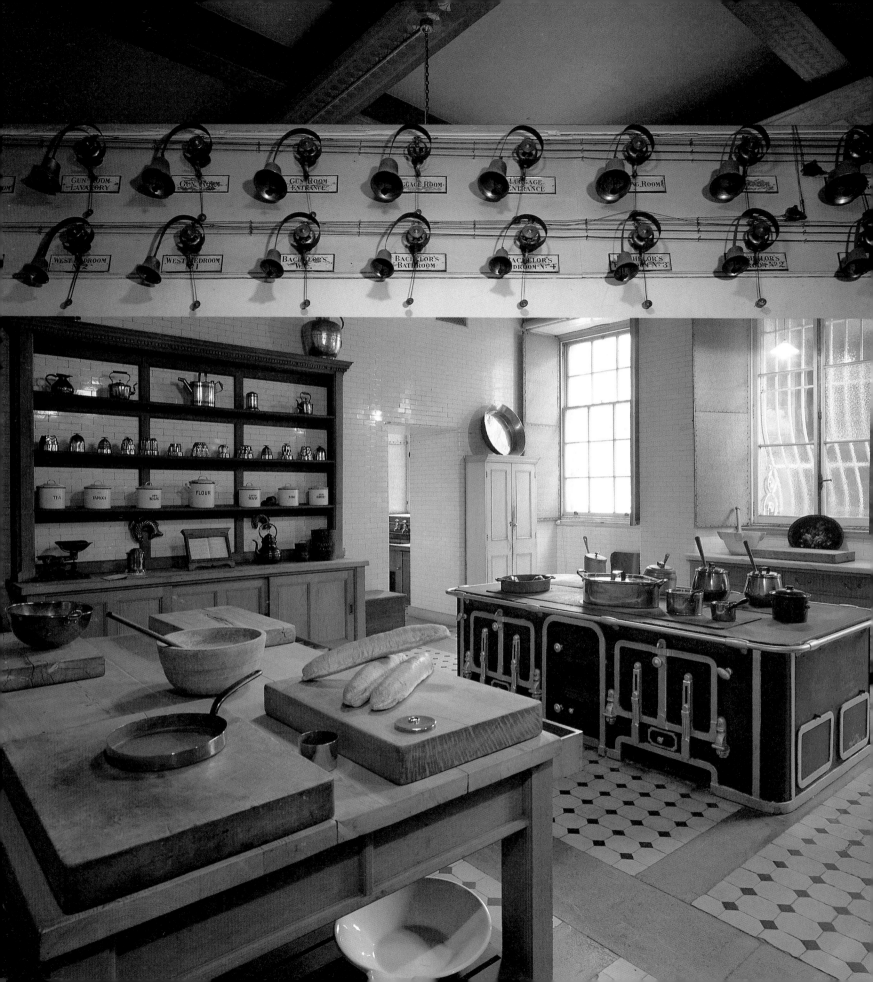

Outside the housekeeper's room is a range of 56 bells, each with a different tone. The kitchen has an Island Range, which was imported from France. The underground flue had to be swept every six months and the sweep was tipped with a bottle of whisky.

Below:
A detail of the kitchen.

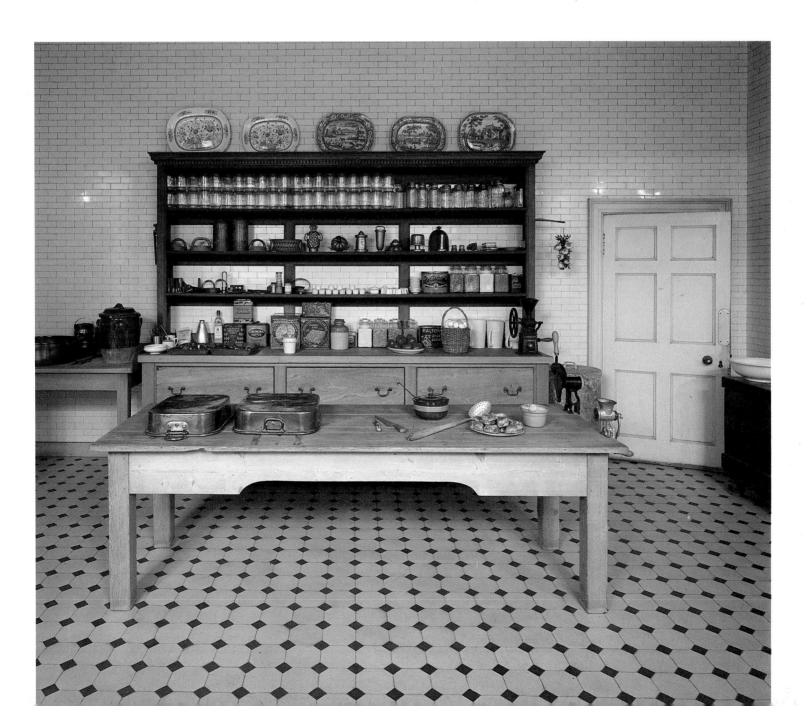

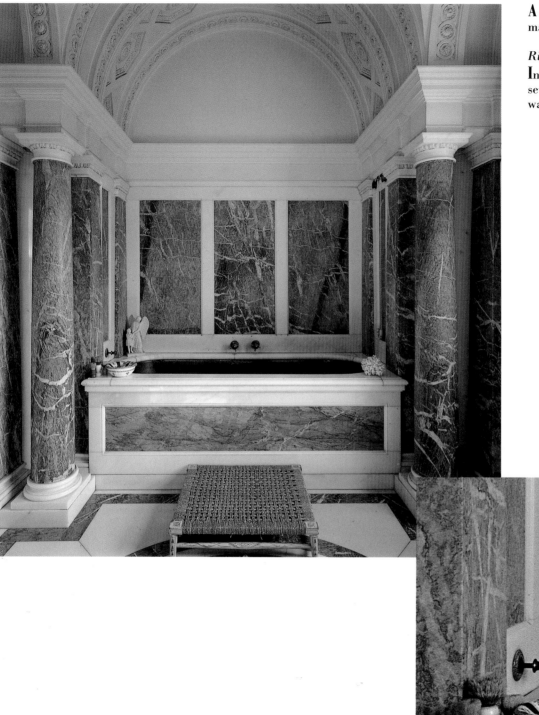

A silver bath in an Italian marble setting.

Right:
In the dairy, marble from seven different countries was used for decoration.

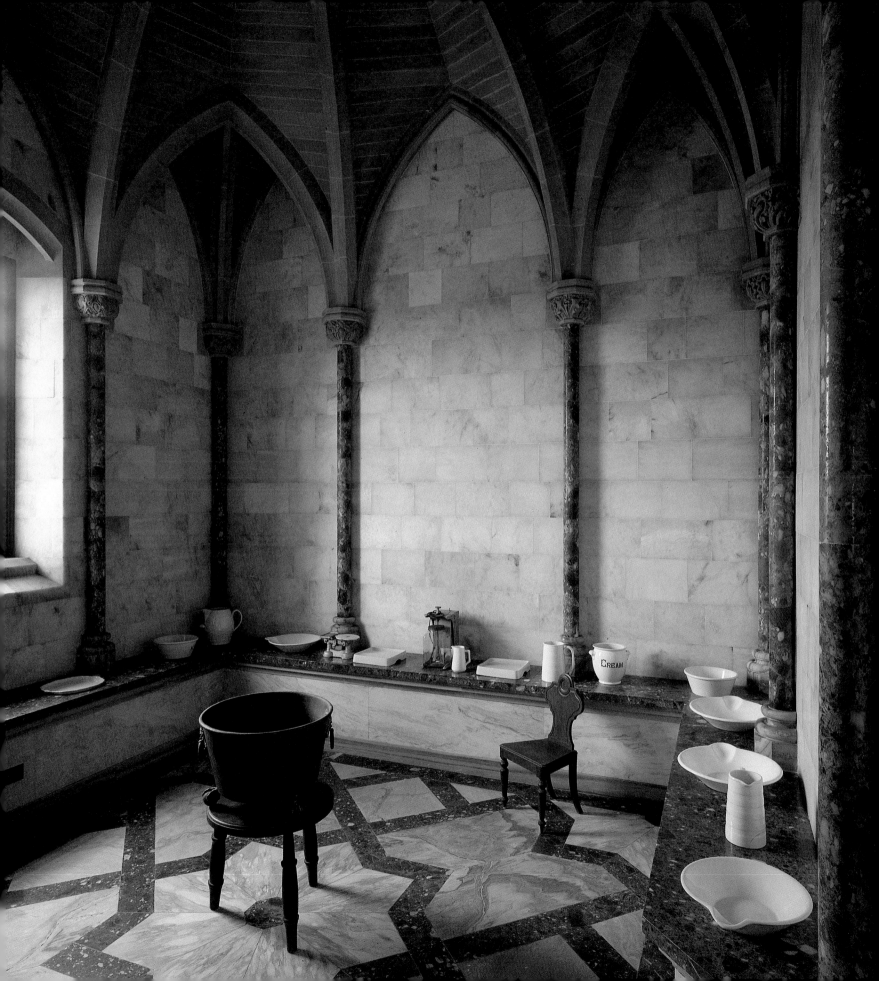

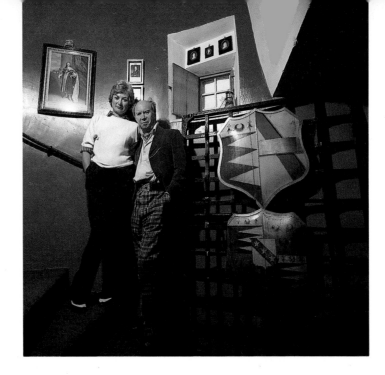

Nicholas and Sam Fairbairn on their entrance stairs. On the door grill are the arms of the Henderson family, who built Fordel, crossed with those of Monteith.

Opposite:
Fordel by night.

Keeping Up a Keep

Some twenty years ago, Nicholas Fairbairn, Member of Parliament for Perth and Kinross and a former Solicitor General for Scotland, purchased a crumbling castle in Fife for the kind of sum which nowadays might buy a reasonable overcoat. Since then, love, dedication and physical effort have transformed this 14th-century Clan Henderson keep into a personal paradise and a refuge from his often controversial political and legal life. An accomplished artist and admirer of beautiful things, Fairbairn takes as much pride in his disciplined garden as in the interiors of Fordel Castle, which he has filled with eccentric acquisitions and personal memorabilia. Since a keep is a tower house, Fordel is no mansion. A twisting stone stairway leads to each floor, which accommodates no more than three rooms.

A fine drawing-room with magnificent open fire on the first floor connects with the dining-room through lofty double doors. The kitchen is on the ground floor and food is fetched up in a service lift. On the second floor, Samantha Fairbairn has recently redecorated the bedroom, using a dramatic leaf-design wallpaper. She has strikingly picked out the Clan Henderson crest which is a feature on the ceiling panels, using pale green on a cream background. Through Fairbairn's dressing-room, the walls of which are covered in Henderson tartan, is his study. Guest and family bedrooms are on the third floor.

Since his second marriage Nicholas Fairbairn has tried to spend more time in Scotland, and Sam Fairbairn now organizes tours for overseas visitors, invariably including a visit to Fordel for lunch or dinner. In the grounds is a tiny deconsecrated chapel where the Fairbairns sometimes hold concerts and exhibitions of the Baron of Fordel's paintings.

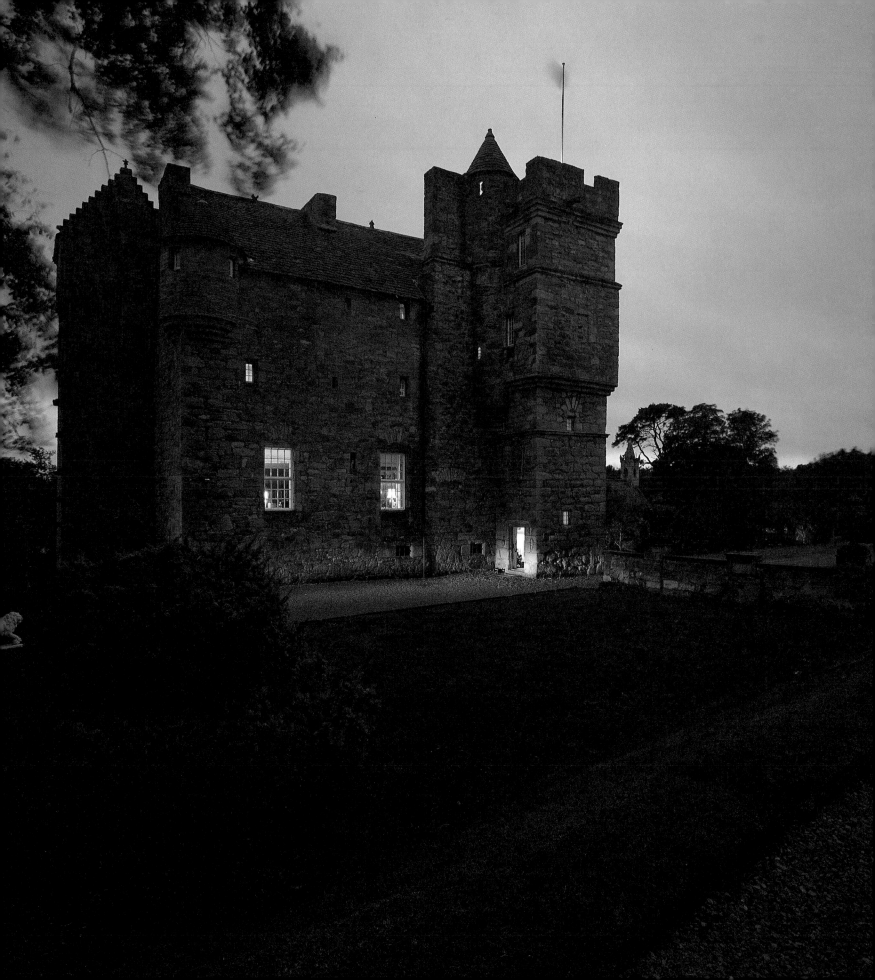

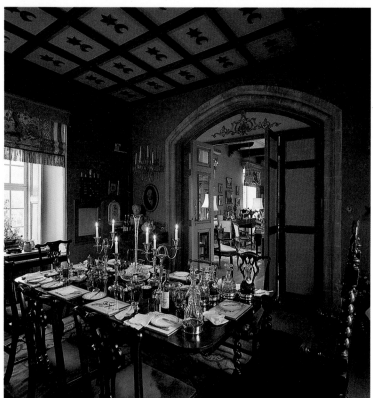

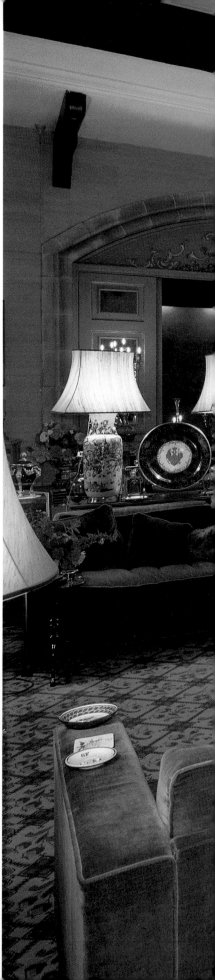

Looking through into the dining-room. The Henderson crest is picked out on the ceiling panels.

Below:
The dining-room, looking back into the drawing-room.

Right:
In the drawing-room, the desk on the right between the windows was purchased by Fairbairn's father and painted green. When it was stripped, the central panel revealed the Prince of Wales feathers. The carpet was made by Drysdales of Edinburgh for Yester House, Gifford. The Russian plate displayed between the two lamps was found smashed in a shoe shop in Edinburgh. The silhouettes on the wall above the desk are by August Eduard, the French silhouettist who fled to Scotland at the time of the restoration of the French monarchy. The centre picture is a view of Edinburgh.

Right:

On a marble-topped table in the drawing-room is a German helmet found in a Glasgow antique shop and French ornaments, including miniatures of the Emperor Napoleon and the Empress Josephine.

Inset:

The marble top of the table came from Tyningham, East Lothian. The Chinese Chippendale mirror above has a cross of the lamb of St Andrew and the *fleur-de-lys* of France. The bronze bust of Nicholas Fairbairn is by Janet Scrymgeour Wedderburn. Above the door is a witch stone said to have belonged to Lady Pittodrie, a former mistress of Fordel.

The stairwell is painted scarlet. There is a collection of black-and-white prints which feature distinguished Scottish personalities.

Right:

A tribute to Mary Queen of Scots for the quatrocentenary of her execution in 1587. Queen Mary attended the wedding of Jean Murray of Tullibardine in the year of her own marriage to Lord Darnley. The Royal couple stayed the night at Fordel and the Queen came to the house again when she escaped from her imprisonment at Loch Leven Castle. On the table is Mary's portrait, a tiny Bible and a copy of *Avis de Ste Thérèse*.

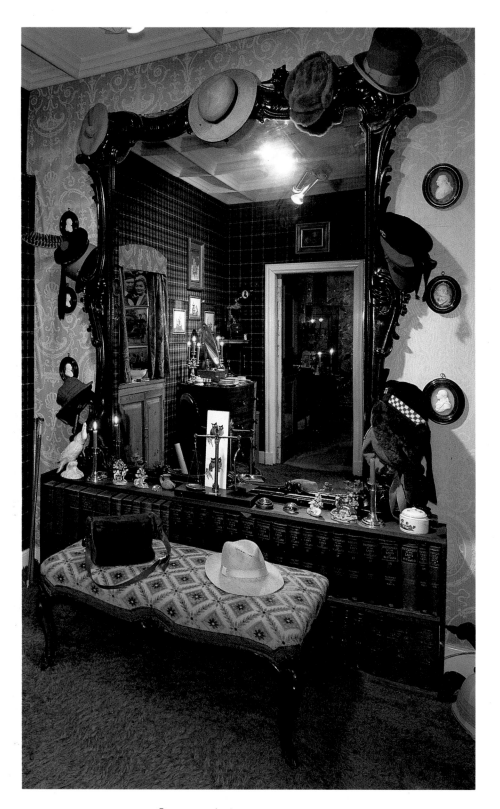

On each side of the mirror in the dressing-room is a collection of Tassy's gems.

The stool is covered with a material designed by the Emperor Napoleon.

The Henderson crest is picked out on the ceiling panels of the main bedroom.

The wallpaper is from Decormac, Edinburgh, and was made in Korea.

The walls of the dressing-room are covered in Gordon tartan. The pictures belong to Fairbairn's collection of Indian prints.

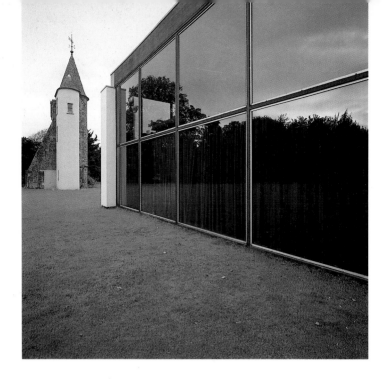

A tower built by William Bryce provides a surprising contrast to the modern house.

Opposite:
Looking out at the tower from the upper floor.

Open to the Sky

James Morris, a well-known Scottish architect, and his American wife, Eleanor, had always wanted to build a modern version of a country house. When they were able to buy an attractive 17th-century estate on which an old, dry-rot infested mansion house had been pulled down, they set about designing their dream home.

The new house, completed in 1977, is surrounded by trees and commands extensive views of the Lothians and the Lammermuir Hills. The drive crosses open parkland and passes through mature trees and clusters of rhododendron bushes. The front of the house faces south to ensure that all the rooms enjoy maximum sunshine. Bedrooms are on the ground floor with bathrooms, kitchen, dining-room, laundry and a playroom. A marble spiral stair leads to the large living area, which is divided into a library, gallery, drawing-room and billiard-room. A long balcony overlooks the double-height conservatory with its ground-floor swimming pool. Both floors are completely enclosed in glass, the roof resting on laminated timber beams supported by eight brick columns. The house is bronze-tinted, double-glazed throughout, except for the conservatory which has clear single-glazing and is roofed with clear plastic vaults. The drawing-room, library and conservatory have open fires. Upstairs is warmed by radiant ceiling heating, downstairs by electric underfoot. The glass and plastic vaults allow so much "solar gain" – that is, magnification of heat through the transparent substance – that a softer and warmer climate is created within the house throughout the year.

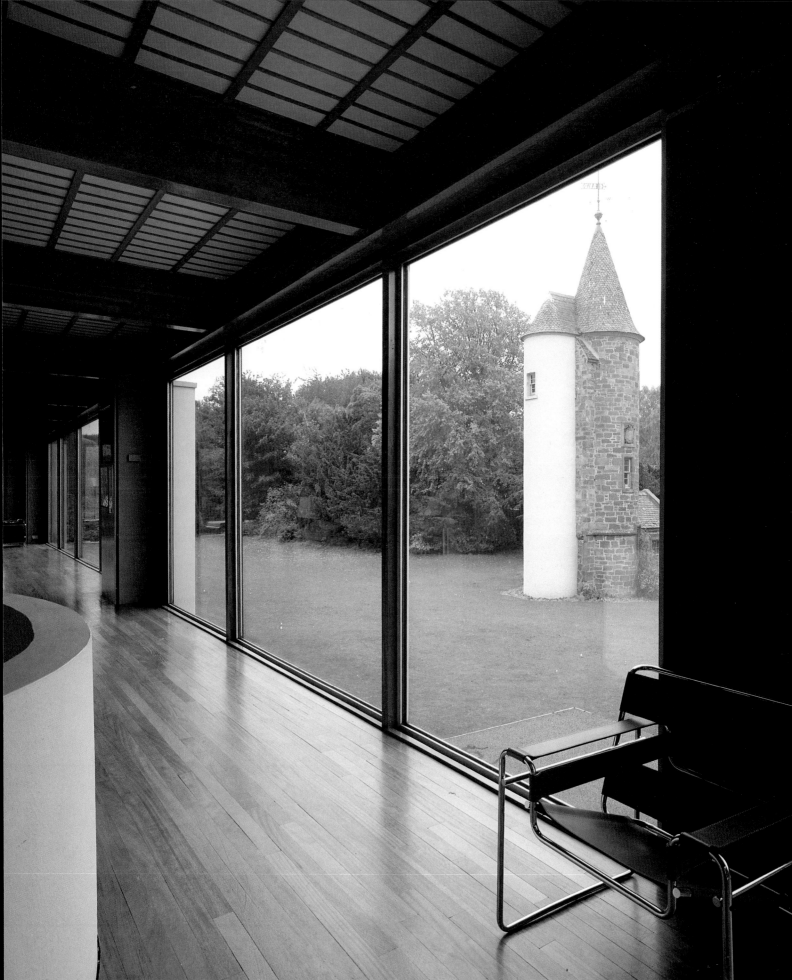

A view of the circular stair.

Right:
An Alvar Aalto lamp stands in the background. On the left are two chairs by Mies van der Rohe.

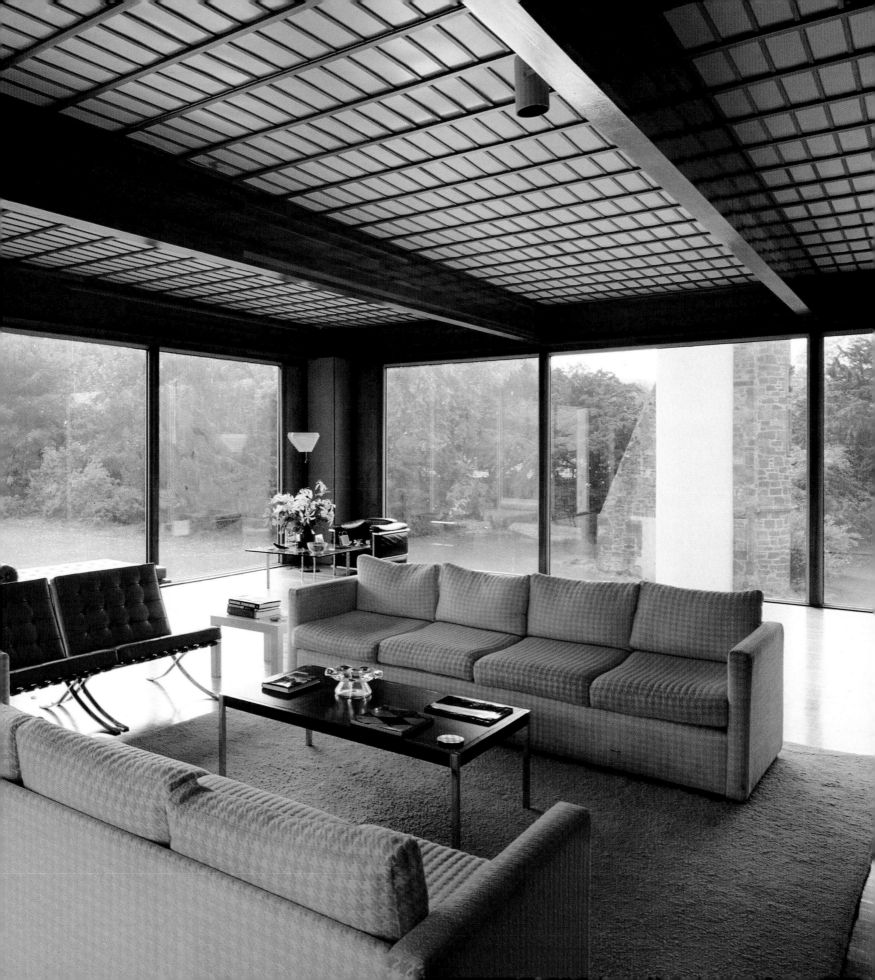

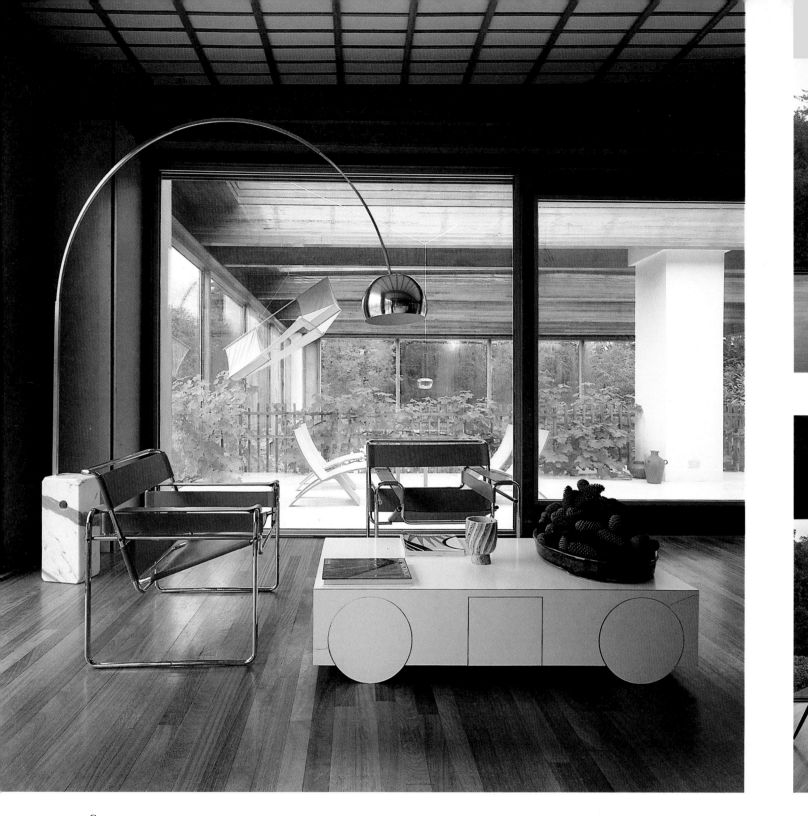

Chairs in the corner of the upper storey are by Marcel Breuer. The games table was designed by James Morris.

Centre top:
A Le Corbusier chair stands beside a table by Eero Saarinen.

Centre below:
A telescope beside a couch by Mies van der Rohe.

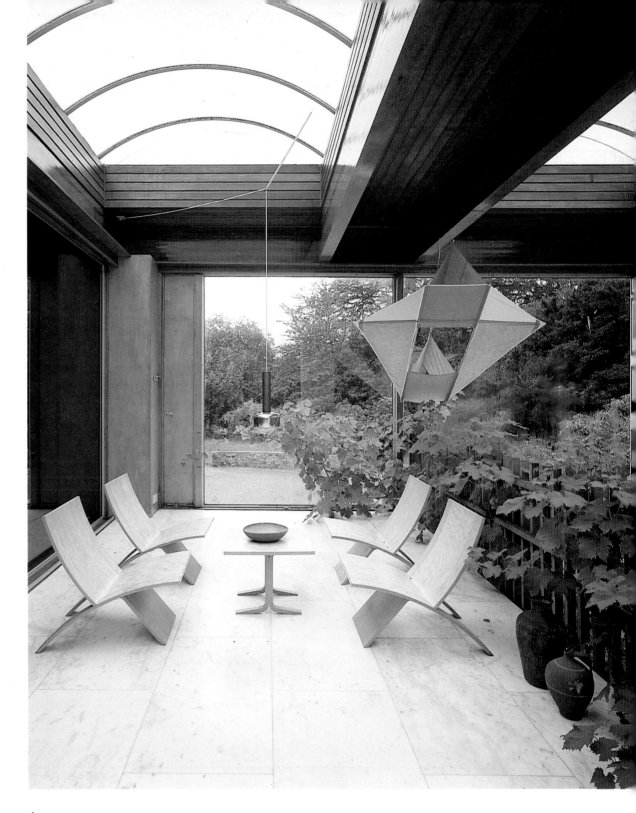

A view of the long balcony.

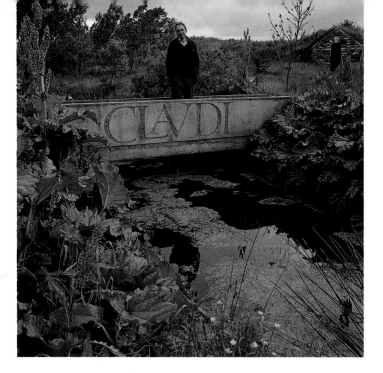

Ian Hamilton Finlay on his bridge, which is inscribed with Claude Lorrain's signature.

Opposite:
Granite slabs reflect the seasons. They are carved with the words of Saint-Just: "The present order is the disorder of the future."

An Oasis of Tradition

A pathway of russet-coloured flagstones, each slab imprinted with the word "pretty", leads into a shady copse. A signpost marked "Siegfried Line" points towards the corner of a field where washing is hung up to dry. A notice placed under thriving gean trees (the wild cherry) bears the ironic message, "Bring back the Birch".

This is Little Sparta, a wooded oasis in the bleak Lanarkshire hills. The loving creation of Ian and Susan Hamilton Finlay, this garden of surprising juxtapositions, related in style and impulse to the English 18th-century garden, is filled with references to the artists, writers and thinkers whom the Hamilton Finlays hold in high esteem. The garden acknowledges in all its aspects a variety of traditions, all of them related to the classical tradition.

Described variously throughout his career as a poet, gardener, sculptor and moralist, Ian Hamilton Finlay enjoys an international reputation. His works in a variety of media are held in important collections in Great Britain, Europe and the United States. He has designed for sculpture parks such as the Kroller-Müller Museum in Otterlo, Holland. At the time of his move to Little Sparta in 1967, he was being referred to as Britain's foremost concrete poet.

In this "poet's garden", conceived in the tradition of Pope and Shenstone, classical columns stand beside a series of ponds and planted areas, where inscriptions and a pair of garden temples have been placed to beguile and instruct the visitor. A Nuclear Sail rises from beyond a hedge; metallic tortoises are labelled panzers; a plaque bearing the words "Emden-Kleiner Kreuzer Sonata" refers by means of word-play to the famous German light cruiser (*Kreuzer*) *Emden* and the well-known story by Tolstoy, *The Kreutzer Sonata*, itself referring to the work by Beethoven. At the Temple of Apollo, visitors are invited to pay homage to the little drummer boy Barra who was killed by the Royalists during the French Revolution, a tragic event painted by J.-L. David.

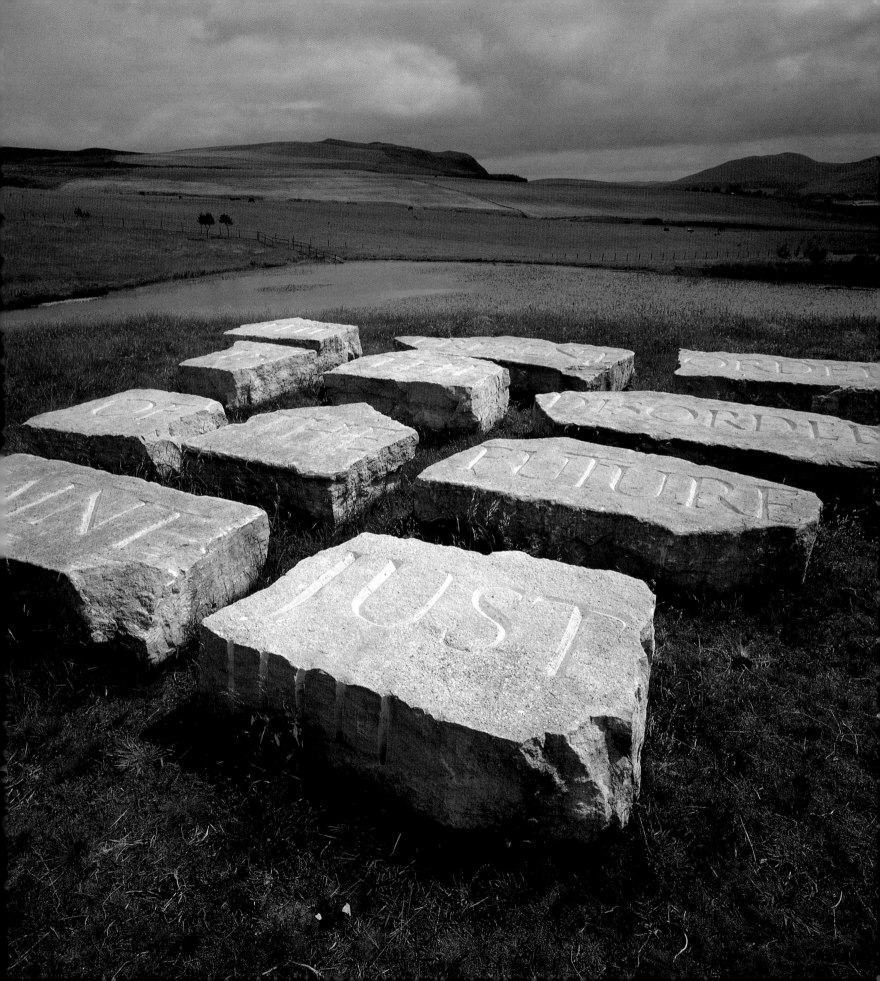

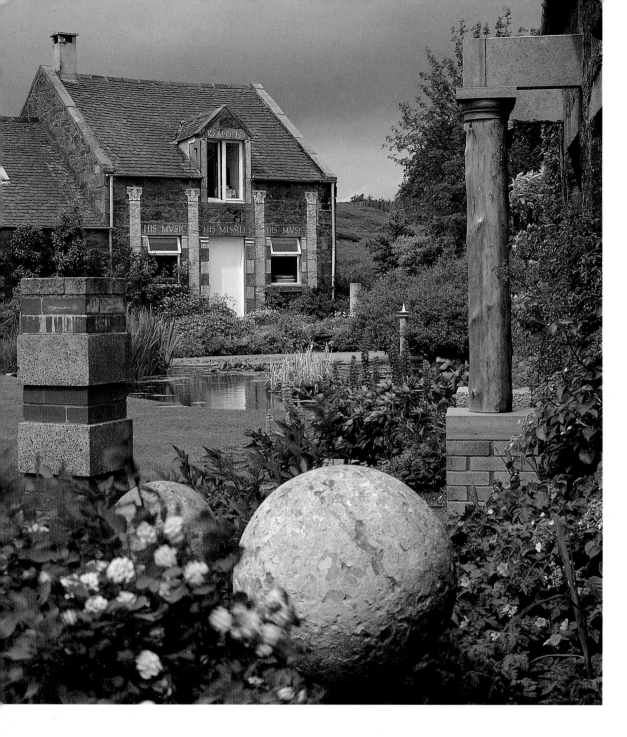

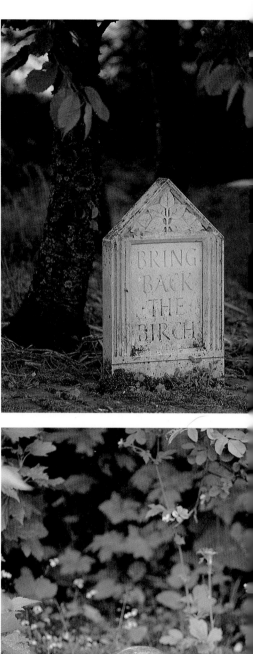

Buildings are grouped around the central garden, which comprises plants, random sculpture and pools of water.

Above:
The temple of Apollo.

Right:
"Bring back the Birch" under the wild cherry trees, and a tortoise inscribed "Panzer Leader".

Below:
The frieze that refers to the last cruise of the *Emden* and the *Kreutzer Sonata.*

Right:
This little island of turf is a tribute to a famous Dürer watercolour called *Das grosse Grassenstück.*

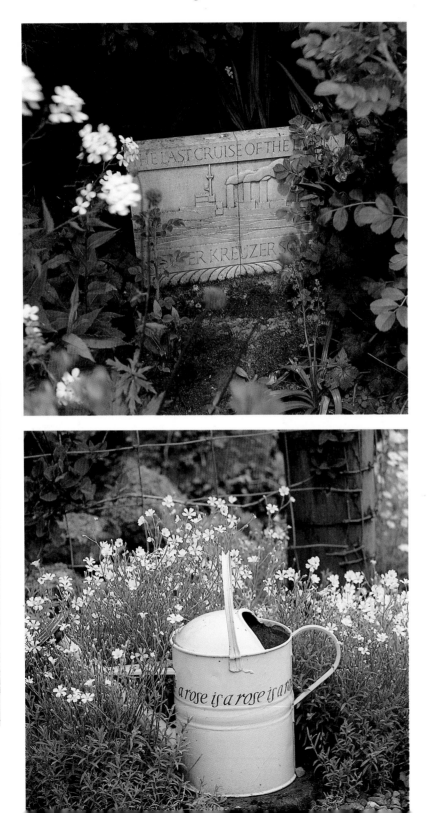

Left:
A watering-can bears Gertrude Stein's definition of a rose.

127

In Gaelic, Eigg means "the notch", and this comes from the deep cleft that divides the Scurr rock from the rest of the island.

Opposite:
Palm trees flank the drive which runs up to the house.

A Magical Island

The islands of the West Coast of Scotland are steeped in romance and legend. The Small Isles – Rhum, Muck, Canna and Eigg – are approximately an hour's (often turbulent) boat trip from the Scottish mainland, 7 miles into the Atlantic from Arisaig, and were once part of a dowry brought into the Lordship of the Isles.

Keith Schellenberg, a former bob-sleigh champion and rugby captain for Yorkshire, a racer of power boats and vintage Bentleys, bought the Island of Eigg in 1975. He had fallen in love with the Hebrides and felt that he could contribute something positive to the crumbling economy and fabric of island life. He started by making the entire island a nature reserve. Fishing was kept to a minimum and shooting banned altogether.

Today Schellenberg farms 2,000 Cheviots and cross-bred Blackface sheep, an expanding herd of Luing and cross-bred cattle, and he grows hay for winter feed. Four hundred acres of forestry have been planted in the middle of the island, including 25,000 hardwood trees landscaped into glen formation.

Schellenberg has also taken steps to encourage tourism, which he believes is critical to the survival of such communities. There is a small hotel as well as a guest house, and cottages are also let out. His wife, Suky, has opened a craft shop which sells items made on the island, such as Eigg baskets produced by islander Trevor Leate.

Although Keith's other business interests frequently take him away from his beloved island, he and Suky spend as much time as possible in their colonial-style house, which was built in 1927. Here the mood of the island is captured indoors as well as out; because they are dependent on hydro-electric power from rainwater, they have very little electricity at their disposal. It is in such places that time seems to stand still. The tranquillity and haunting beauty of this island are difficult to convey without the accompanying experience. The light is constantly changing over a seemingly endless seascape, and the problems of the world seem petty, irrelevant and far away.

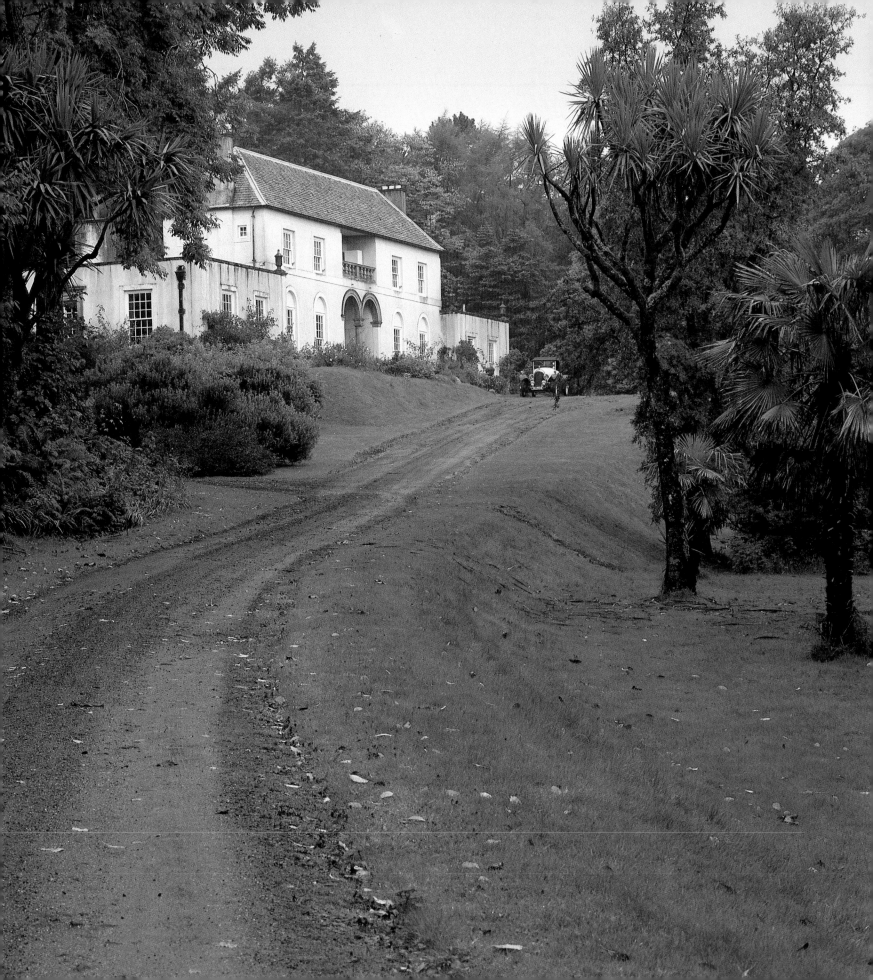

Trophies and memorabilia are cluttered on Keith Schellenberg's desk.

Below:
An old map of the island is entitled "Eigg – the property of Ranald George Macdonald, Esq, of Clanranald surveyed by Wm Bald in 1806."

The loggia is filled with paraphernalia used during the annual Eigg Games. There is an old Gaelic stone found on the island and various pieces of shipwreck salvage. A 1927 cream-and-green Bentley stands out in the rain.

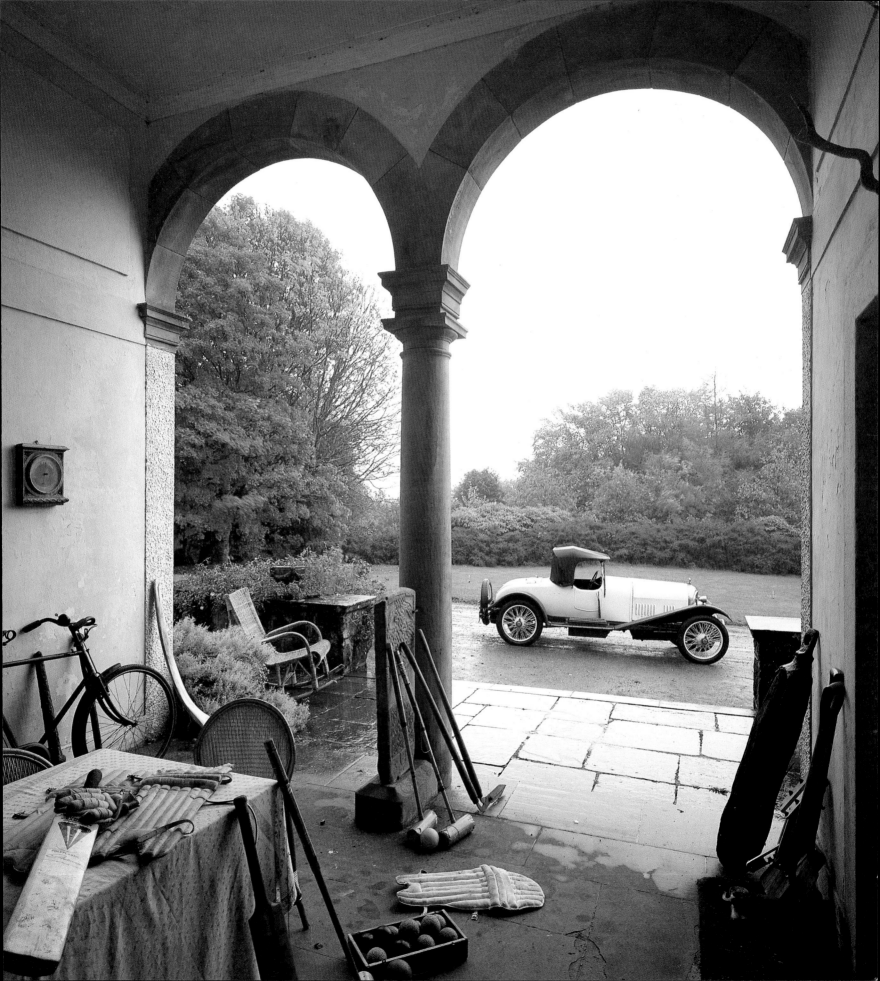

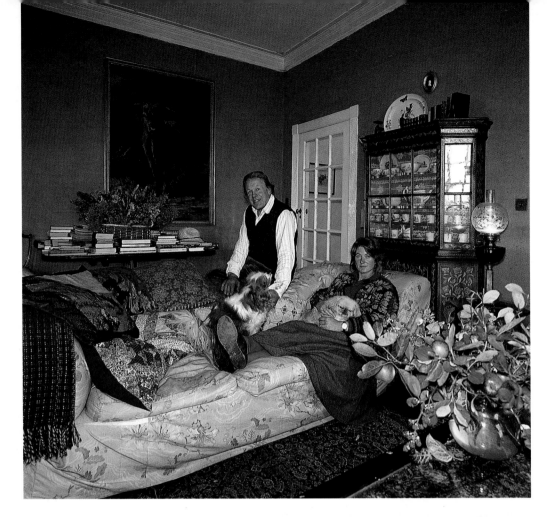

Right:

A Louis XV clock sits on top of a French inlaid roll-top desk (*c.* 1750). Another collection of Davenport, depicting British scenes, is in a corner.

Keith and Suky Schellenberg in their drawing-room, with Tufty and Bruno.

A painting of sheep in a Scottish landscape by MacWhirter hangs over the fireplace. The Victorian oil of a Highland bull is by J. Denovan Adam and one of a pair. The Dutch Marguerite cabinet contains a Davenport tea set.

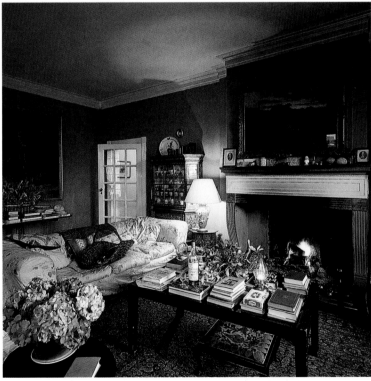

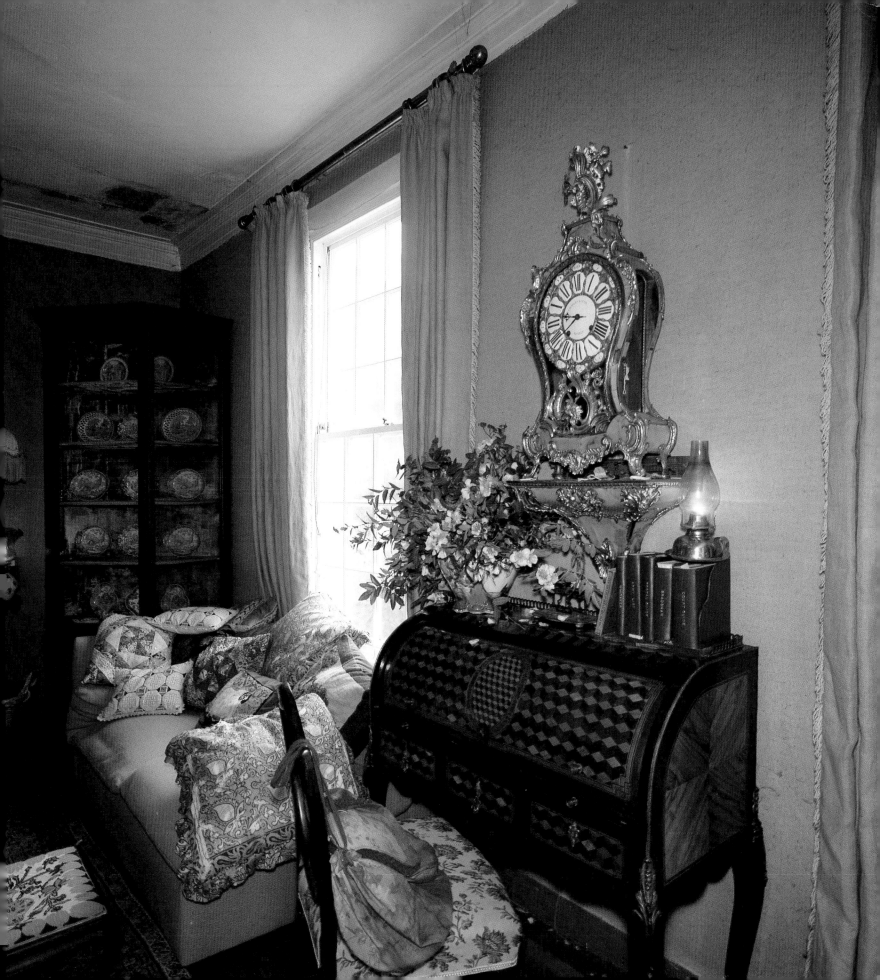

A collection of tea- and
coffee-pots sit beside the Aga
stove.

Opposite:
A general view of the
kitchen.

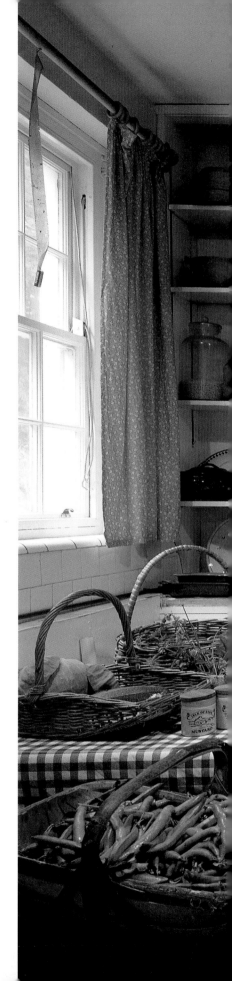

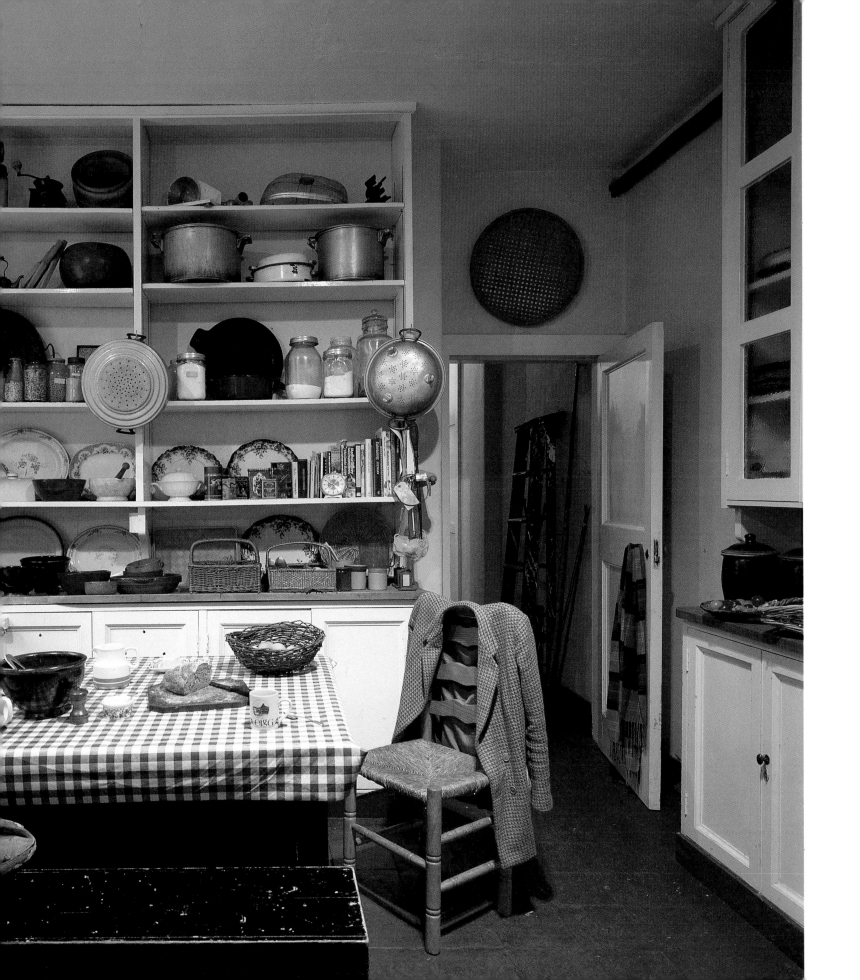

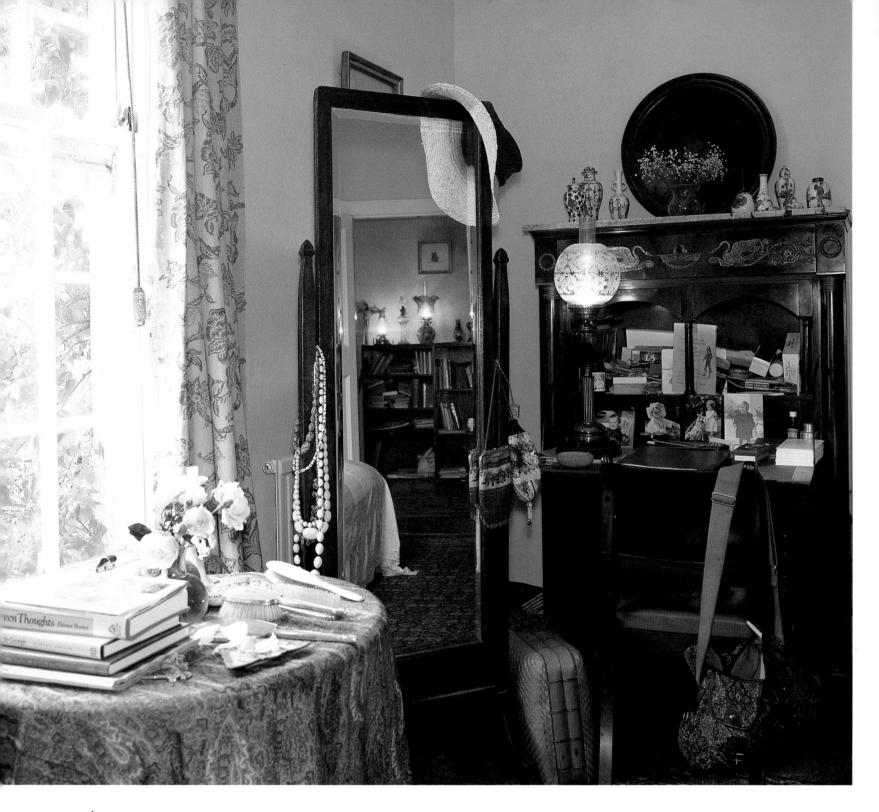

A corner of the master
bedroom.

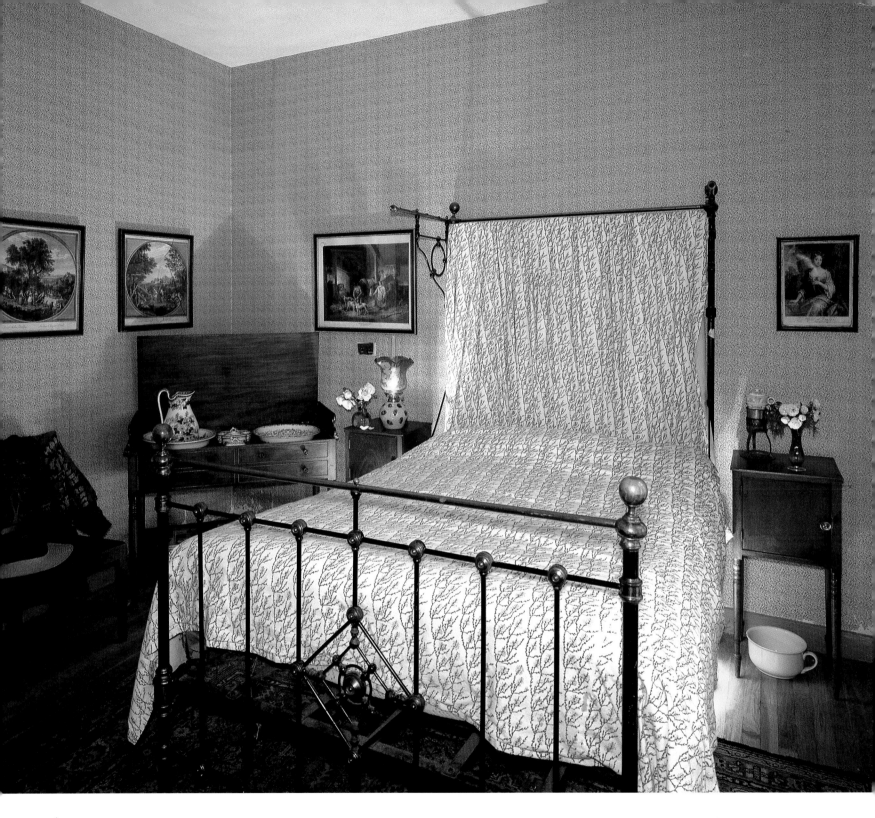

A guest bedroom with blue wallpaper and black-and-white prints on the wall. Over the chair is a Kaffe Fassett floral jacket.

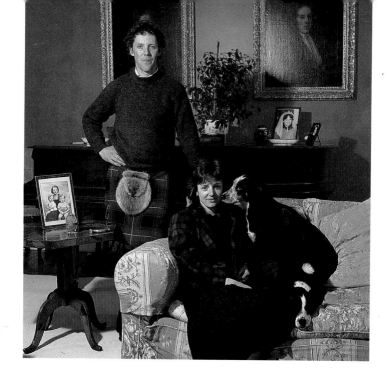

Lachlan and Nicola Rattray in the drawing-room of their half of Craighall-Rattray. The photograph on the table is of Lachlan's mother, Christian Rattray.

Opposite:
A view of the house from the river.

Living Apart Together

Rattrays have lived at Craighall-Rattray for centuries. The name itself means "cliff-dweller", which could hardly be more appropriate, as Craighall-Rattray perches spectacularly above a wooded gorge, 200 feet above the River Ericht. So impressed was the great Sir Walter Scott on a visit that he is supposed to have used Craighall as the inspiration for "Tully-Veolan" in the Waverley novels.

The present Laird, Captain James Rattray of Rattray, lives nearby, but his younger son and daughter-in-law, Lachlan and Nicola, settled in the house shortly after their marriage in 1983. At present they run their Architectural Recycling Company from home, buying and selling architectural fittings acquired from neighbourhood country house sales. They share Craighall with a young South African kinsman, Martin Rattray, an interior decorator who is enthusiastically working on some of the rooms.

From the road and from the river, Craighall is as dramatic as the views which it commands from its drawing-room windows. One imagines that Ludwig of Bavaria would have been at home in such a house, but in fact no place could be more uniquely Scottish.

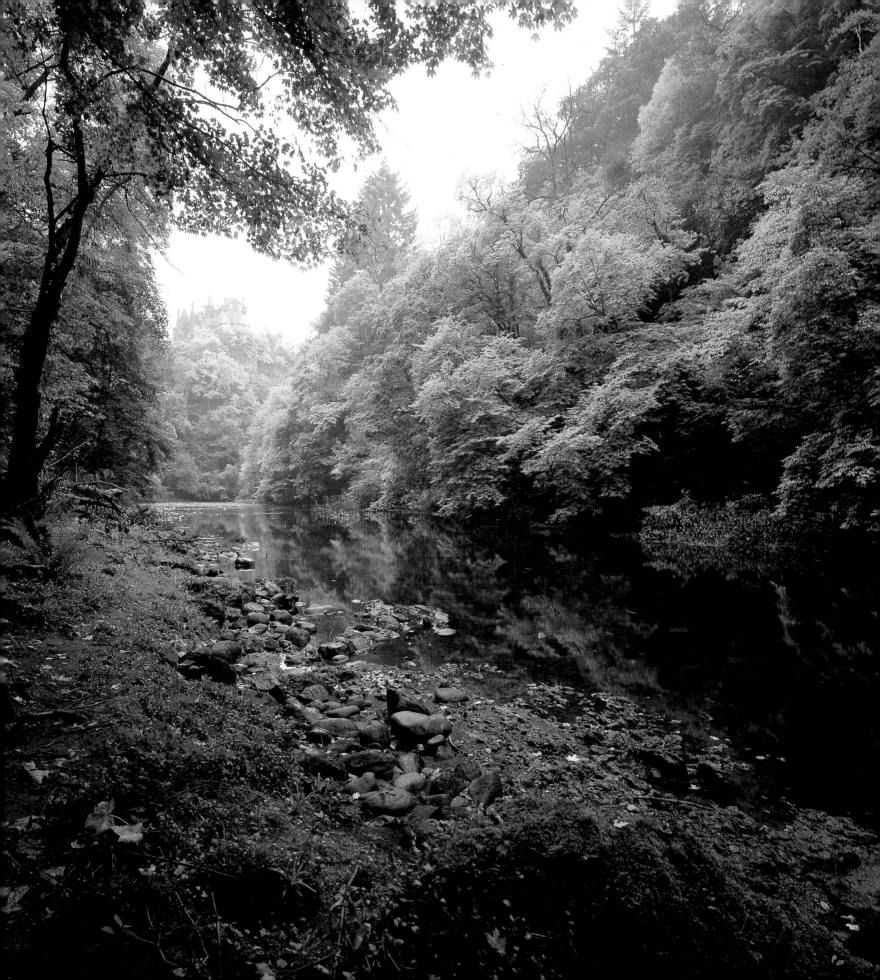

A balcony surrounds the
drawing-room, and through
a French window there is a
view of the gorge onto the
woods and River Ericht
below.

Right:
A long hallway runs through
the house, which has now
been divided in two.

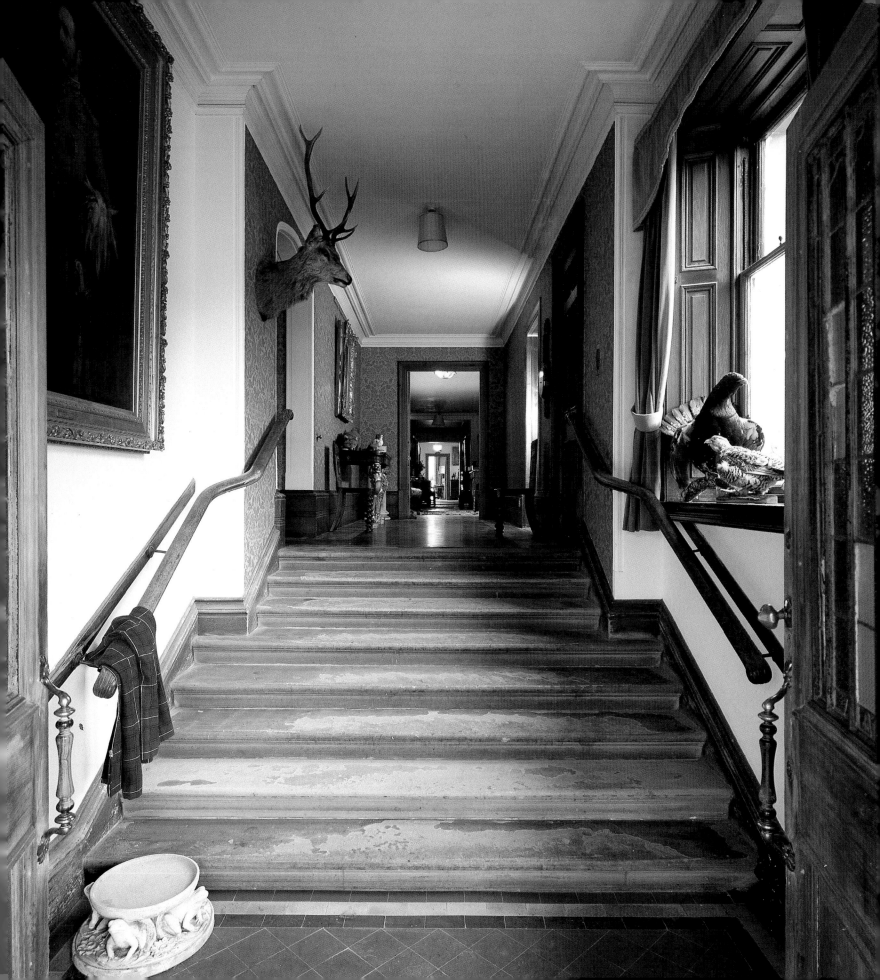

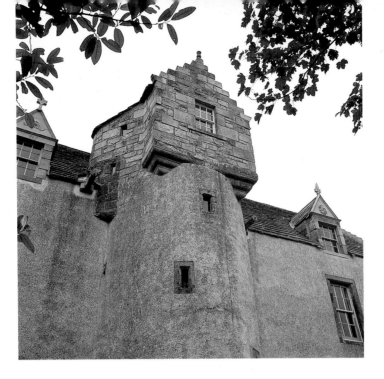

An L-shaped fortified house
with a turret stair.

Opposite:
Angus, Fleur and Gay
Grossart in the great hall.

A Banker's Choice

Having founded his own extremely successful Scottish merchant bank in 1967, Angus Grossart has a deeply felt commitment to living in Scotland. He is a director of more than eighteen companies in the United Kingdom and North America, and his business interests have ranged from North Sea oil to Goldcrest Films.

Born and brought up in Glasgow, Grossart read English at Glasgow University and qualified as a chartered accountant. He then practised law at the Scottish Bar for seven years. Noble Grossart Ltd, merchant bankers, were in 1980 the first new bank for twenty-five years to be recognized by the Bank of England.

As an undergraduate, Grossart used to spend his lunchtimes in Glasgow auction rooms, and from the moment he could first afford it, he became a "steady collector of Scottish paintings, furniture, ceramics and metalwork". He has a particular regard for craftwork and for those artisans in the Charles Rennie Mackintosh era who worked in textiles and metal.

It took some years, but he finally found the castle of his dreams, a neglected keep in the north-east of Fife, and in 1978 he began to put it in order. A serious fire proved something of a setback, but Grossart pushed on nevertheless, devoting every moment of his free time to the project.

Pitcullo is described by its owner as "an L-shaped fortified house with turret stair at the re-entry angle and a blister at the back with a rear stair". Using local builders and craftsmen, he has sought to capture the original atmosphere of the house. A series of ceiling paintings in the traditional style – the Flowers of Fife in the Great Hall, the story of Robert the Bruce in a bedroom – executed by the Glenrothes artist Michael Pinfold adds both decorative and historical interest. Elaborate traditional carving has been cleverly undertaken by Peter Nicolson, who lives at Auchtertool.

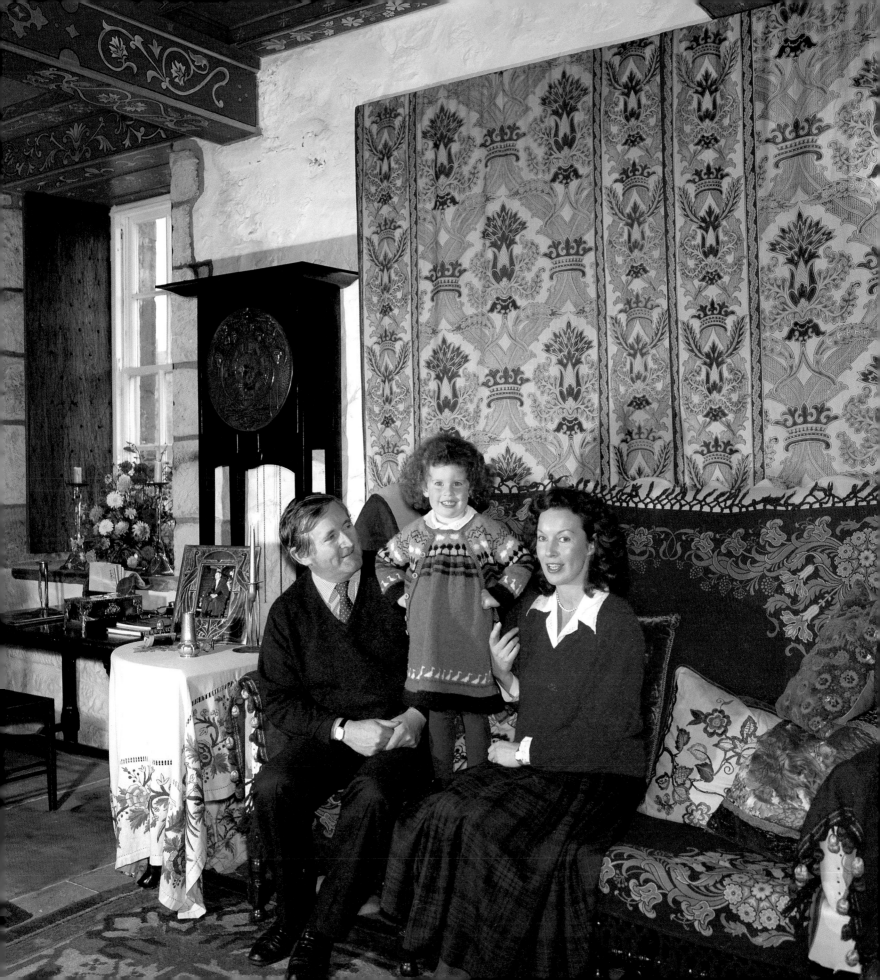

Top:
A colourful old crewel-work wall hanging above a chair with Glasgow Art Nouveau cushions. The chairs on each side are based on a high-backed oak design and are known as Hammerman chairs. These two were probably designed by George Walton in Glasgow.

Left:
The fender of the fireplace in the great hall was designed by Sir Robert Lorimer.

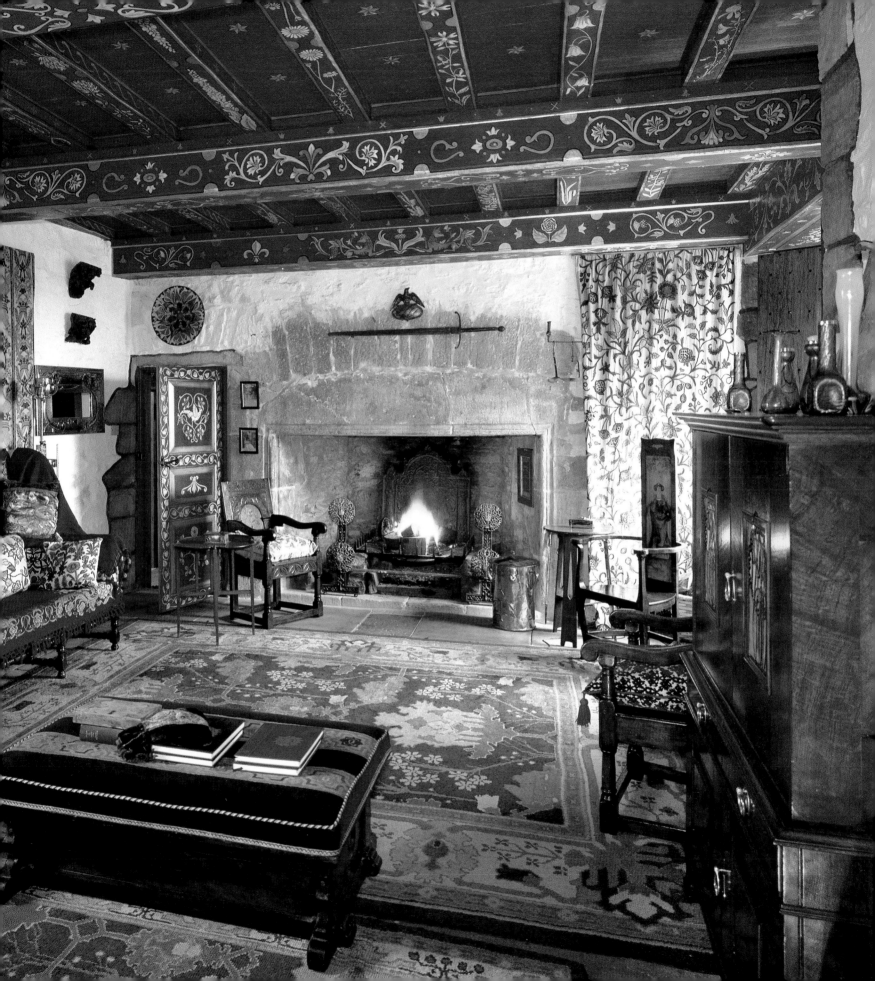

A collection of Glasgow Art Nouveau cushions.

Below:
An embroidered bedspread in the Glasgow style.

Overleaf:
The ceiling beams of the great hall are decorated with the flowers of Fife. The Glenrothes-based artist, Michael Pinfold, was commissioned to paint the ceilings throughout the house. In the foreground is an ottoman stool which came from the Fine Art Society in Edinburgh.

Opposite:
Ceilings in the bedrooms are decorated by Michael Pinfold. Lying over the embroidered bedspread is the robe of an Honorary Doctorate at Glasgow University. Behind the bed is an attractive crewel-work wall hanging.

146

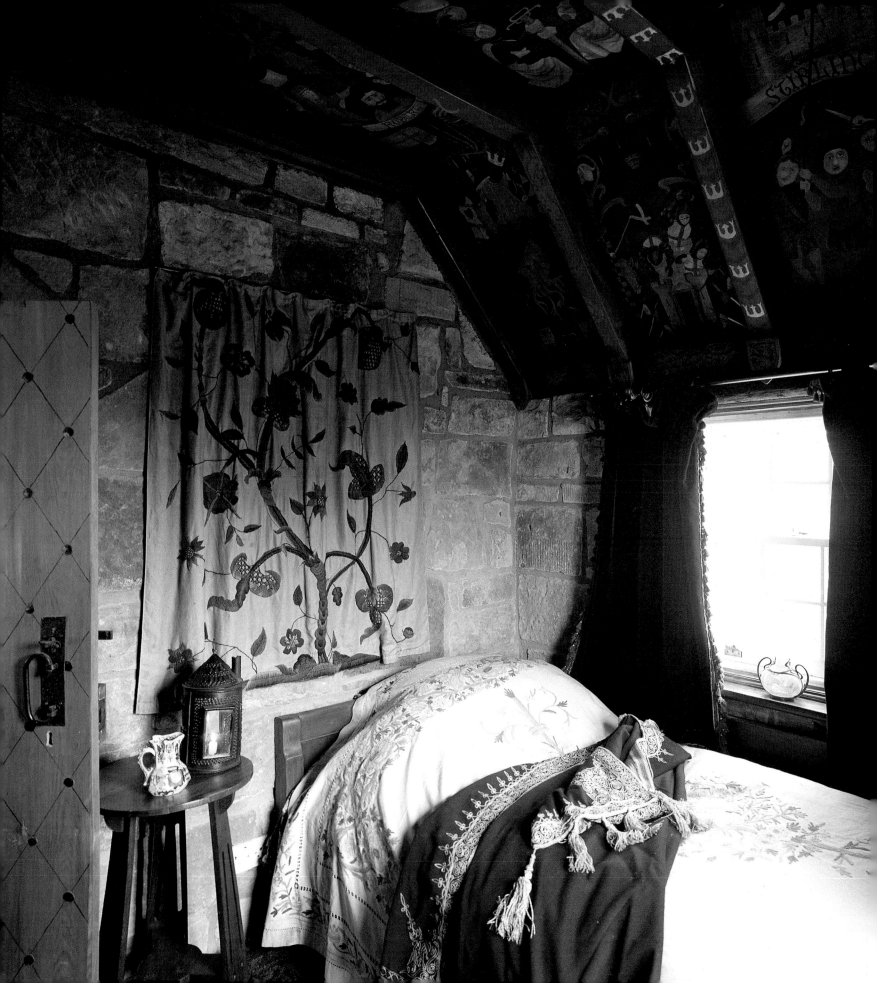

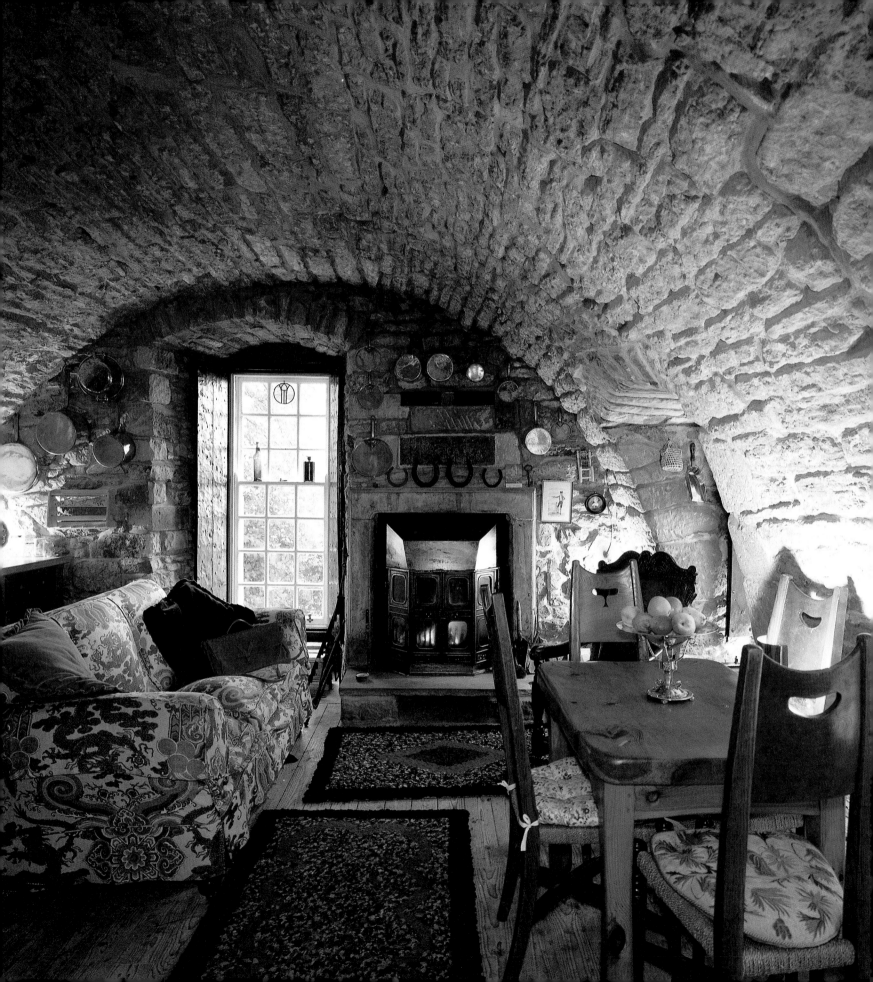

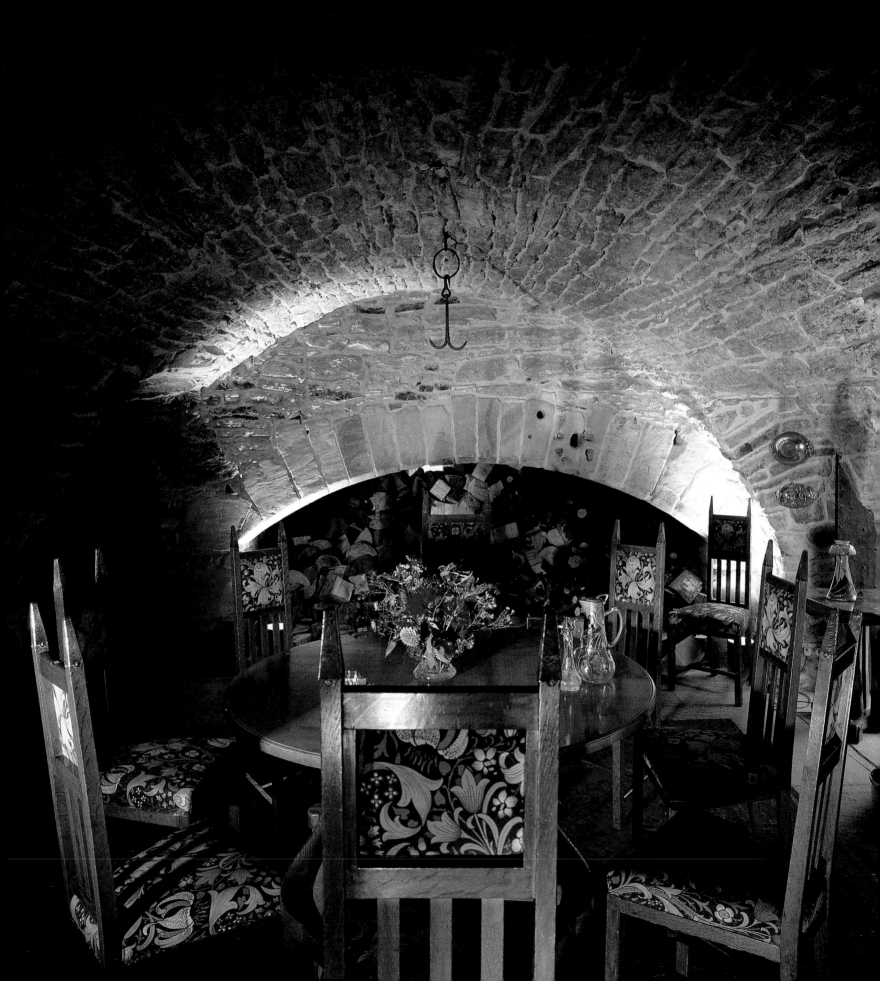

Previous pages:
In the vaulted kitchen is a Tim Stead table. The Arts and Crafts chairs are by William Birch.

The vault of the old castle is used as a dining hall. The chairs are from Liberty's.

Opposite:
The stair walls have a Celtic tracery painted by Michael Pinfold. The design ties in with the ceiling panels. On the stair-rail hang two old Cruisie lamps.

Above:
There is a collection of Art Nouveau glass and framed tiles, depicting the seasons, on show in the window of the staircase.

Alexander and Cecilia
McEwen with their dogs
Minnie and Dimmie.

Opposite:
View of the south-facing side
of the house, showing the
original Watson building
with the extension by Sir
Robert Lorimer.

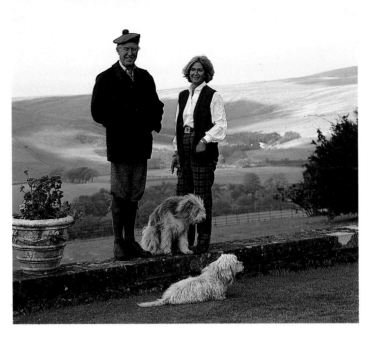

Far Away in the West

A house on a hill, originally built by T. L. Watson for R. F. McEwen in 1893 and extended by
Lorimer in 1905, in the south-west corner of Ayrshire was a childhood holiday home for the six
sons and one daughter of Sir John McEwen, 1st Baronet of Marchmont and Bardrochat. Two
of those sons, Rory and Alex, achieved a certain fame as folk singers back in the 1950s and '60s, but
Rory went on to become an accomplished artist and Alex joined the board of Scotland's foremost
newsagent.

Having lived for many years in Berwickshire, Alex and Cecilia McEwen moved to Bardrochat with
their two sons and daughter in 1983. And with immense energy and flair, Cecilia set about transform-
ing an already delightful house into a stylish and luxuriously comfortable family home. She had the
woodwork stripped throughout the hall and staircase area, and also in various other rooms, including
a bathroom. Alex McEwen, a keen collector of contemporary art, displays his collection to great
advantage alongside family portraits and treasures. The house commands extensive views, and the use
of bright colours and decorative fabrics gives the interior a fresh and appealing serenity.

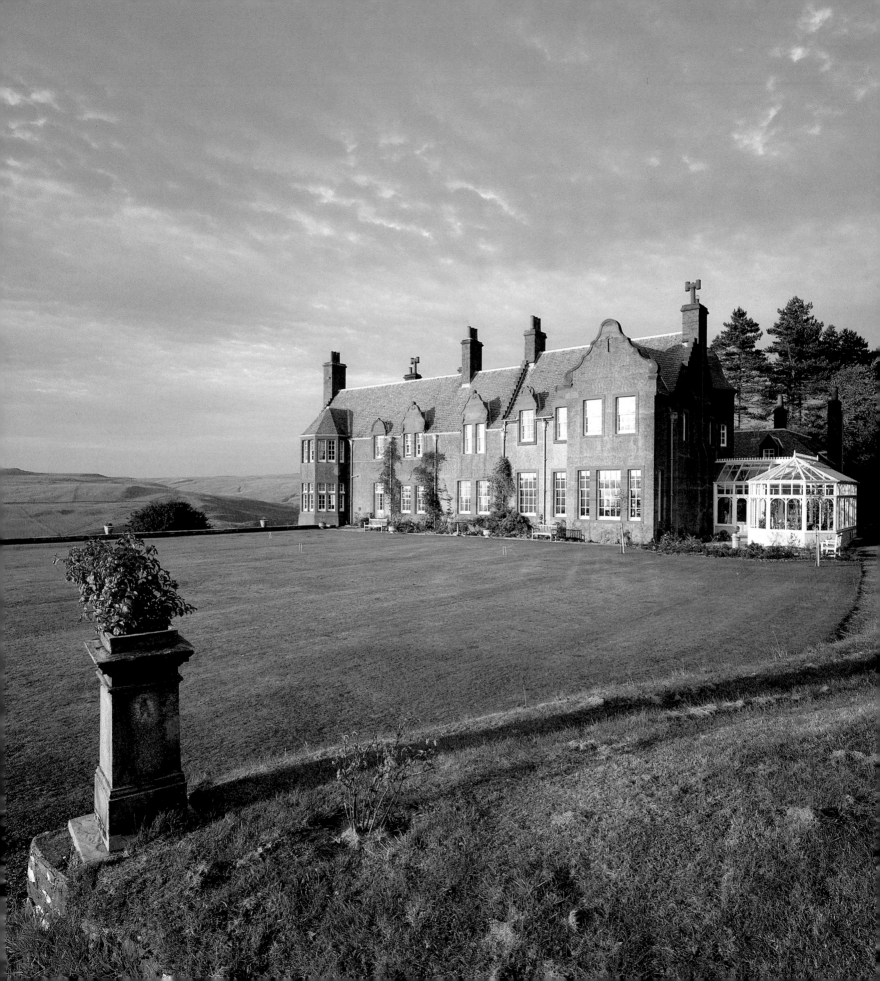

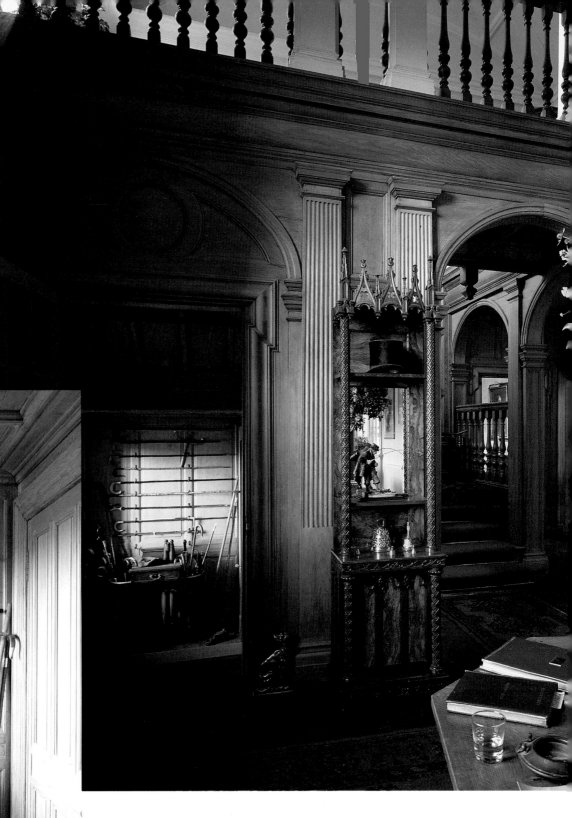

Below:
A collection of crooks and
sticks stands inside the front
door.

Above and right:
Two views of the panelled
entrance hall, which Cecilia
McEwen has stripped back
to the natural wood.

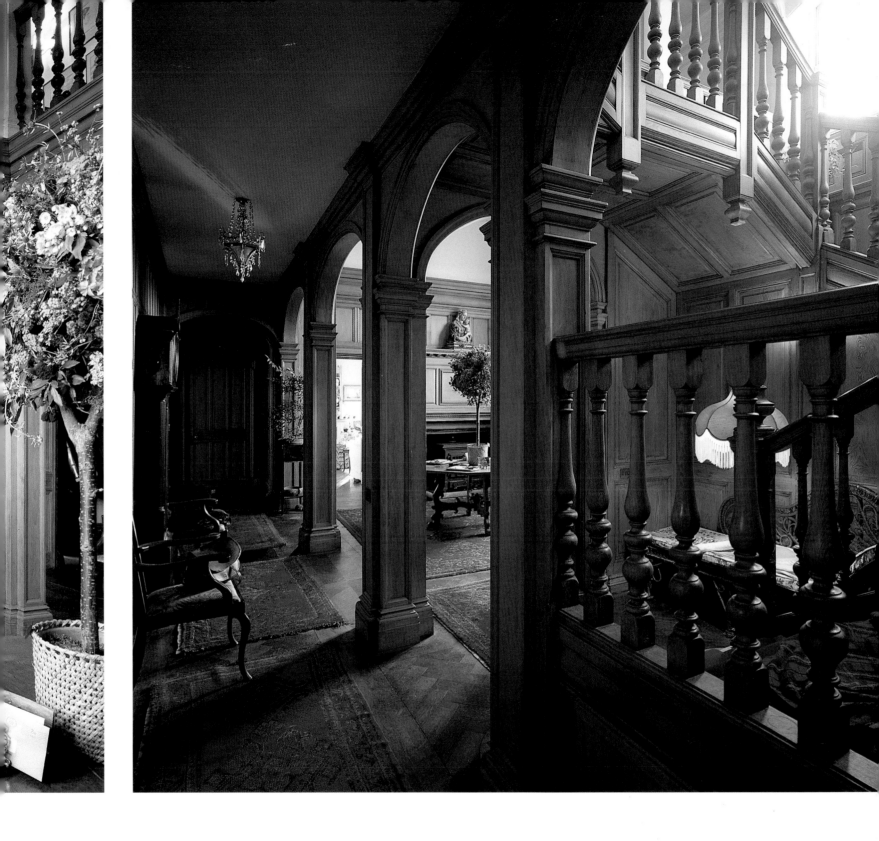

A portrait of James Robert Dundas McEwen (1896-1916) by Laszlo hangs in the elegant drawing-room.

Below:
The cabinet in the drawing-room contains a collection of Derby, Nymphenburg and Meissen porcelain. The paintings on each side are by J. van der Ulft.

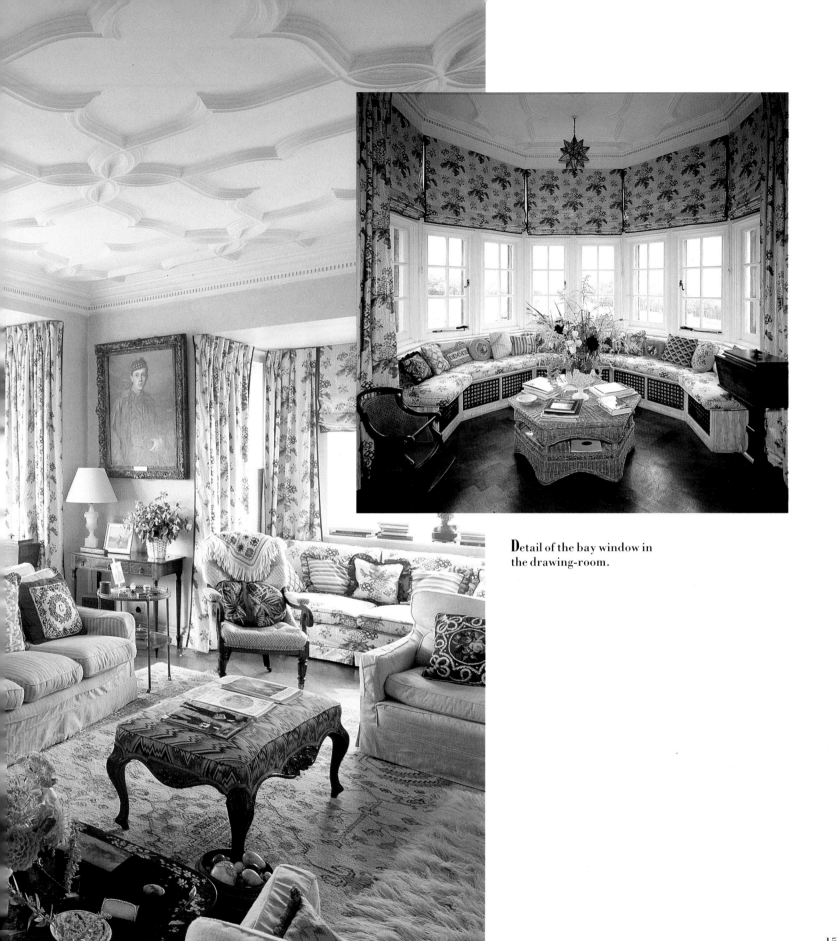

Detail of the bay window in
the drawing-room.

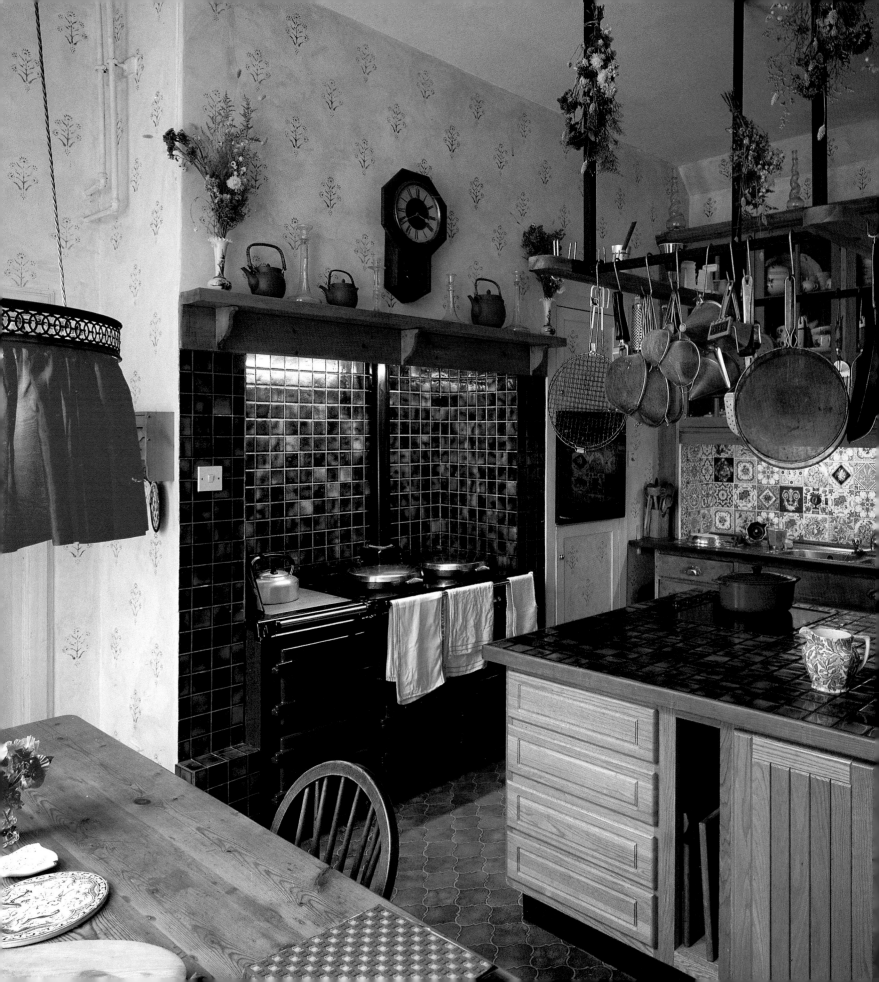

A general view of the kitchen where the walls have been stencilled by Emily Todhunter. The wall tiles above the sink were collected by Cecilia McEwen and are a mixture of Victorian and Art Deco.

Right:
House rules composed by Lady McEwen hang on the kitchen wall.

Plate-rack in the kitchen. The two watercolours of bulls are by H.J. Gow (1839).

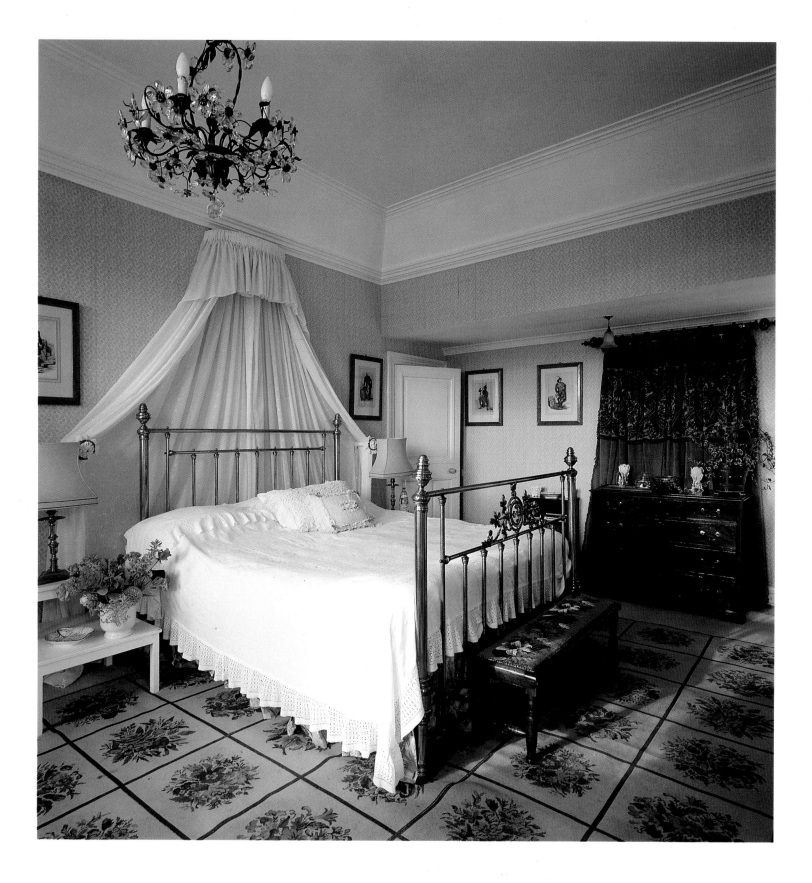

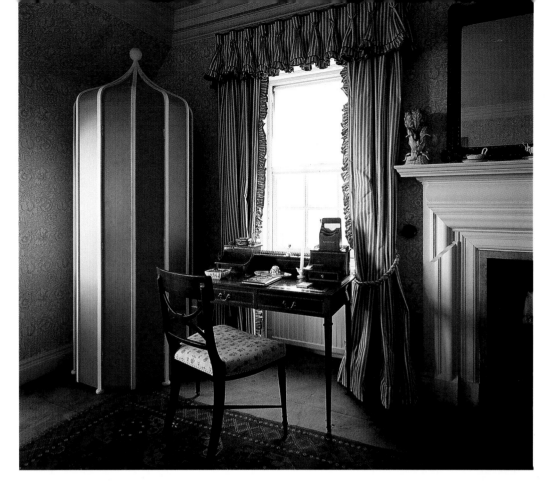

An octagonal free-standing corner cupboard with gazebo roof in the ex-nanny's room.

An engraving entitled "Jeune Ecossaise", drawn by A. Lady, hangs above a chest of drawers in the master bedroom.

Cecilia McEwen found the lace curtains for this guest bedroom in a local shop in Edinburgh.

Opposite:

In a guest room, formerly the nursery, is a large brass bed with a wall canopy. There is a tapestry carpet on the floor and on the walls are prints of Scottish clans by R.R. McIan in maple frames.

Right:

Cecilia McEwen stripped the wood on the bath and basin in this guest bathroom. On the wall is blue-and-cream William Morris wallpaper.

Below:

A tartan rug sits on an old leather chair beside the fireplace in the study.

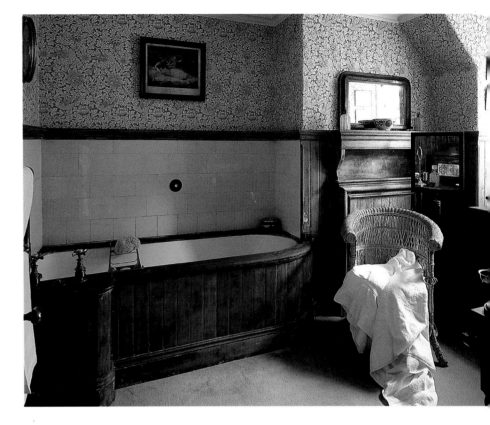

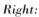

Right:

Two pictures of leaf and geraniums by Rory McEwen hang in Alexander McEwen's dressing-room.

Opposite:

Detail of wash-basin in the master bathroom.

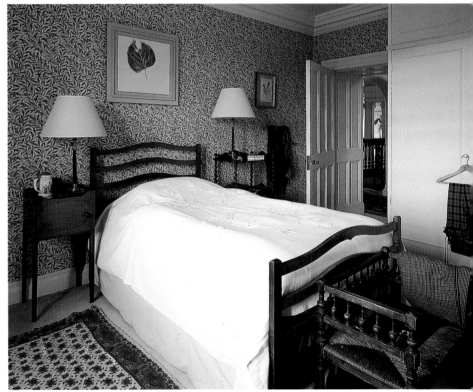

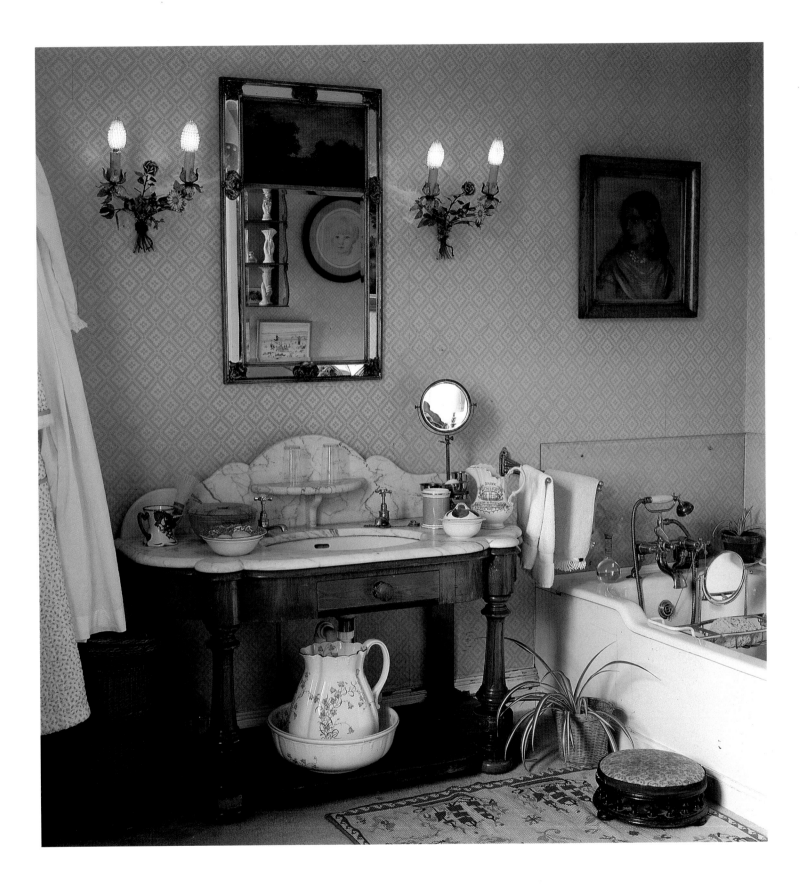

Head keeper Jim Gillies and under-keeper Frank Law prepare to take a party out onto the hills.

Opposite:
The lounge is lined with rough pine bark and dominated by stags' antlers and other animal heads.

Overleaf:
One of the views from Kinveachy Lodge.

High in the Hills

The red deer is the largest game animal in the British Isles and deer-stalking has been part of the Highland way of life for centuries. But it was the Prince Regent's passion for the sport which made it mandatory for families of note to acquire or build their own lodges in the 19th century in order to indulge in what became an integral part of the Scottish autumn social season. Remotely located, often spartan, but sometimes not dissimilar to well-run country hotels, these lodges would be opened for a few weeks each year for house-parties of sporting friends and privileged acquaintances renowned for their sporting abilities.

With the economic pressures of the present century, however, the traditional ways of sporting life have had to change. Many landowners are no longer able, or would wish, to keep their sport exclusively to themselves; while syndicates are an option, the most popular and successful compromise is to attract paying sportsmen from overseas.

Kinveachy Lodge near Boat of Garten, Inverness-shire, was built for the Earls of Seafield who owned both Castle Grant and Cullen House, and is a particularly good example of how such a property can be employed nowadays. Since 1984, the Seafield family has been accommodating parties for salmon fishing, grouse shooting, stalking and mixed shooting, opening Kinveachy from mid-May to mid-November.

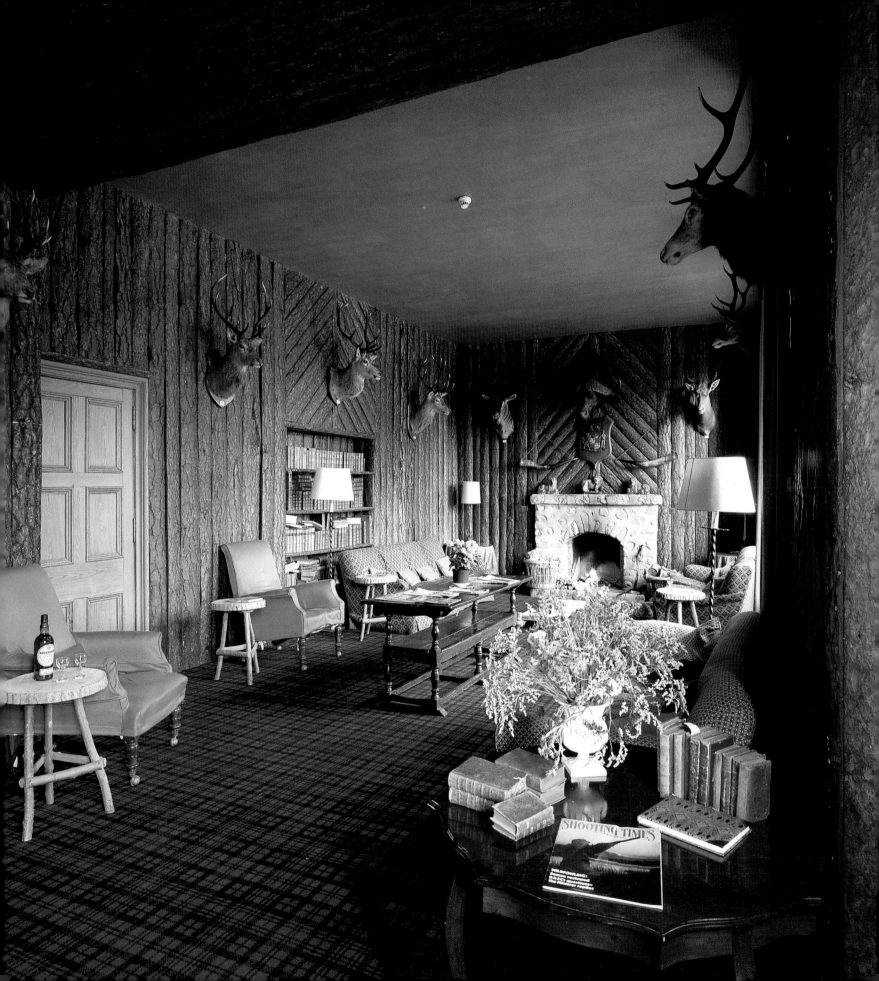

The drying room, an essential feature of every Highland lodge.

Below:
A portrait of Alistair Grant "Mhor", Champion 1714, which shows the original style of plaid kilt worn before the 1745 Rebellion; after that the wearing of tartan was made illegal.

Bottom right:
The game larder.

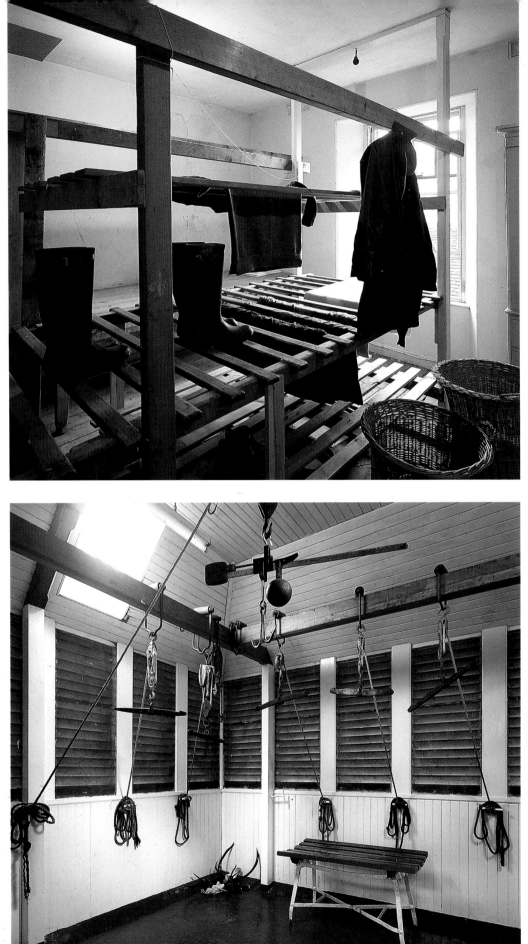

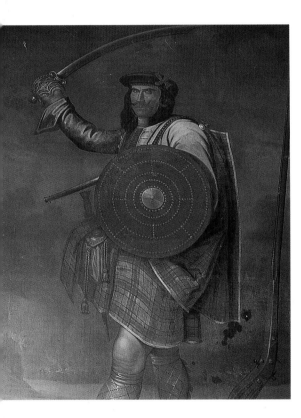

Opposite:
A green Grant carpet covers the floor and stairs of the main hall. Each of the bayonets on display is engraved with the name of Sir James Grant.

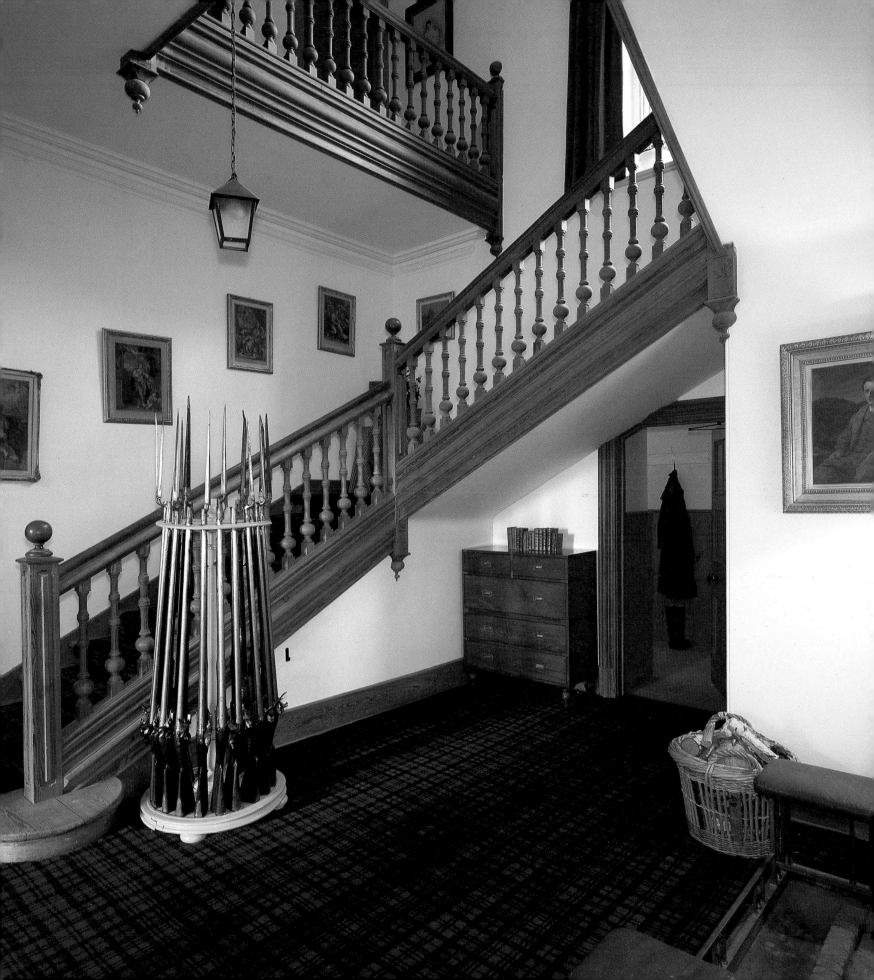

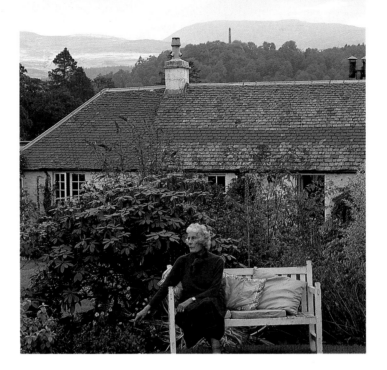

Pam Elliot in her garden.

Opposite:
In the entrance hall is a painted *trompe l'oeil* by Maggie Montagu Douglas Scott.

A Highland Smithy

For a number of years, Mrs Hubert Elliot had driven regularly along a country road past a group of small cottages which included a former forge occupied by an elderly couple. Coincidentally she saw it advertised for sale in a local paper at just the time when she had decided to move from the family home into something more manageable.

The purchase was completed in September 1982 and work started in January 1983. During June of that year she moved in.

By knocking rooms together, she has turned the old smithy into a spacious, one-storey home, full of light and air, which opens out onto an intimate garden with leisurely views of the surrounding hills.

Left:
The sitting-room adjoins the
dining-room, and Sanderson
wallpaper is used
throughout, creating a
stylish, yet cosy atmosphere.

Above:
The portrait over the dining-
room sideboard is of the
owner's great-grandmother.

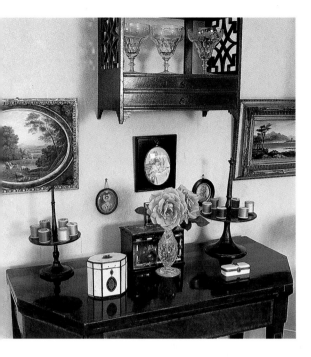

Cotton reel holders and personal items provide a decorative feature in a corner of the drawing-room.

Right:
A splendid breakfront bureau-bookcase dominates one end of the drawing-room, which was created from five rooms in the original smithy building.

Opposite top:
A general view of the drawing-room which is papered in apricot wallpaper from Osborne & Little.

Opposite below:
Beside the door is a screen painted by Maggie Montagu Douglas Scott.

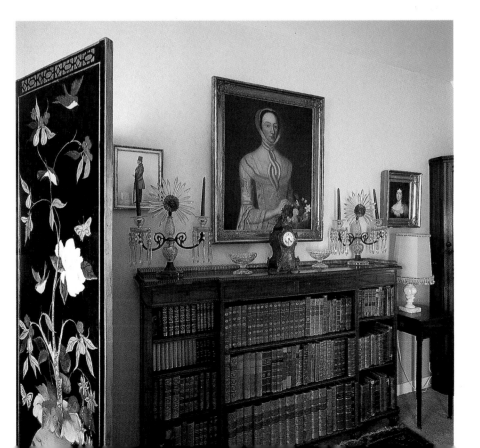

A dovecote seen through a mass of delphiniums, campanula and various shrub roses.

Opposite:
Lady Maryoth Hay on the steps that lead down to her front lawn.

Surrounded by a Garden

Lady Maryoth Hay announces proudly that her East Lothian garden took her twenty years to get right. When her family had grown up and left home, this sister of the 12th Marquess of Tweeddale was brought back by her clannish instincts to settle on the former Tweeddale lands where her ancestors have lived since the 13th century. Yester House, the imposing Adam palace built for one of her forebears, is now owned by the international impresario and composer Gian Carlo Menotti, with whom she enjoys a neighbourly friendship.

Lady Maryoth describes her home as a "mini-mansion". Built in the late 18th century, it is architecturally summarized by Colin MacWilliam in his book *Buildings of Scotland: Lothian (except Edinburgh)* as having "3 bays with dressed quoins and an oval bullseye in the centre pediment, all in pink sandstone". Single-storey wings were added at a later date and the interior remodelled in or around 1841. Its appearance is rather more English than traditional Scottish. Lady Maryoth has created a beautiful garden full of scented roses and wooded bowers. At the far end of a lower lawn, a bridge leads precariously over a stream which tinkles musically below.

Many of her furnishings for the house came from Yester when the estate was dissolved, and her arrangements are strikingly individual. It is an elegant house and Lady Maryoth is perfectly happy to talk about the ghost which sometimes appears in the guest bedroom.

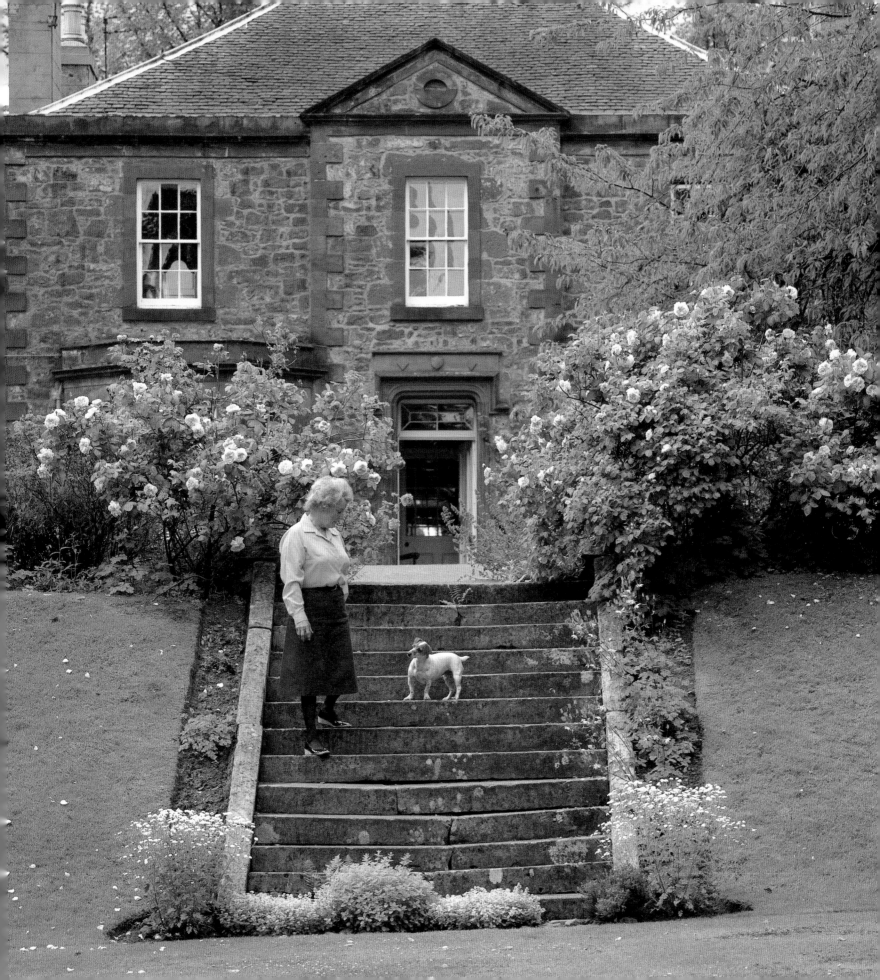

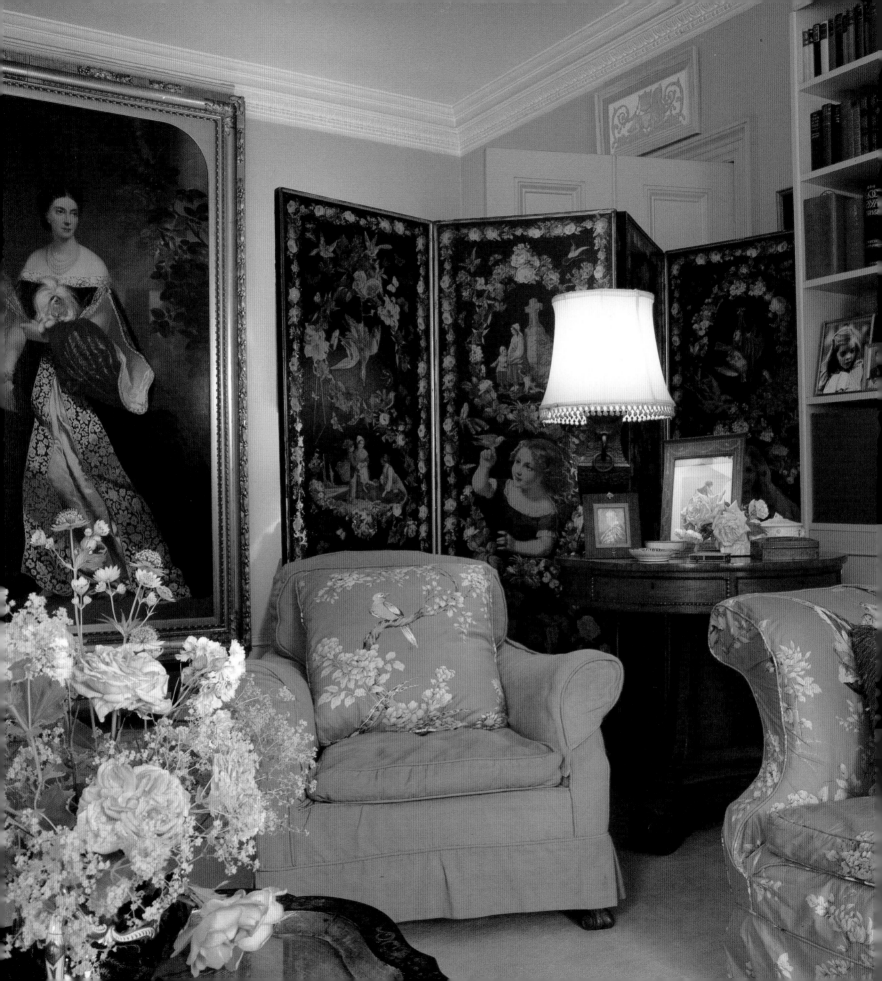

Opposite:
A portrait of the Duchess of Wellington dominates the sitting-room. The Victorian screen (details this page) was made in 1864 by Lady Maryoth's great-uncles in the schoolroom at Yester House. It was assembled from a kit popular with children.

Above:
The mauve bedroom features an antique bedspread and lace hangings made by Lady Maryoth.

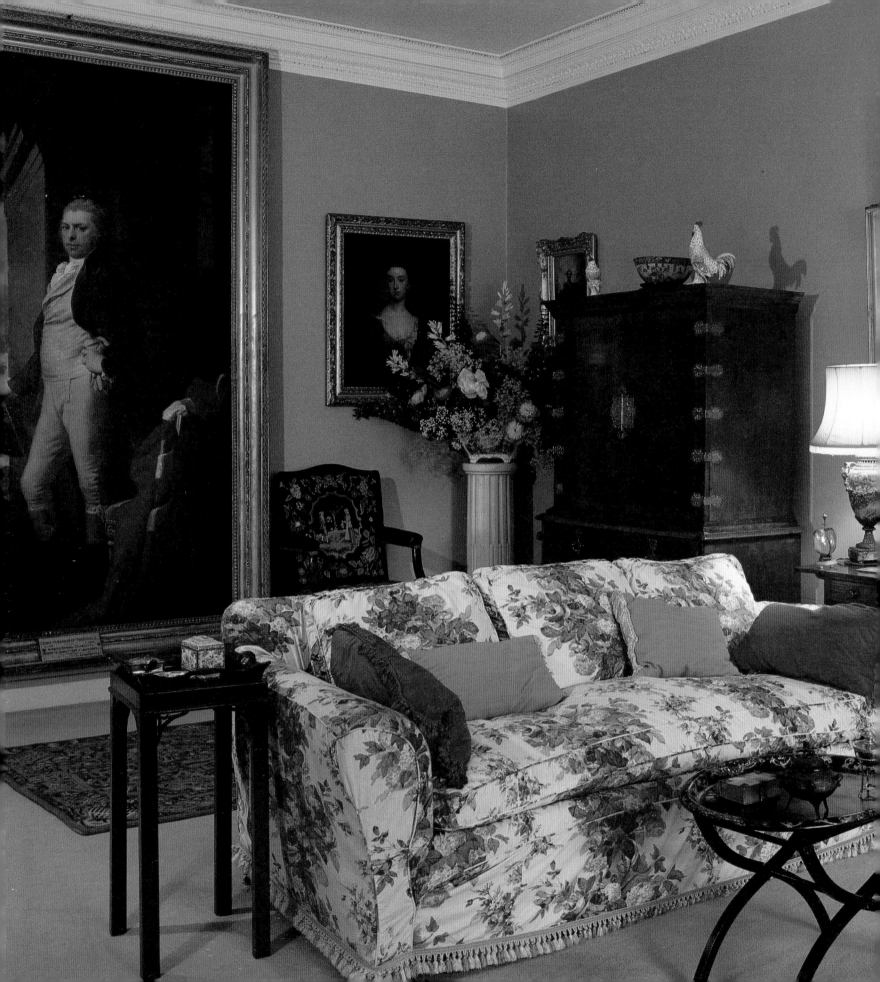

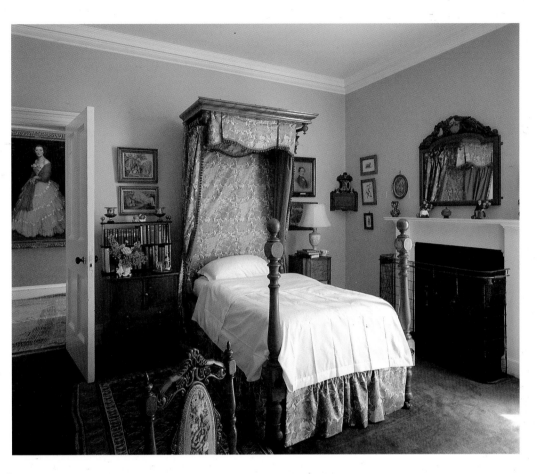

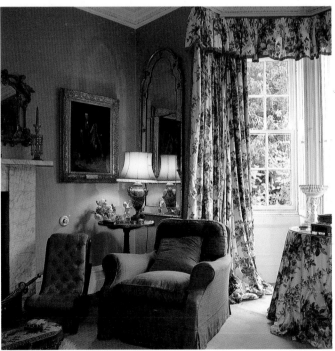

Opposite:
A portrait of the 7th Marquis of Tweeddale by J.S. Mosnier, dominates the drawing-room. The chintz chair-covers were made by Lady Maryoth.

Above:
A view through the door of the blue bedroom onto the landing where there is an oil portrait of Lady Maryoth Hay by Norman Hepple, painted in the 1950s.

In the drawing-room, the English 1780s mirror is one of a pair hung on either side of the windows. Lady Maryoth herself made all the curtains in the house, and the small buttoned chair by the mantelpiece is Regency.

The Duke of Buccleuch &
Queensberry in a Range
Rover painted in his livery
colours.

Opposite:
The north front of
Drumlanrig Castle.

Overleaf:
View of Drumlanrig against
the Lowther Hills.

In the Hills of Dumfriesshire

At times the 9th Duke of Buccleuch & 10th Duke of Queensberry could be forgiven for not remembering where he is. As the owner of four spectacular homes – Boughton House in England, Bowhill at Selkirk, Dalkeith Palace outside Edinburgh and Drumlanrig Castle in Dumfriesshire – his dilemma is entirely enviable. Yet he and the Duchess realistically see their role as life-time custodians, preserving some of the most spectacular furniture and paintings in the world, accumulated through ancestral marriages to great families such as the Douglases, the Montagus and the Scotts.

Each autumn the Buccleuchs are in residence at Drumlanrig, which must surely be one of the most romantically lovely houses in the land. Built by the 1st Duke of Queensberry between the years 1679 and 1690, it stands on the site of two former Douglas castles. Sir William Bruce was involved with the original plans, but it was James Smith, son-in-law of the King's Master Mason, Robert Mylne, who was responsible for this example of Scottish Baronial style. Although Drumlanrig is particularly Scottish in feeling, it marked a departure from the medieval castle towards a decidedly Renaissance concept.

Today this handsome house accommodates the finest collection of furniture, paintings, china and silver in Scotland. Not least among these are the items inherited through the marriage of Anne, Duchess of Buccleuch, to the ill-fated Duke of Monmouth, a natural son of King Charles II and Lucy Walter, a descendant of King Edward I of England. Many of the old families in Scottish history have failed to keep pace with the centuries and have either lost their lands or disappeared altogether. The Buccleuchs have consistently cultivated and administered their properties with skill, pioneering new trends in agriculture and forestry. Their reward can be seen at Drumlanrig.

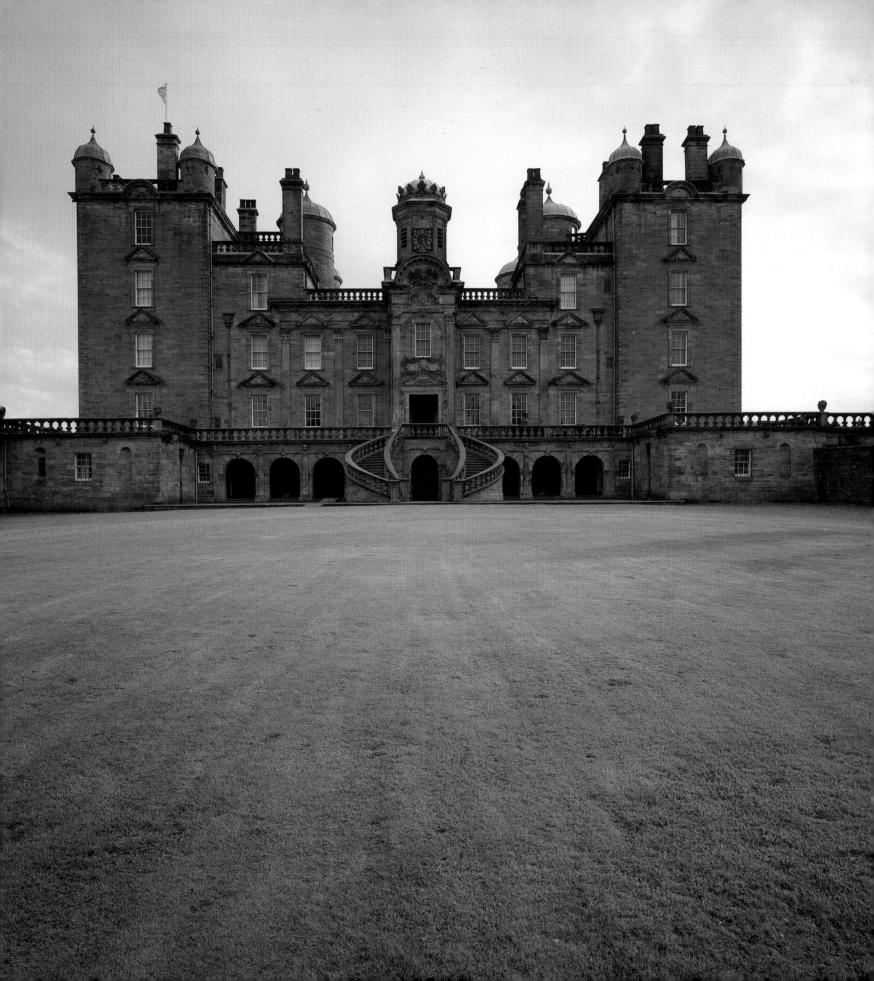

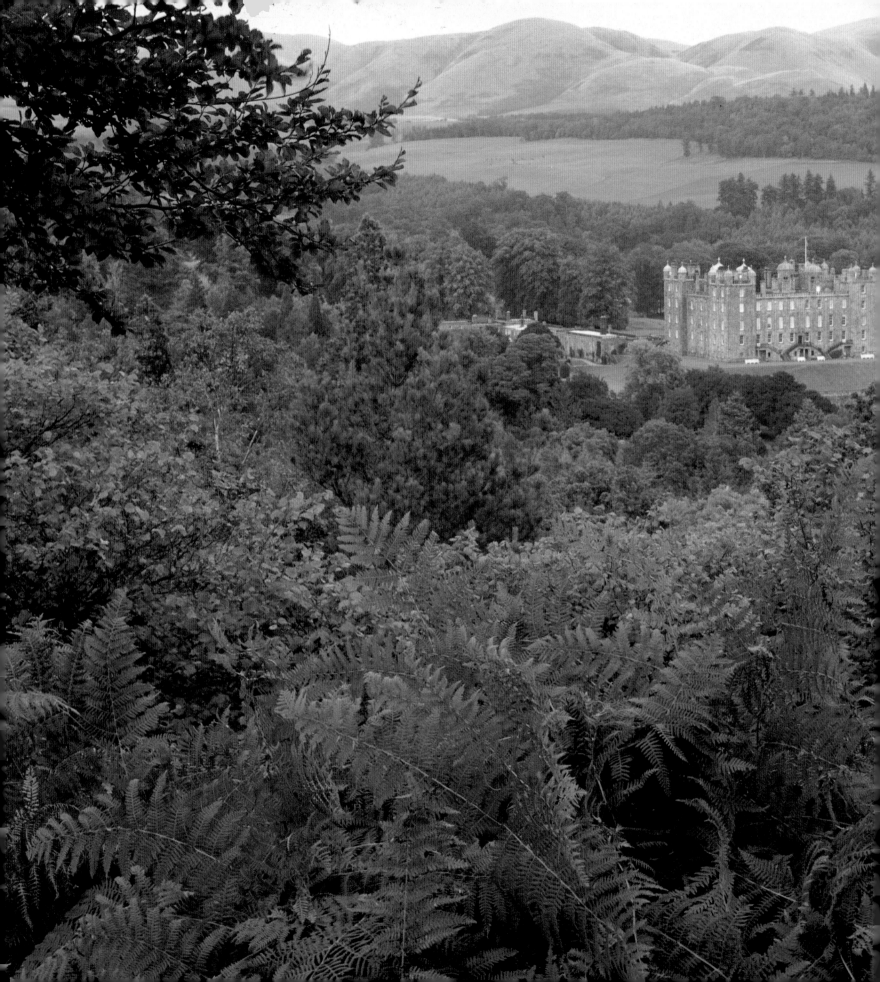

The staircase hall, looking through to the dining-room. On the wall is Rembrandt's *Old Woman Reading*.

Right:
A ram's head decorated in silver and with cairngorms sits on a sideboard in the dining-room.

Opposite:
The panelled staircase hall, looking through to the morning-room. The central lit painting is *Madonna with the Yarn-winder* by Leonardo da Vinci.

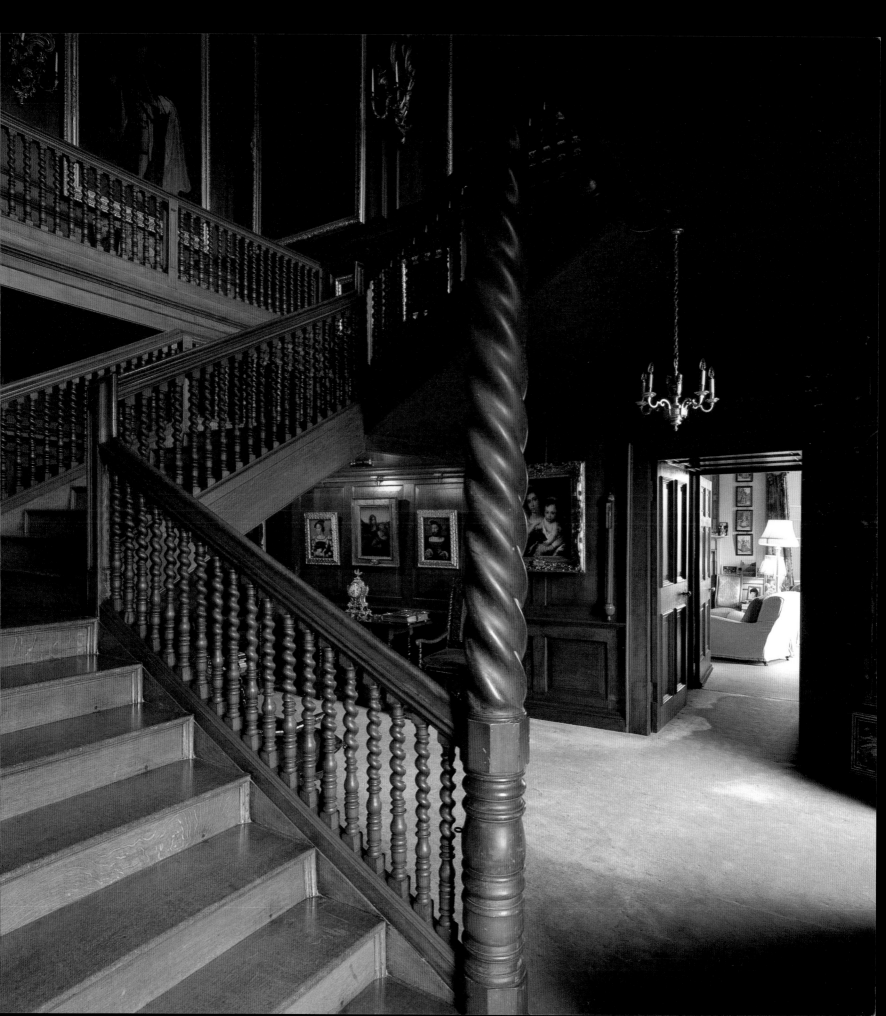

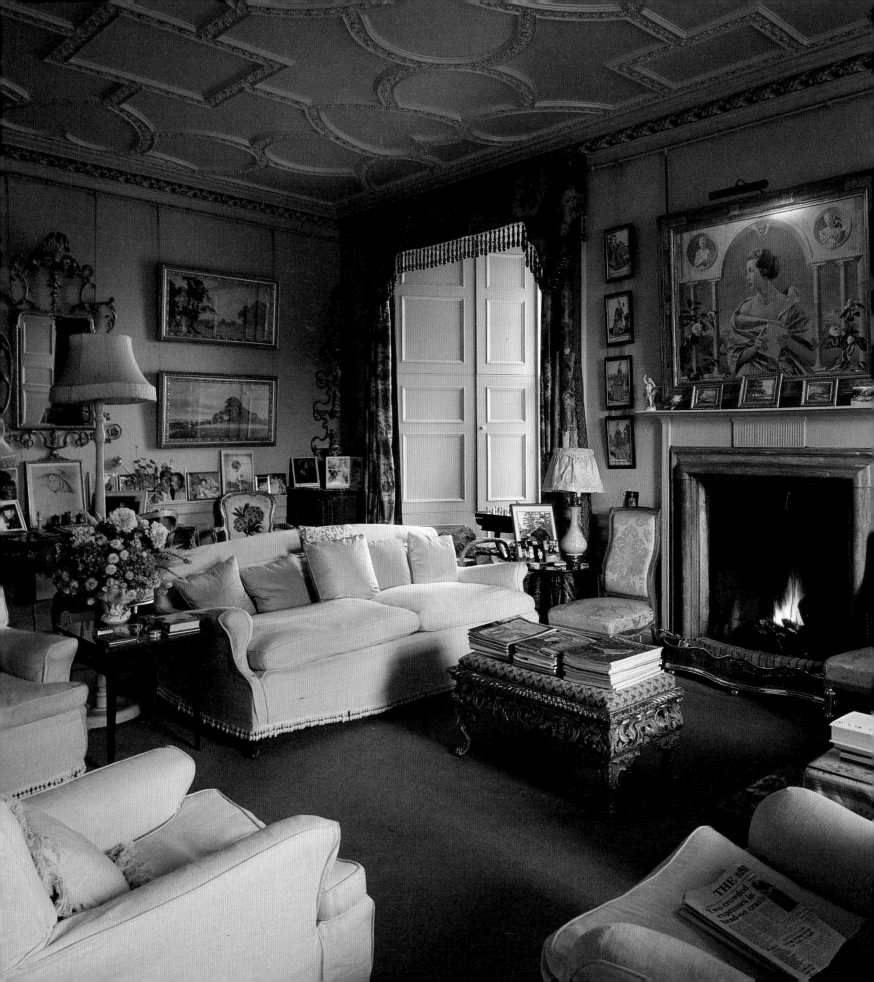

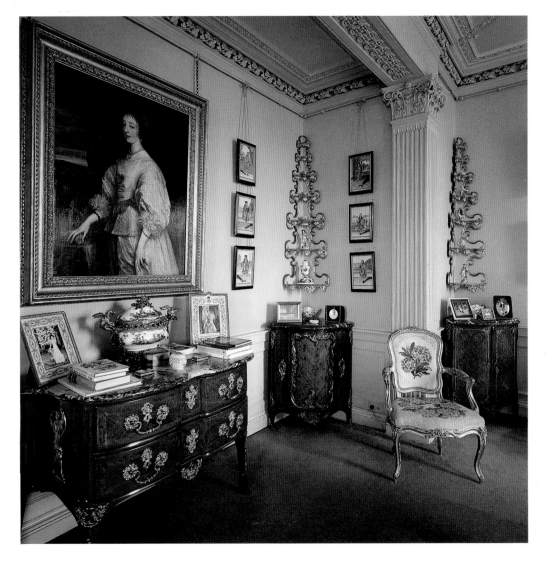

Left:

Over the fireplace in the morning-room is John Merton's portrait of the present Duchess of Buccleuch & Queensberry, when she was Countess of Dalkeith in 1957. This is the only painting since 1918 to receive a Royal Academy "A" award. The small pictures on each side are in needlework. The chintz curtains are mid-19th century. The late 17th-century stools are covered in needlework sewn by Mary, Duchess of Buccleuch, in 1966.

Above:

Over the French Regency commode (Charles Cressent, 1685-1768) in the morning-room is a painting of Queen Henrietta Maria by Van Dyck. The small engravings, enriched by collage, portray notable French personalities of the 1860s. The porcelain on the 18th-century corner shelves is mainly Chelsea and Derby. The gilt chair with arms is signed by Philippe Poirie (*c*. 1765), with *gros point* needlework of a later date.

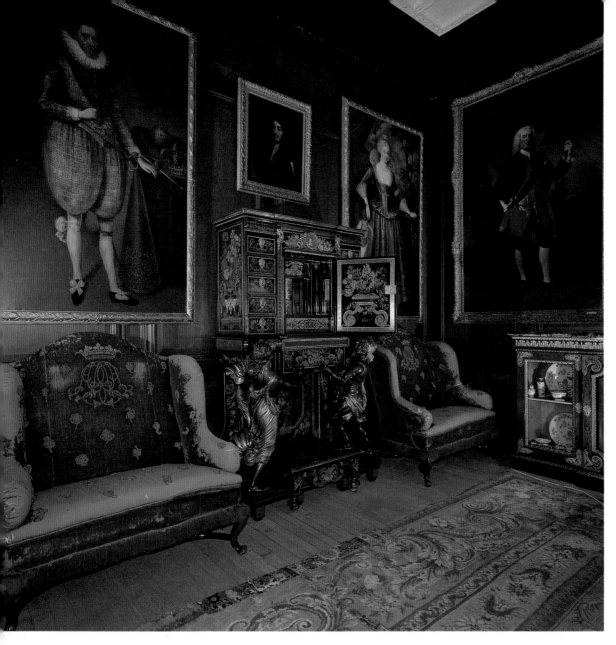

Above:

In the drawing-room, the French cabinet is believed to have been presented by Louis XIV of France to Charles II, who in turn gave it to his natural son, the Duke of Monmouth. An almost identical cabinet is in the Paul Getty Museum in California. On the left is a painting of James VI (I of England) and his Queen, Anne of Denmark. In the middle is a portrait of Charles II by Lely. The crimson velvet settees bear the monogram of Duchess Anne.

Right:

In this view of the drawing-room, the portrait on the left is of John, 2nd Duke of Montagu, by Shackelton. At the far end are paintings of Sarah Jennings, Duchess of Marlborough (*c.* 1700), and Lady Anne Scott (*c.* 1714). The Savonnerie carpet is of the first half of the 19th century, as are the ormulu-and-glass chandeliers which came from Dalkeith Palace. The small chair is covered in Beauvais tapestry and signed by J. Lebas (*Maître ébéniste en 1756*).

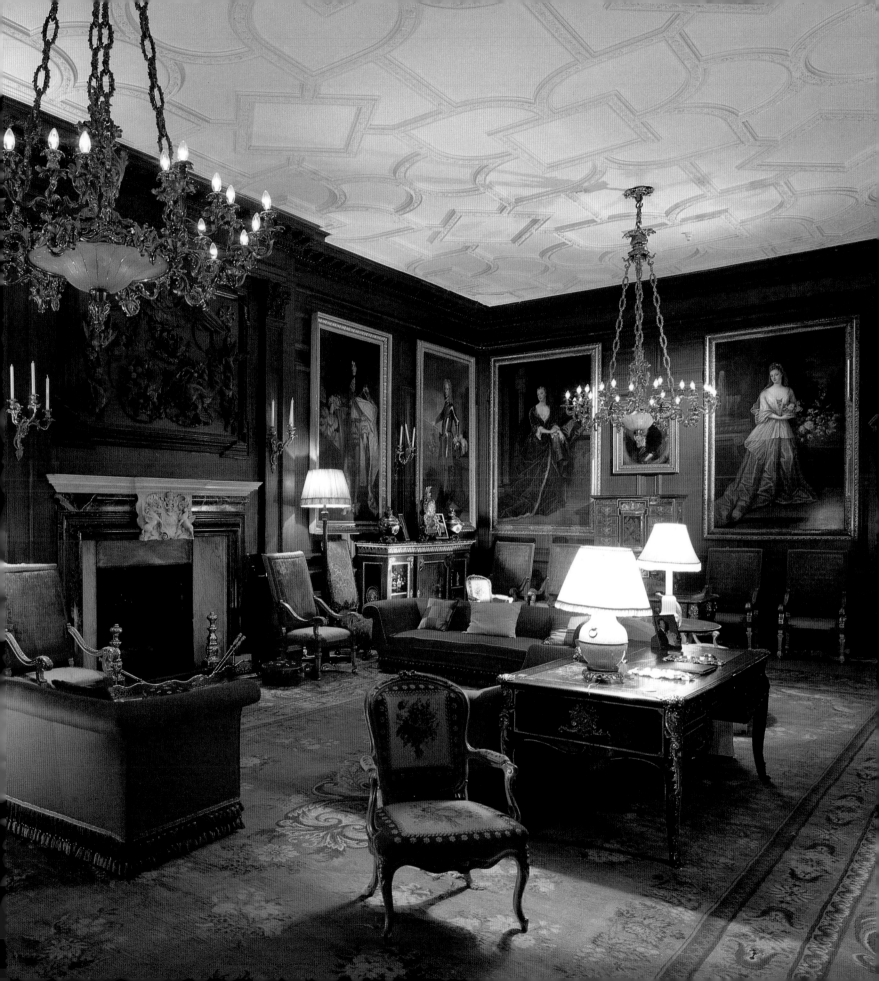

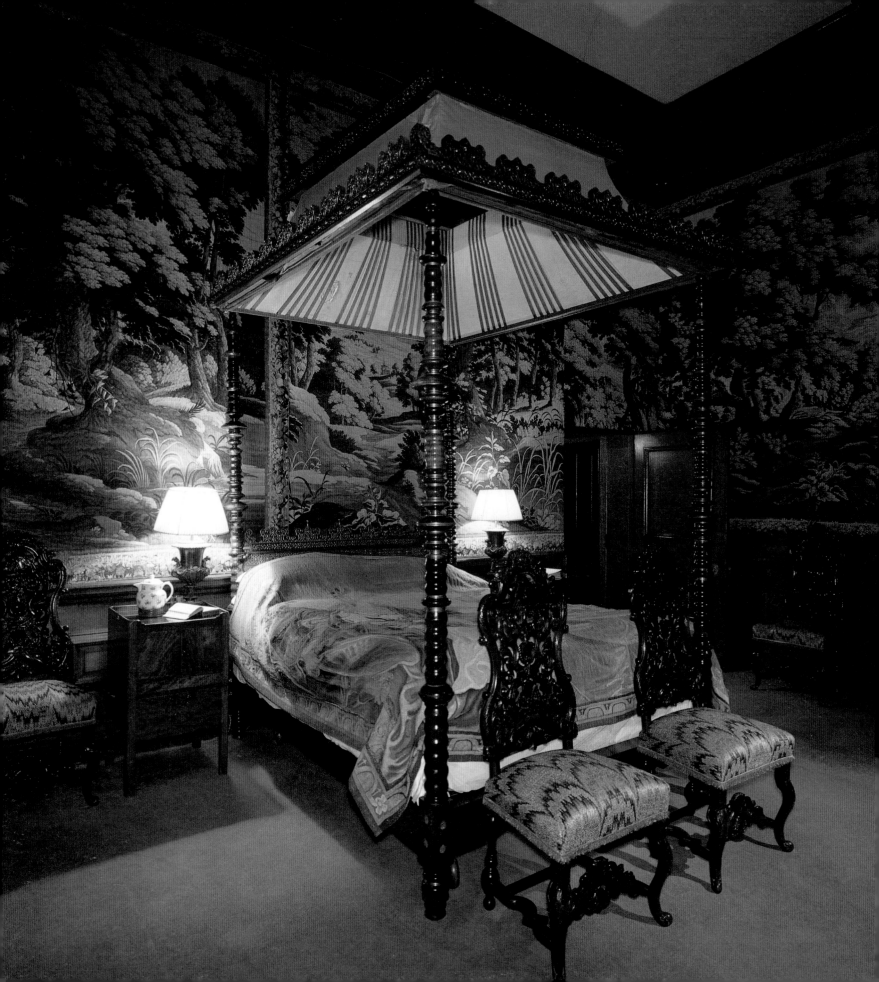

Left:

Prince Charles Edward Stuart occupied this room on his retreat northwards from England in 1745. The tapestries are late 17th-century, woven in Brussels. The late 17th-century fourposter bed is of Indo-Portuguese origin. The high-backed William and Mary chairs by Daniel Marot have Hungarian pattern needlework reputedly worked by Anne, 1st Duchess of Buccleuch.

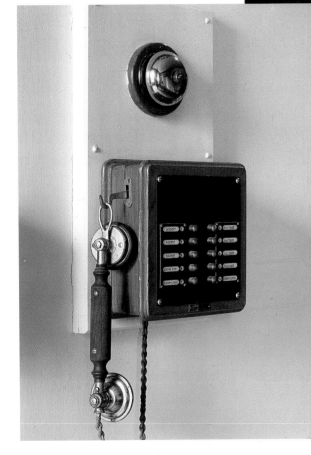

Above:

In the serving room off the dining-room are several portraits of the Buccleuch household painted around 1817 by John Ainslie. This one is of Joseph Florence, the chef at Drumlanrig.

Left:

There is an internal staff telephone in the serving room.

CITY DWELLING

Scotland's two great cities, Edinburgh and Glasgow, contrast dramatically in their cultural heritage and in their present-day tastes. Edinburgh's Georgian elegance, however, is unsurpassed in the same way as Glasgow's Victorian magnificence.

Edinburgh still clings to a self-conceived superiority, based on a debatable European and intellectual awareness, whereas Glasgow, despite the setbacks of industrial decline, challenges the future with dynamic enterprise which many consider characteristic brashness. Although the two cities are no more than 40 miles apart, their attitudes deeply reflect their origins – Edinburgh, the east-coast capital of Scotland, seat of government, law, medicine and banking; Glasgow, the west-coast industrial and manufacturing metropolis.

Remarkably, Edinburgh has survived as a city whose inhabitants can actually live in considerable style in the very centre. Local conservationists have defiantly repelled the wilder excess of city planners, and the medieval Old Town and graceful New Town accommodate a surprising variety of distinctive residences, both large and small. Glasgow, having endured the worst kind of inner-city clearance in the 1950s, is in the process of reviving its centre with imaginative schemes backed by both local government and private enterprise.

In the following pages are a selection of town dwellings, chosen for their individuality, in both Edinburgh and Glasgow.

Stylish stone-built Georgian tenements are glimpsed through the astragaled windows of Edinburgh's New Town houses.

Imposing Gothic pillars are a feature of this Edinburgh crescent.

Opposite:
The staircase with a view towards the front entrance. The cabinet by the front door is early Dutch (late 17th-century). On top of it is a collection of blue-and-white porcelain. Marble busts are prominently displayed, such as the one behind the pillar on the left which is of Antinous, the favourite of Hadrian.

A Town House

Living in a castle in the Scottish Borders would appeal to most people, but William Mowat Thomson found that commuting every day to Edinburgh to administer his successful Theatre School of Dance and Drama was becoming increasingly exhausting, particularly in the winter months. It was with understandable regret, however, that he decided to sell his castle in favour of a town residence. After an intensive search, and not being entirely sure what he wanted, he found a spacious three-storey rooming house with a basement. It was in considerable disrepair, but the structural features were sound.

"I had to scrape linoleum and paint off the floor and start from scratch," he remembers.

Built in 1825 in the Greek Revival style by architect James Milne, the house has rooms with splendid proportions appropriate for Georgian New Town living at its most civilized. On the ground floor, a dining-room doubles as a comfortable sitting-room – with a bedroom next door which is occupied by Noel, Countess of Mayo. In the extensive drawing-room on the upper floor, William Mowat Thomson has introduced a magnificent William Kent mantelpiece, rather too large for the room but sufficiently imposing.

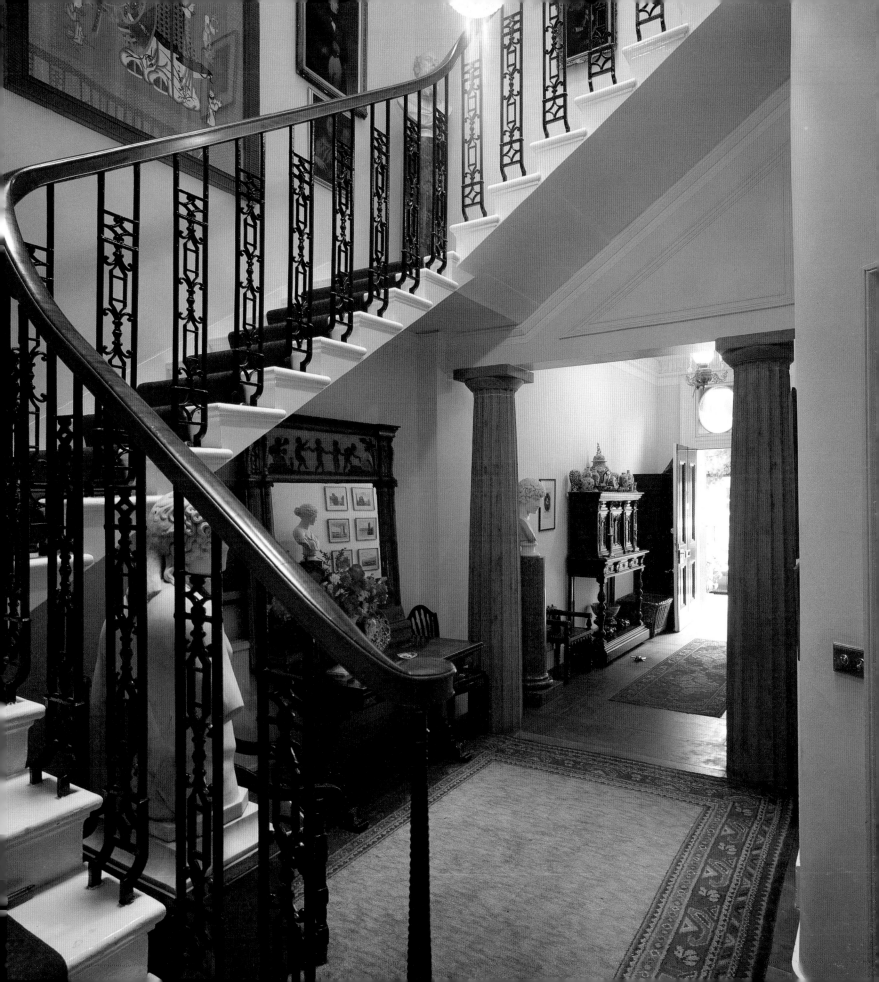

Majolica plates, Irish glass
and a pair of Victorian urns
sit on a Regency sideboard in
the dining-room. The
painting is by Marshal
Brown and was exhibited at
the Royal Academy in 1938.

Right:

In a corner of the dining-
room, blue-and-white china
(Nankin, *c.* 1780) is
displayed on a table. A
golfing cushion, depicting a
royal foursome on Leith
Links in 1663, sits on a
Victorian chair covered in
tartan.

William Mowat Thomson in
front of the dining-room
chimneypiece.

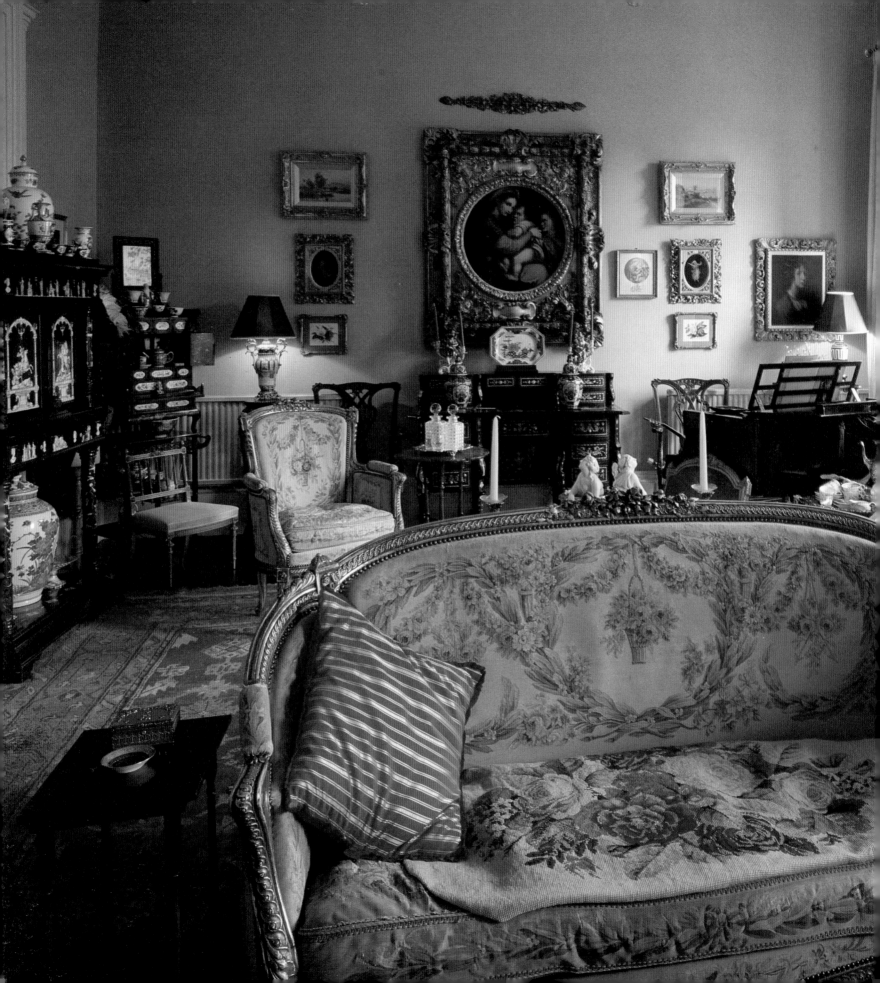

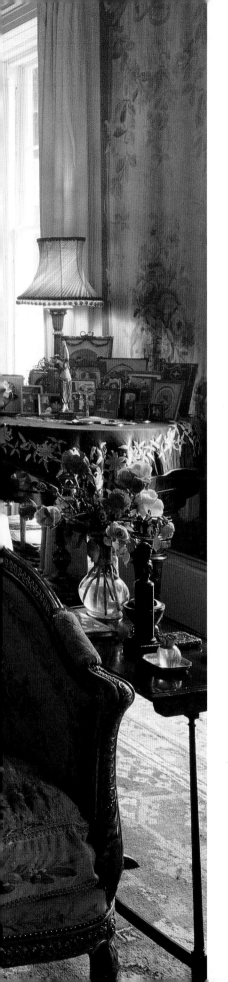

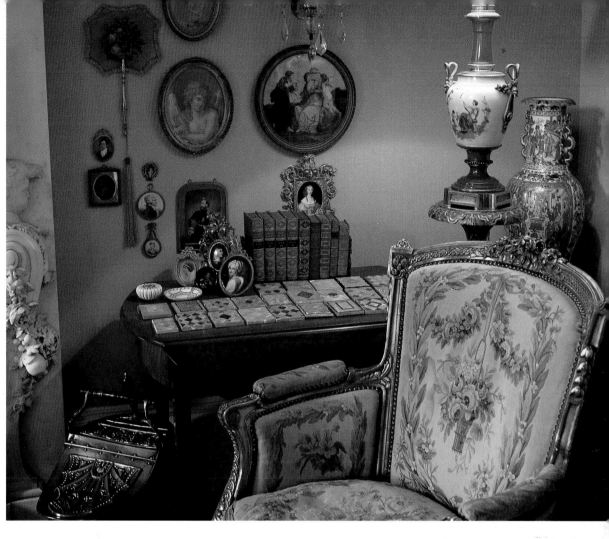

On the right-hand side of the
drawing-room fireplace is a
collection of mother-of-pearl
ladies' visiting-card cases.
The fauteuil is covered with
Aubusson needlework.

Left:
On the drawing-room
mantelpiece is a French
clock and white Derby,
Royal Copenhagen and
Meissen figures.

Opposite:
A French canapé covered in
Beauvais needlework stands
in the drawing-room.
Against the far wall are gold
anchor Chelsea candlesticks
and a pair of 18th-century
Japanese export porcelain
Imari ginger jars. The centre
painting is a copy of
Raphael's *Madonna of the
Chair*.

Ken McCulloch adjusts his bow tie in the mirror of his Art Deco bathroom.

Opposite:
This block of fashionable Glasgow flats was built in 1936. Ken McCulloch's parents used to live opposite the one their son bought in 1981.

A Glasgow Tradition

Ken McCulloch, a young and successful restaurateur and hotel-owner, knew Kelvin Court long before he purchased his own flat in this fashionable part of Glasgow. His parents, the theatrical impresario Archie McCulloch and the singer Kathie Kaye, had lived there, and their windows were directly opposite his across the block.

Kelvin Court was built in 1936 and the first owner of the flat McCulloch now occupies was the baking tycoon Lord Bilsland. It was to this apartment that the fugitive Rudolf Hess was taken when his plane crashed near Glasgow. The famous telephone call which Winston Churchill chose to disbelieve is said to have been made from the sitting-room.

The next owner was Gaelic singer Calum Kennedy, who sold it to McCulloch in 1981. In the 1930s the "new style" was all the rage in Glasgow, and Ken McCulloch, a fanatic for detail and design, stripped the walls back to their original state. The structural features were simple but effective. Additions, such as a door with porthole windows leading into the sitting-room, enhanced the period atmosphere. In the sitting-room is a souvenir from an early restaurant venture, a life-size model of jazz singer Fats Waller seated at a piano which serves as a cocktail cabinet. The unusual cornice mouldings in this room are illuminated with blue strip lighting from behind. The Art Deco fireplace was an original fixture.

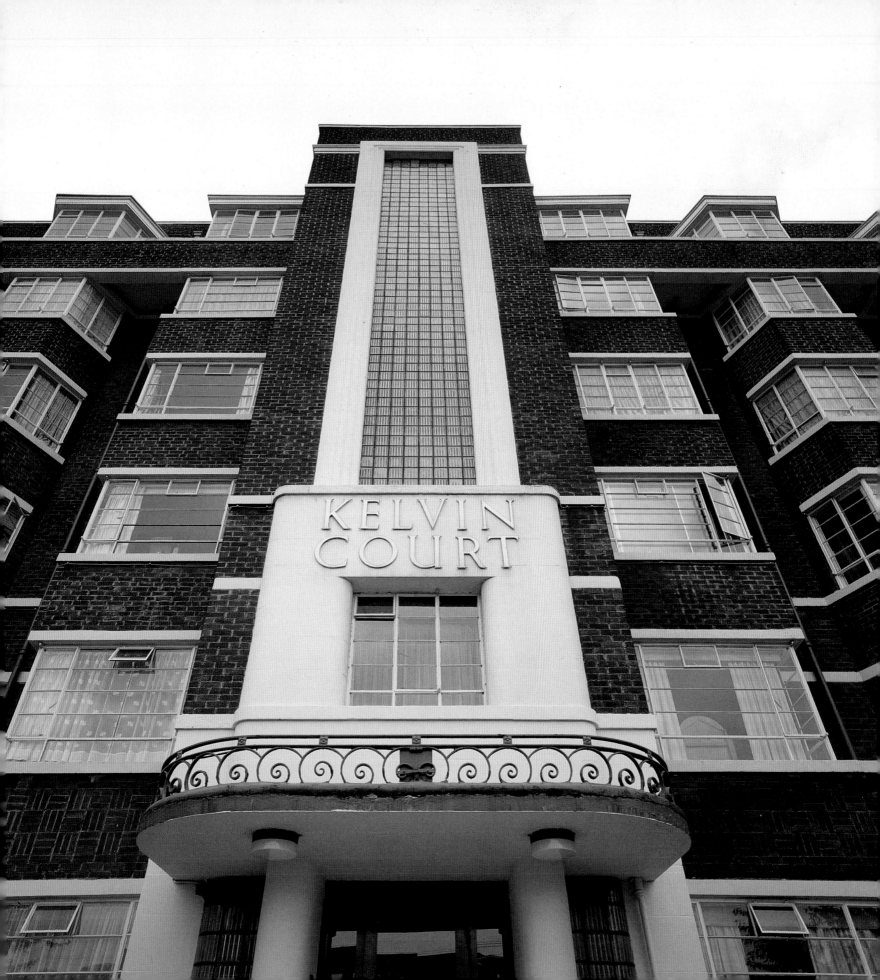

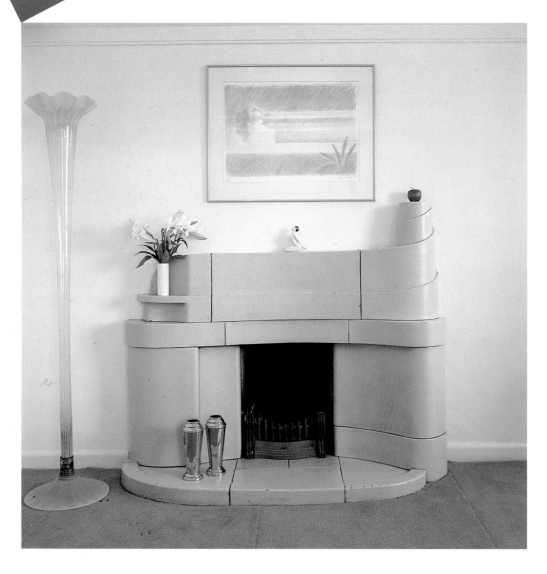

Left:
The drawing-room is glimpsed through a porthole in the door leading off the hall.

Below:
A print by Adrian George hangs above an original Art Deco fireplace. The plant-holder was a gift from a friend.

Right:
The drawing-room is furnished with Le Corbusier chairs and the marble table base was made by Toffolo Jackson of Glasgow. In the far left corner is an Art Deco trolley.

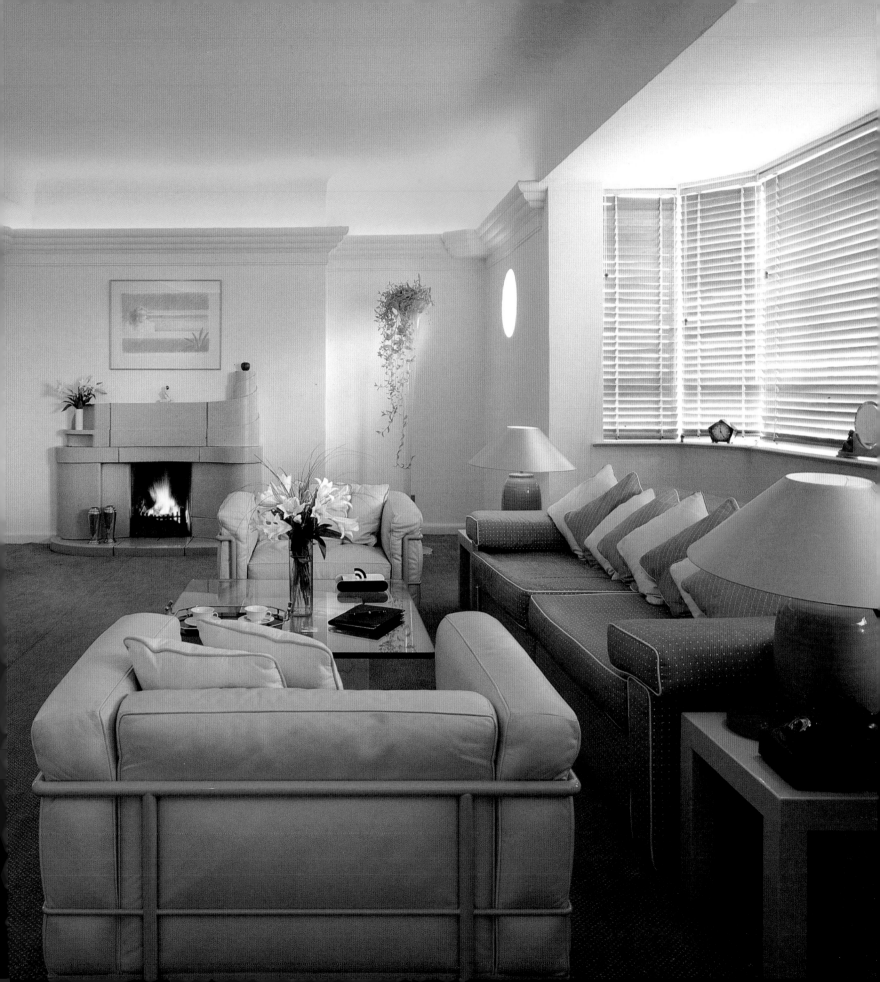

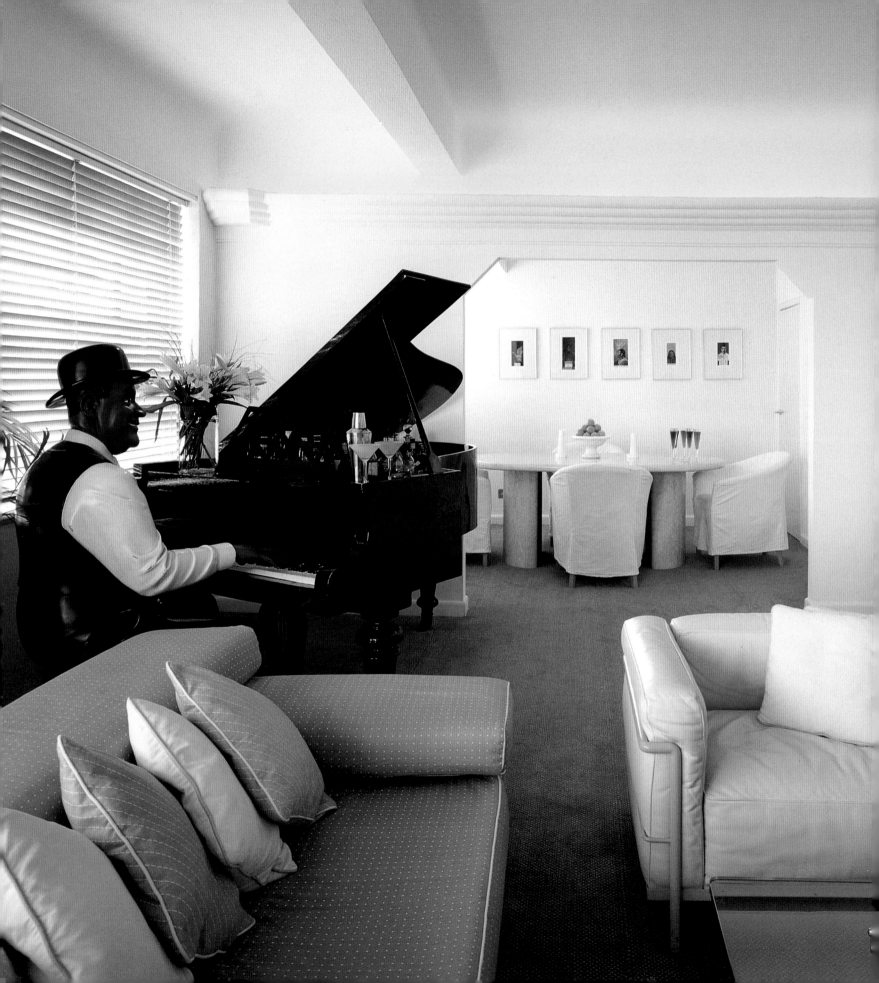

Left:
Looking towards the dining-room from the drawing-room. The piano on the left is a cocktail cabinet featuring a life-size model of Fats Waller made for one of McCulloch's early cocktail bar ventures. The original cornices of the room are lit with blue light. The chair in the foreground is a Le Corbusier design and the marble dining-table was made by Toffolo Jackson of Glasgow. The set of pictures on the far wall are by Peter Blake.

The hallway features a large painting by Glasgow artist Fraser Taylor. The chairs came from Habitat and the table was designed by Eileen Gray.

Soft light filters through lace curtains into Susie Raeburn's sitting-room.

Opposite:
Ramsay Garden rises above the graceful slopes of Edinburgh's Princes Street Gardens.

A Flat in the Skyline

Susie Raeburn is a working advocate, which means that her career centres on the Law Courts in Edinburgh, located on the Royal Mile which runs between Edinburgh Castle and the Palace of Holyroodhouse. It was therefore most propitious when she was able to buy a small flat in Ramsay Garden, a cluster of picturesque buildings erected by Patrick Geddes in the 19th century, incorporating the houses of that fine Scottish poet Allan Ramsay (1686-1758) and his distinguished painter son, also Allan Ramsay (1713-84). On the Edinburgh skyline, Ramsay Garden rises elegantly at the very foot of the esplanade of Edinburgh Castle.

Although the flat is tiny – a hall, minute kitchen, sitting-room and bedroom – Susie Raeburn has strong ideas on the use of space. The result is an impressive sense of light and uncluttered comfort based on an uncomplicated approach to decor.

In the yellow-and-black tented hallway, curtains specially made by Ken Hart of Edinburgh's Curtain Boutique conceal the bathroom/cloakroom and kitchen. Susie's sitting-room is spacious, simply furnished and boasts a collection of attractive contemporary Scottish paintings. One might imagine being in the depths of the countryside, for the peaceful atmosphere is broken only by a small Gloucestershire canary called Samuel which lives in the bedroom and sings constantly.

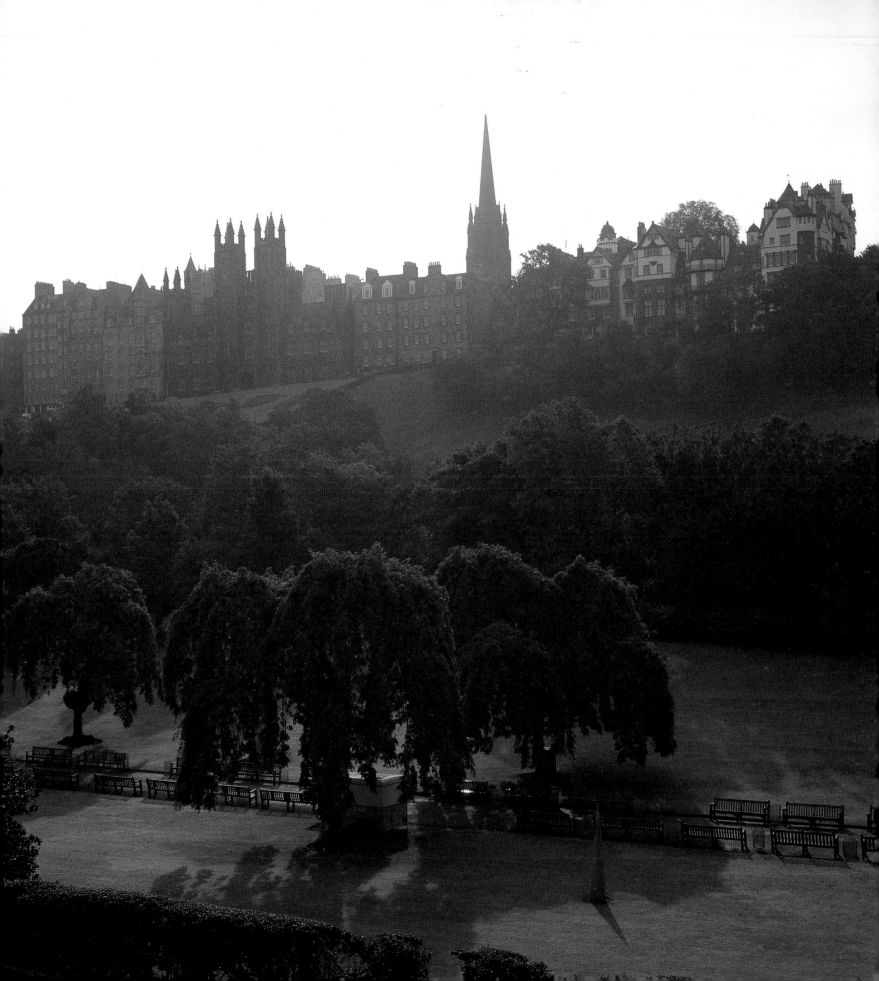

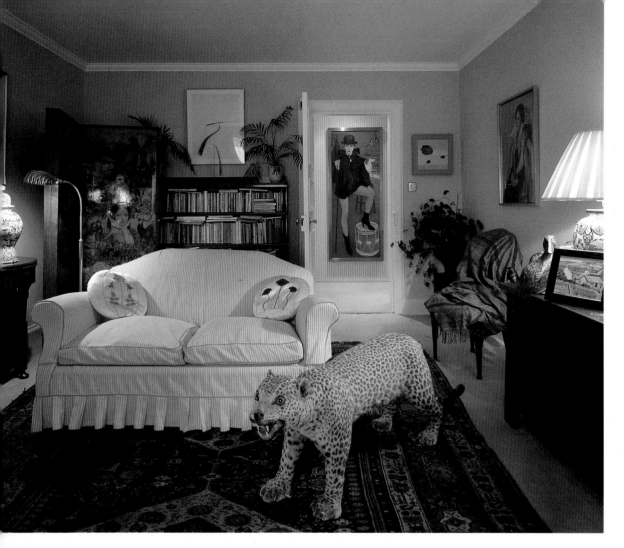

Left:

A stuffed leopard, a childhood gift from parents, is a focal point of the sitting room. The portrait seen through the far door is by Sandy Moffat. The small painting on the chest at right is by F.C.B. Cadell.

Right:

Ramsay Garden was built in the 19th century and it is hard to believe that this picturesque cluster of buildings is located at the very heart of the city of Edinburgh.

Below:

In the bedroom are two tile-topped tables bought from an antique shop. On the left, a bird cage contains an extremely musical canary called Samuel. On the right hangs a painting by William Crosbie. The wallpaper is by Bakers.

In the window is a Crystal Palace cage of free-flying finches.

Opposite:
Brodrick Haldane relaxes in his sitting-room. Between the windows is a Chinese lacquered cabinet. Above it are Chinese rice pictures of flowers, fruits, pheasants and butterflies (*c.* 1780). In each window is a Colebrookdale perfume urn filled with flowers.

A Lifetime of Style

When Brodrick Haldane returned to live in Scotland in 1960 after a career as a top international society photographer in London and Europe, he bought a first-floor flat in a 4-storey block in a section of the New Town of Edinburgh built by Robert Hutchinson in 1819. What adds particular interest to this façade is that the building also stands six storeys above a lower street at the side, reached by a public stair.

The renovation work was extensive and it was several months before Haldane was able to move in. Now he lives with a varying number of songbirds – finches and canaries – in a particularly splendid example of how Georgian Edinburgh was intended to look.

Haldane's approach to decoration is entirely instinctive. "I don't like things to be done up," he says. "Somebody once said, 'You must have something shabby in a room, otherwise it's no good.' " The one rule he does insist on is that bedroom walls must always be papered, never painted. He is fortunate in being able to surround himself with many of his family collections, some from the family home of Gleneagles, the majority from a childhood home in Nether Lochaber, where his grandfather was Bishop of Argyll and the Isles.

Haldane is a keen collector and has photograph albums which he started in 1932, when he was barely out of school. Virtually every famous face of the Thirties, Forties and Fifties features in their pages. Among the photographic memories pasted up on a board, and left over from a exhibition of his work held at Traquair House a few years ago, are Haldane portraits of the Duke and Duchess of Windsor, a young John F. Kennedy with his sisters, Noël Coward, Marlene Dietrich, Cecil Beaton, W. Somerset Maugham and Queen Victoria Eugenie of Spain, who was extremely proud to have been the only member of the British Royal Family born at Balmoral.

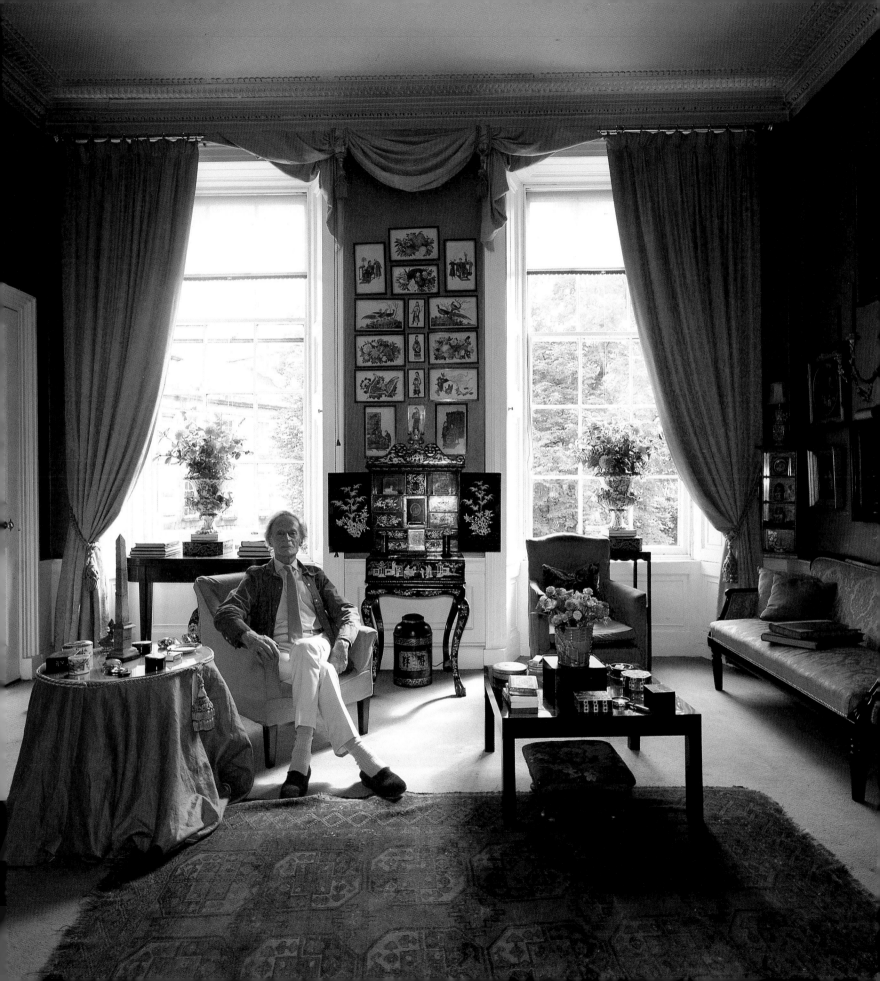

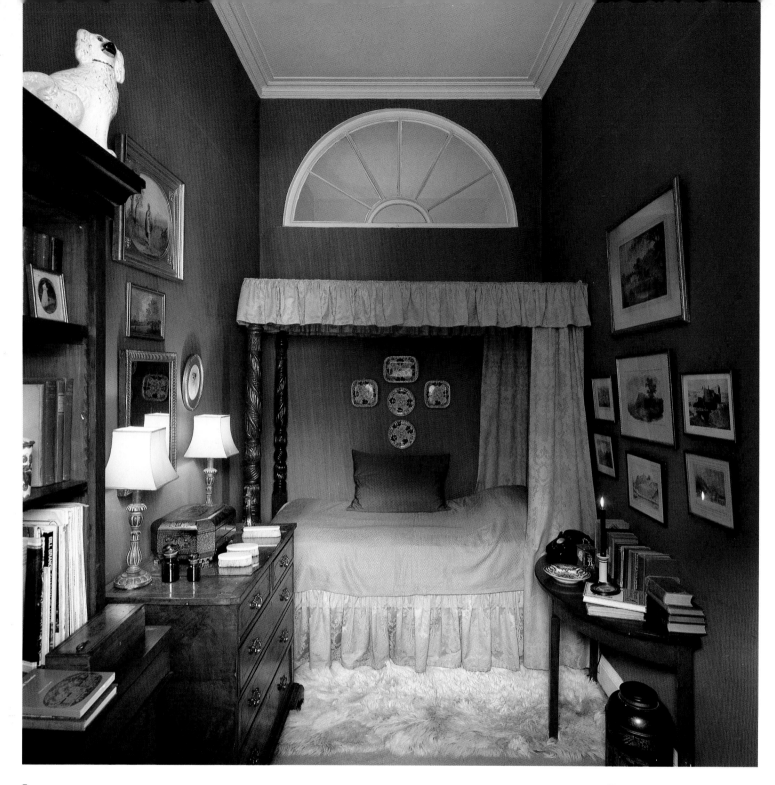

In the main bedroom, the walls are papered in dark green. The fourposter bed came from Brodrick Haldane's family home. Above the bed is a large fan window which looks onto the passage.

Looking through the sitting-room door into the passage. On the black lacquered Chinese cabinet are white China miniature busts. The central portrait is of Sir Walter Scott's great aunt, Mrs Scott of Whitehaugh.

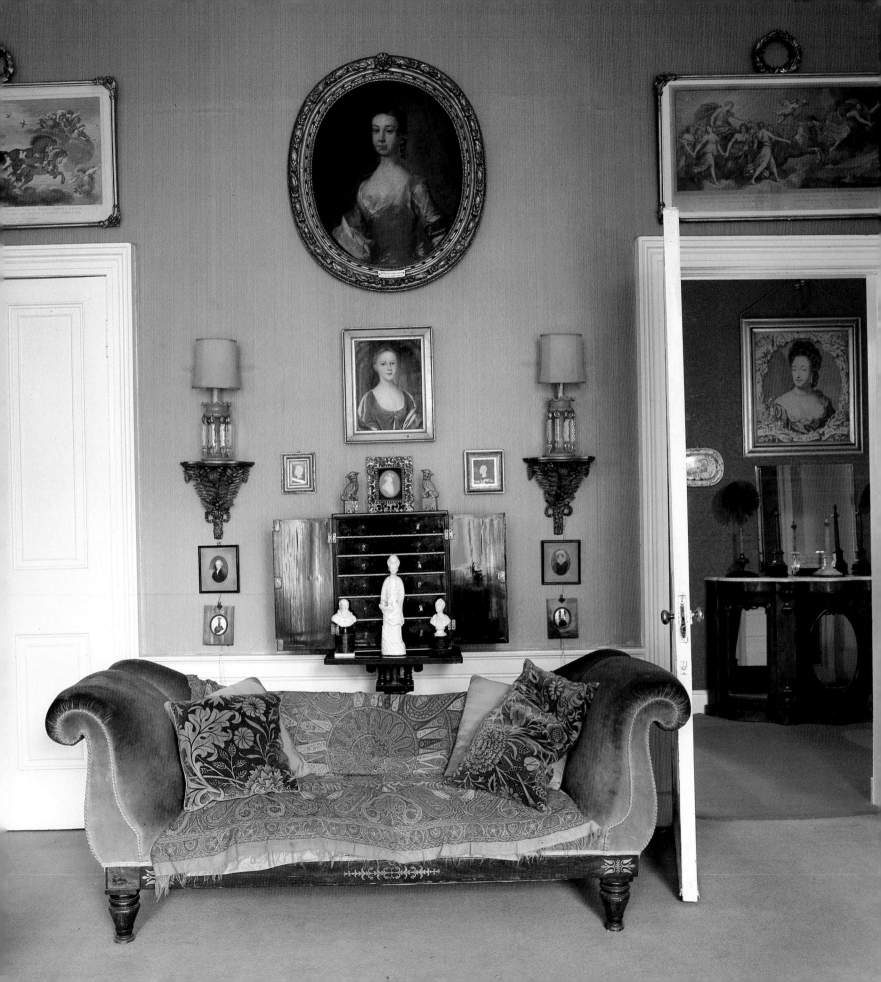

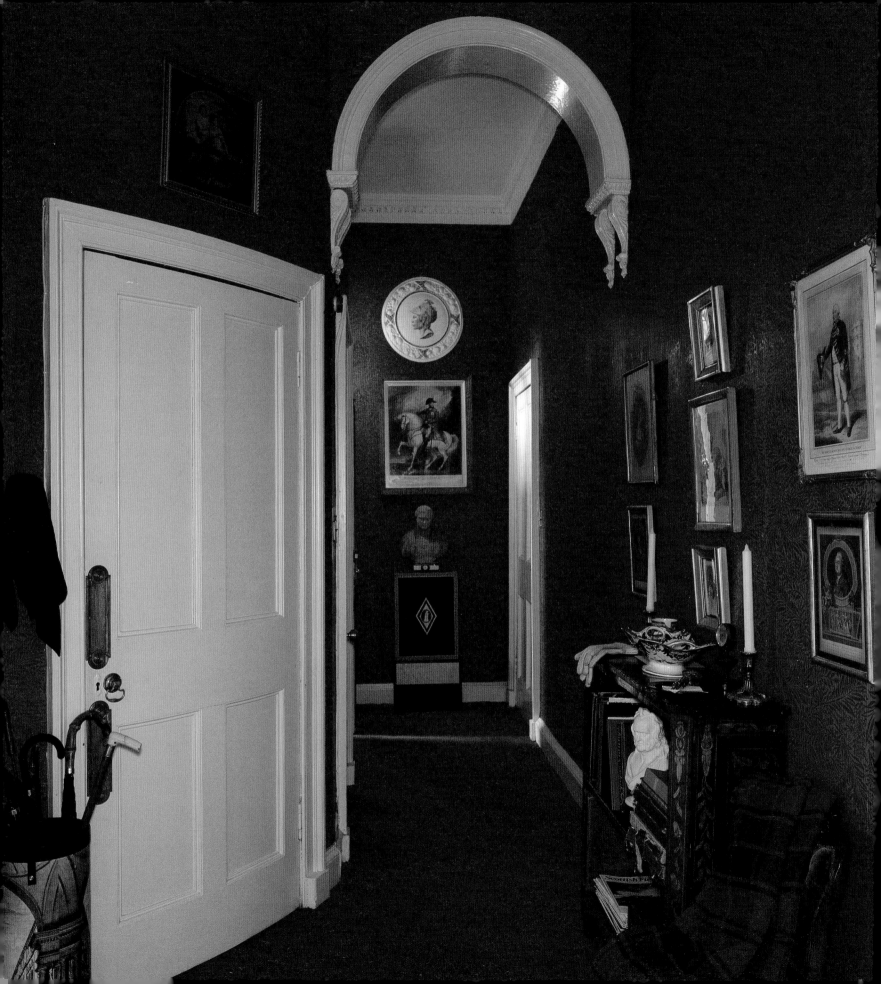

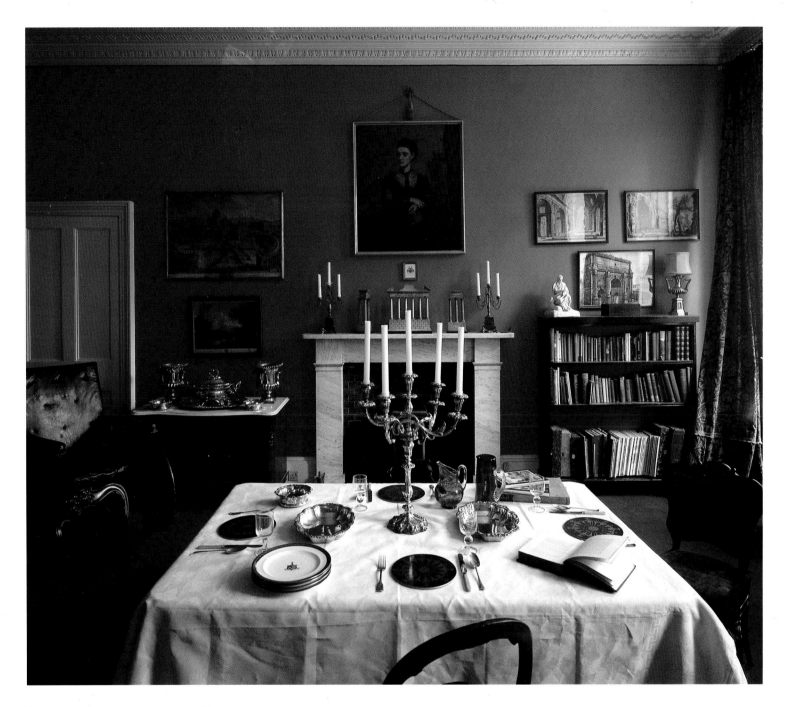

Looking towards the front door. The wallpaper is by William Morris.

On the left-hand side of this view of the dining-room can be seen the folding invalid chair used during Sir Walter Scott's illness. The portrait above the fireplace is of Brodrick Haldane's grandmother, Anna Chinnery, heiress of Sir Nicholas Chinnery Bt. of Flintfield, Co. Cork. On the mantelpiece are Roman ruins in Sienna marble. The pictures on each side are prints of Roman scenes.

The imposing frontage of Edinburgh's Great King Street.

Opposite:

In the sitting-room in Edinburgh, a painting by Lintoff (*c*. 1913) dominates walls covered in textured silk. Among the other paintings are works by Crozier, McGlashan and Fortuny. The Lorimer stool is by Whytock & Reid.

Living above the Shop

What better way to sell fine art than by displaying it in the splendid settings of houses in the city centre? This was the strategy adopted by the Fine Art Society when, after a hundred years in London, they opened up galleries in Edinburgh and Glasgow.

The Scottish connections were strong. Over the years, the Fine Arts Society had presented many one-man exhibitions of Scottish artists – John MacWhirter, Sir David Murray, William McTaggart, W.H. Paton and Sir William Russell Flint. And it was the energetic Dundonian Managing Director, Andrew McIntosh Patrick, who pursuaded his directors that they should open up first in Scotland's capital in 1973 and then in Glasgow in 1979. At the time, he was enthusiastically supported by another Scot, a newcomer to the Board and now Chairman, Sir Norman Macfarlane.

In Edinburgh the Society occupied a whole house in Great King Street, a wide, noble avenue designed by Robert Reid in 1804. In Glasgow, the gallery is housed in Blytheswood Street. But the very nature of the Fine Art Society's operation, with a Managing Director constantly moving between the galleries or travelling about the world, means that there must be some kind of home-base in each city. To this end, McIntosh Patrick, a modest and instinctively stylish man, has created a residential area in each of the Society's galleries, not solely to provide himself and his directors with accommodation when required, but also to enable him to entertain visiting dealers and clients.

In both Edinburgh and Glasgow, the walls are covered with pictures. McIntosh Patrick is an insatiable collector and all over the rooms are curiosities and eccentric treasures acquired on his travels. The decoration has been supervised entirely by himself, and if it seems surprising that a room in Glasgow should resemble an old-fashioned sheikh's tent, that is just a clue to the variety of aesthetic taste enjoyed by the man.

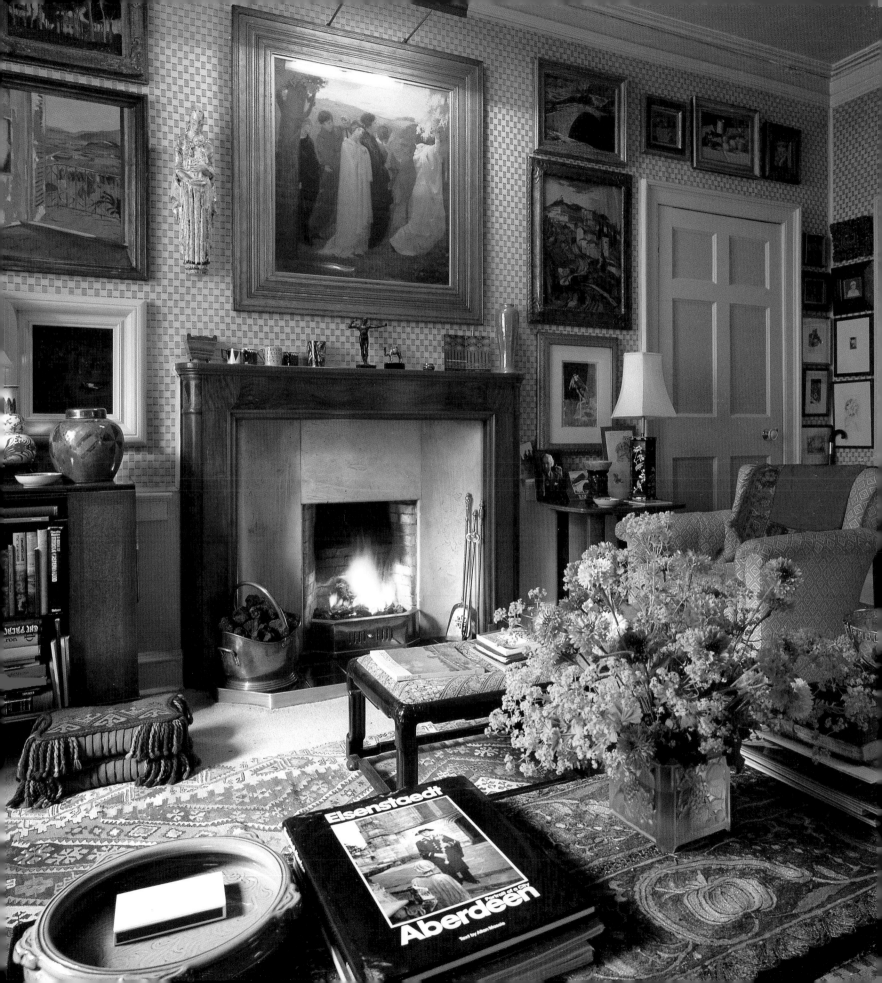

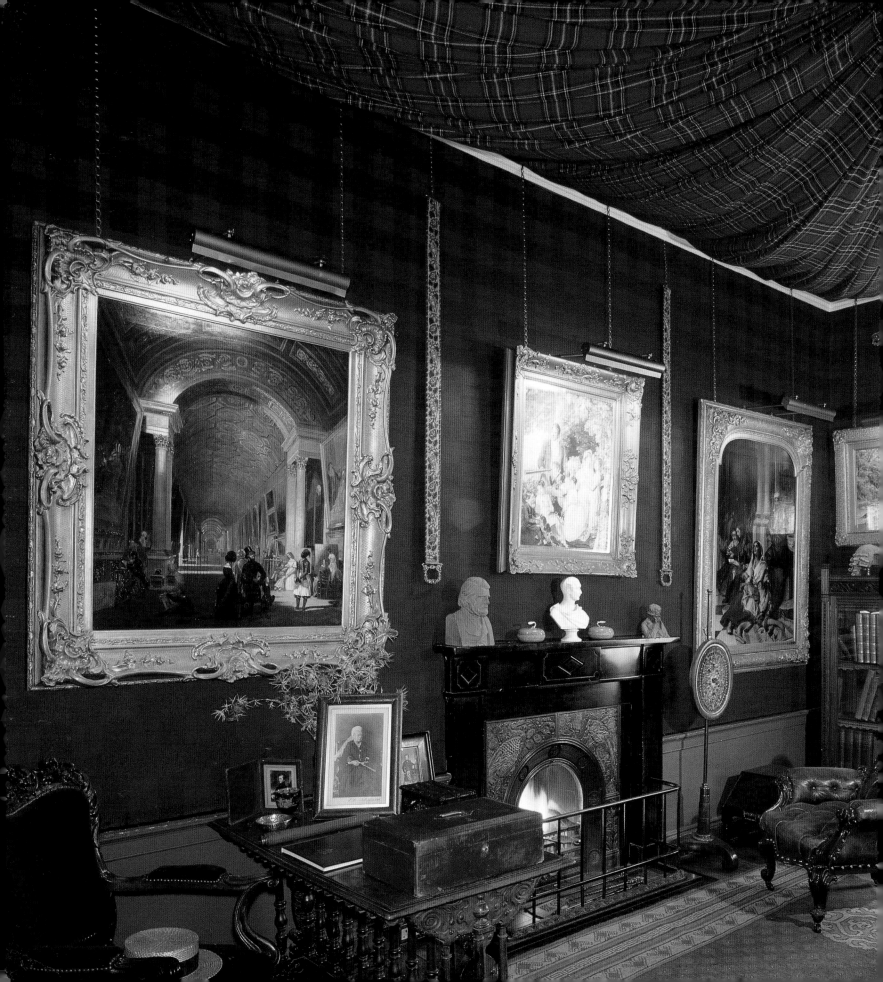

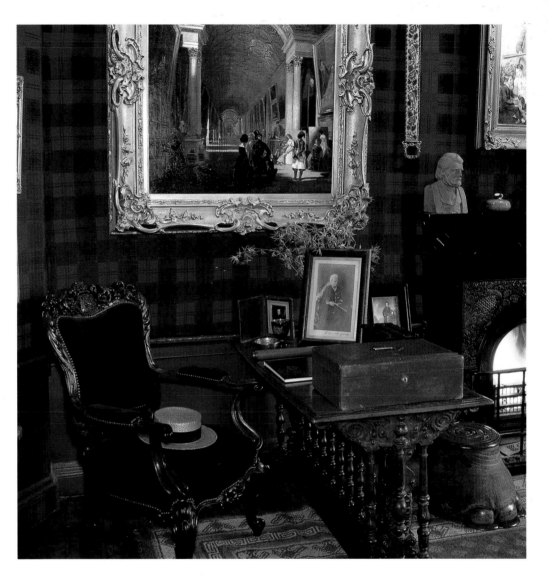

For the Edinburgh Festival in 1986, the Fine Art Society created a Balmoral Room, tented in Stewart tartan with Lindsay tartan fabric used to cover the walls.

Above:
A hat sits on a Victorian chair carrying the Dundas crest *c.* 1860. The red despatch box belonged to a Lord Advocate. Beside the fireplace is an elephant's foot cellarette.

Opposite:
On the mantelpiece are busts of Ruskin and Sir Walter Scott. The magnificent painting of the Louvre is by Patrick Allan Fraser (died 1890).

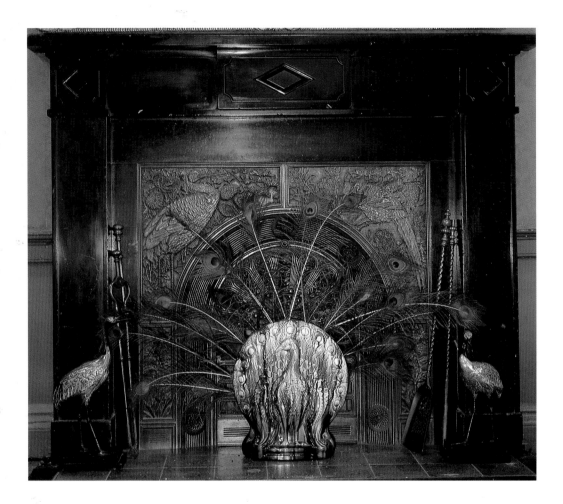

An Ault peacock vase sits in the hearth of the fireplace.

Opposite:
In the bedroom of the Edinburgh flat, walls are hung with heavy pleated canvas. The tapestry over the bed is by Ronald Cruikshank. The Arts and Crafts curtains are in woven wool.

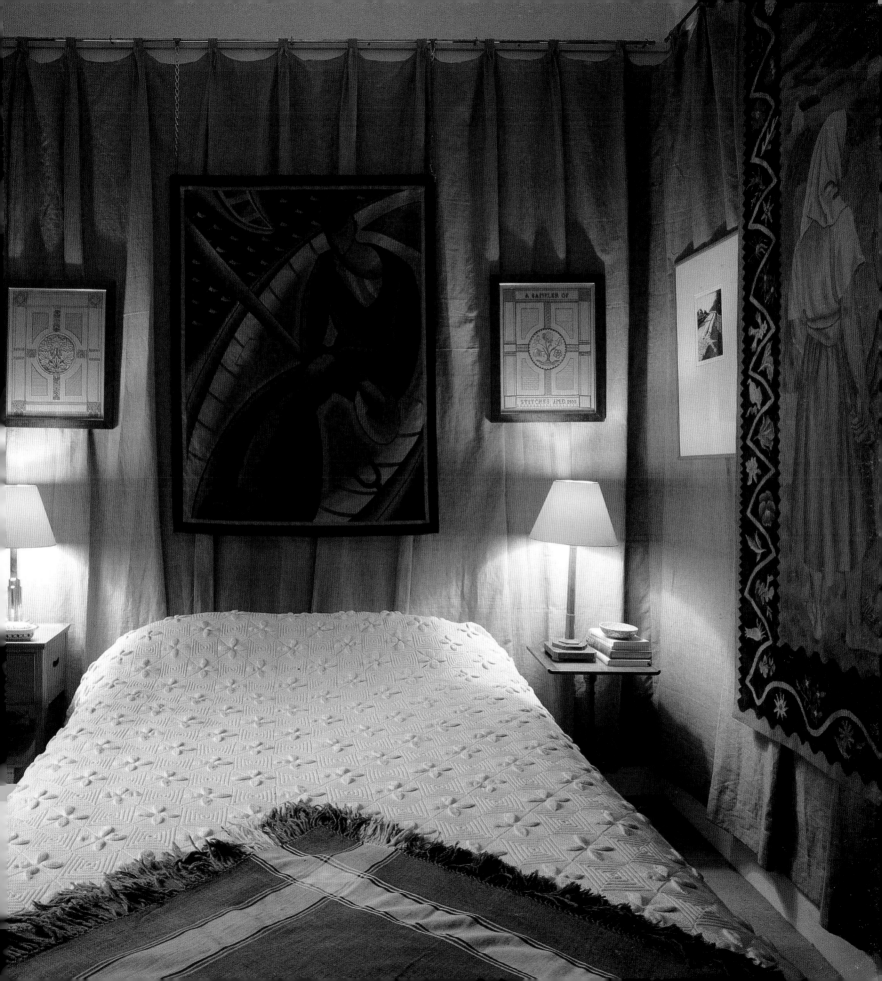

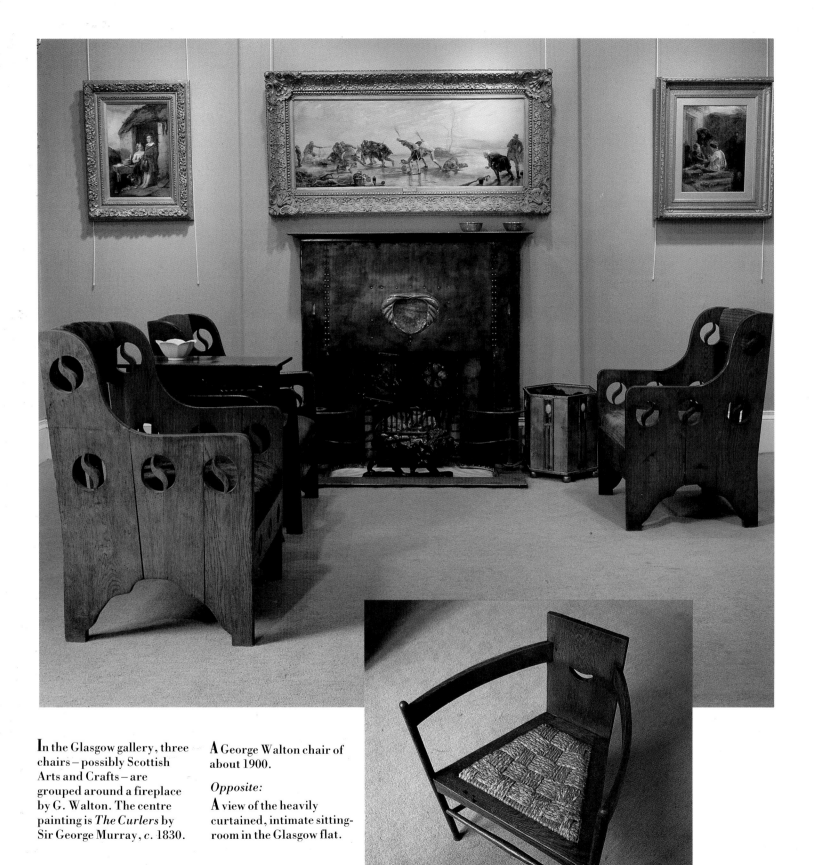

In the Glasgow gallery, three chairs – possibly Scottish Arts and Crafts – are grouped around a fireplace by G. Walton. The centre painting is *The Curlers* by Sir George Murray, *c.* 1830.

A George Walton chair of about 1900.

Opposite:

A view of the heavily curtained, intimate sitting-room in the Glasgow flat.

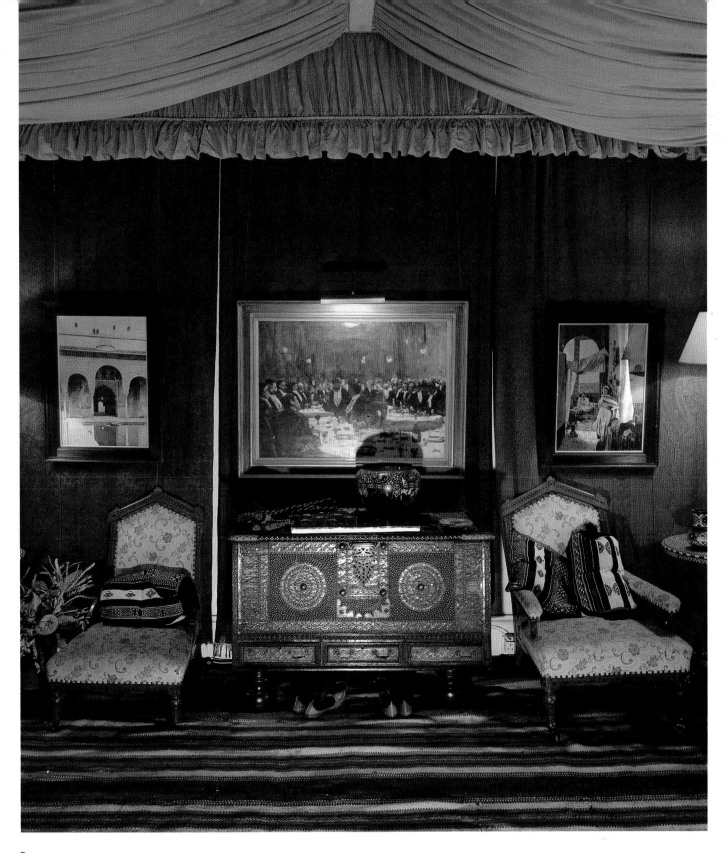

In the tented dining-room in Glasgow, a painting, *Company at Dinner* by Arthur Melville, is balanced by a pair of deep-seated Victorian chairs.

Opposite:
The walls are hung with a rich variety of Paisley shawls. Two oak refectory tables are joined together for dining.

Chris Clyne with a selection from her summer collection.

Opposite:
A typical Georgian façade in Edinburgh's New Town.

A Designer's Choice

Edinburgh has never been considered a centre of *haute couture*, and yet international dress designer Chris Clyne, who spends a good deal of time either in London or promoting her clothes in Europe and America, decided long ago to make her home in Scotland. In 1984 a former gentlemen's club in the centre of Edinburgh's New Town came up for sale. With workshop space in the basement, plus ground and second floors for living accommodation, it was exactly what she had been looking for.

To get things into order took some months but, as in the case of most of Edinburgh's fine buildings, the structure was excellent and the rooms all had superb decorative features. On the ground floor, the drawing-room joins the dining-room and together they span the width of the house. Clyne has amassed a collection of model elephants and is attracted by Oriental fabrics and objects. Her home is stylish but organized to meet the demands of a busy working schedule and bringing up a young family.

Astragaled windows look out onto the buildings across the street. On a table covered in an old red tablecloth is a collection of Indian artefacts.

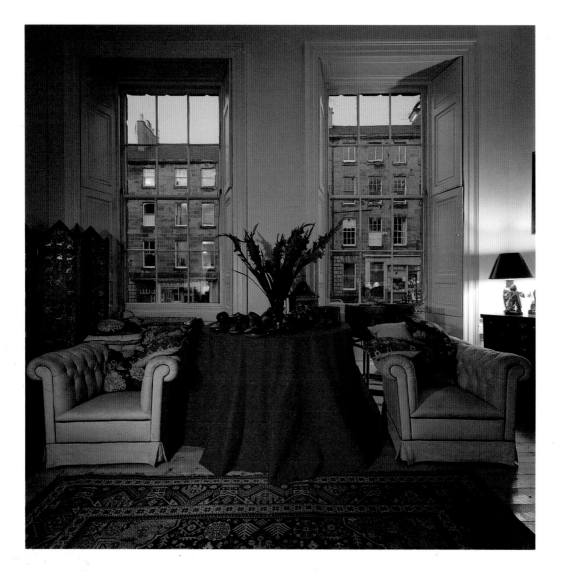

The drawing-room opens through an arch into the dining-room. The matching armchairs are covered in blue-and-gold Venetian cotton. At the time the photograph was taken, Chris Clyne had not decided what she should do about the central lighting, and so the ceiling lights were bare.

Overleaf:
In the kitchen the cabinets have been distressed in a paler yellow than the walls. The worktop is white marble. In the foreground is a vase of South American primitive tulips.

Toys and games clutter the children's playroom where the walls are coloured scarlet.

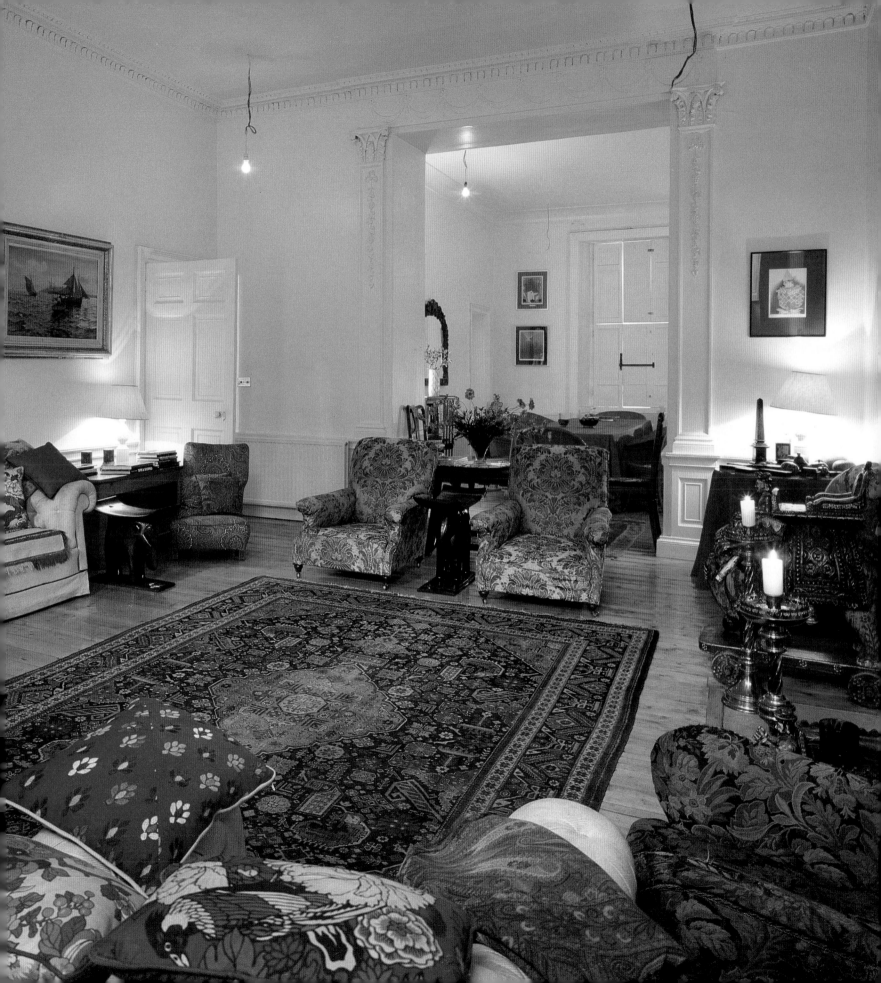

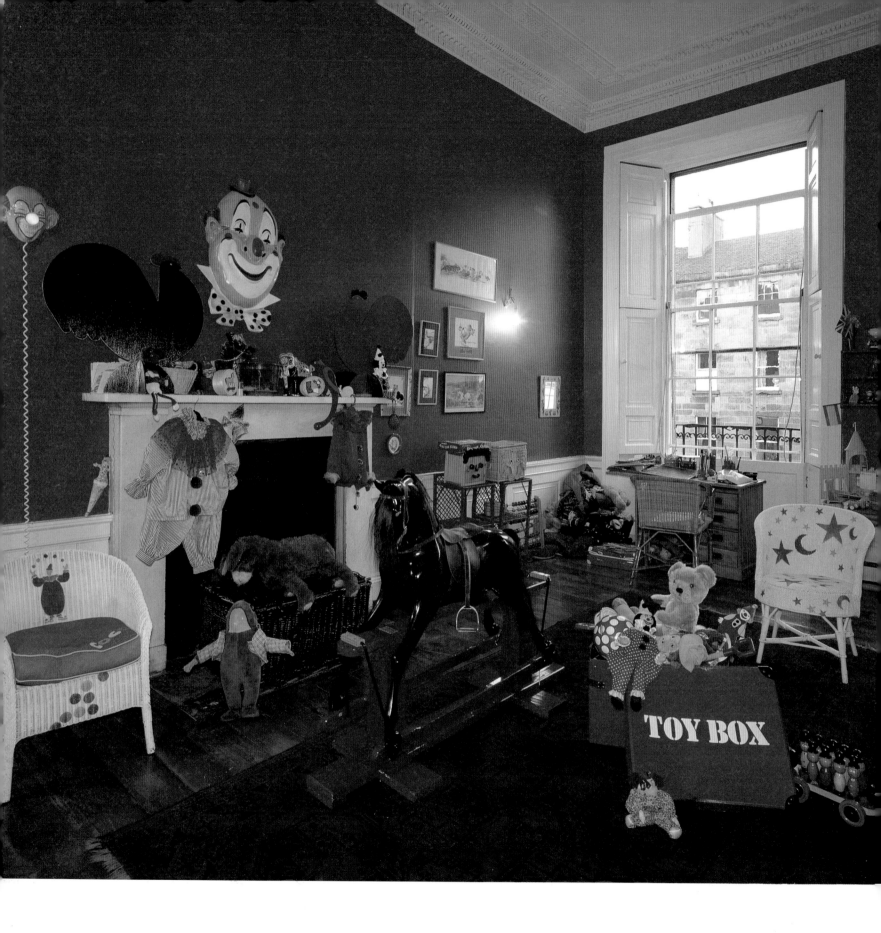

CATALOGUE OF SOURCES

This catalogue contains a selective list of sources and suppliers of some of the items contained in the photographs published in this book. Obviously many of the items shown are inherited and unique, but in some cases reproductions can be found. Under the circumstances it would be impossible to produce a comprehensive guide and we have simply endeavoured to suggest some outlets which are accessible and, if necessary, have persons who can give advice.

Various goblets and dishes laid out in the kitchen at Manderston.

ANTIQUES

Kenneth Jackson
66, Thistle Street
Edinburgh EH3 6QQ
031-225 9634
Fine art and furniture

Architectural Recycling
Company
Craighall, Rattray
Blairgowrie PH10 7JB
(0250) 4749
*Doors, mantelpieces,
panelling, iron and
wooden staircases,
Victorian bathrooms,
garden furniture and
statuary*

Eric Davidson (Antiques)
Ltd
4, Grassmarket
Edinburgh EH1 2JU
031-225 5815
*Furniture and quality
antiques*

Letham Antiques
20, Dundas Street
Edinburgh EH3 6HZ
031-556 6565
*Furniture, china, glass,
MacMarry pottery,
curios*

Hand In Hand
3, North West Circus
Place
Edinburgh EH3 6ST
031-226 3598
*Period Victorian
furnishings, lace and
antiques*

Whytock & Reid
Sunbury House
Belford Mews
Edinburgh EH4 3BT
031-226 4991
*Furniture suppliers,
fabrics, wall coverings,
carpets and upholstery*

Unicorn Antiques
65, Dundas Street
Edinburgh EH3 6RS
031-556 7176
*Furniture, china, glass,
curios*

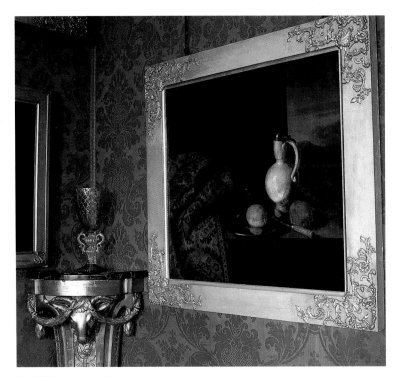

Still life painting in a corner
of the drawing-room at
Ardgowan.

A golfing cushion on a
Victorian chair covered in
tartan in an Edinburgh
townhouse.

Harrald
38, Queen Street
Edinburgh EH2 1JX
*Fine quality
reproductions, antique
furniture, Persian rugs*

The Old Curiosity Shop
Templeton Mill
Mill Street
Ayr KA8 8AG
(0292 280) 222

Martin Reproductions
Bowden Spring Fishery
Linlithgow EH49 6QE
(0506 847) 269
*Charles Rennie
Mackintosh
reproductions*

J. & J. Hardie Antiques
222-224, Newhaven Road
Edinburgh EH6 4JY
031-552 7080
Antique restoration

Galloways (Edinburgh)
Antiques
St Stephen Street
Edinburgh EH3 5AL
031-225 3321

Thrie Estaits
49, Dundas Street
Edinburgh EH3 6RS
031-556 7084
*Miscellaneous antiques,
china, glass, furniture*

At A Price Antiques
307, Cowgate
Edinburgh EH1 1NA
031-556 6251
*Period furniture, fine
art, clocks*

Magpie Antiques
487, Great Western Road
Glasgow G12 8HL
041-357 3601
*Art Nouveau, Art Deco,
furniture*

FINE ART

The Fine Art Society
12, Great King Street
Edinburgh EH3 6QL
031-556 0305
and 134, Blytheswood
Square,
Glasgow G2 4EL
*Paintings, furniture,
objets d'art*

Bourne Fine Arts Ltd
4, Dundas Street
Edinburgh EH3 6HZ
031-557 4050
*18th and 19th century
paintings*

Cyril Gerber Fine Art
148, West Regent Street
Glasgow G2 2RQ
041-221 3095
*19th and 20th century
paintings*

Logie Galleries Ltd
11, Stafford Street
Tain
Ross-shire IV19 1AJ
(0862) 4148

The Broughton Gallery
Broughton near Biggar
Lanarkshire ML12 6HJ
(08994) 234
*Paintings, prints and
crafts*

The Carlton Gallery
10, Royal Terrace
Edinburgh EH7 5AB
031-556 1010
*19th and 20th century
British and European
paintings*

CARPETS

R.L. Rose
19, Waterloo Street
Glasgow G2 6AY
041-248 3313
Oriental carpets

Graeme Renton
72, South Street
St Andrews
Fife KY16 9JT
(0334) 76334
*Oriental carpets
specialist*

TEXTILES AND FABRICS

A.F. Drysdale
35, North West Circus Place
Edinburgh EH3 6TWX
031-225 4686
*Furnishings, wallpapers,
fabrics, etc.*

Osborne & Little, Ltd
39, Queen Street
Edinburgh, EH2 3NH
031-225 5068
Wallpapers, fabrics

The Ardgowan Collection
Ramm, Son and Crokker
through leading decorators

Martin & Frost
83, George Street
Edinburgh EH2 3ES
031-225 2933
Furnishings, etc.

Dunedin Interiors, Ltd
6, North West Circus Place
Edinburgh EH3 6ST
031-225 4874
*Fabrics and wallcoverings,
cabinet-makers*

The Curtain Boutique
46, Marionville Road
Edinburgh, EH7 5UB
031-661 8533
*Blinds, bedcovers,
curtains, custom made*

Liberty Retail Ltd
47, George Street
Edinburgh EH2 2HT
031-226 5491
and
105, Buchanan Street
Glasgow G1 3HF
041-221 7792
*Floral prints, lawn
cotton, Art Nouveau and
William Morris designs*

Laura Ashley Ltd
126, Princes Street
Edinburgh EH2 4AD
031-225 1218
and
137, George Street
Edinburgh EH2 4JY
031-225 1121
and
215, Sauchiehall Street
Glasgow G2 3EX
041-333 0850
*Co-ordinating floral,
geometric, striped and
plain cottons, chintzes,
bed linen and lampshades*

Habitat
32, Shandwick Place
Edinburgh EH2 4RG
031-225 9151
and
140-160 Bothwell Street
Glasgow G2 7ES
041-221 5848
and
381-383, Union Street
Aberdeen AB1 2BX
(0224) 594 762
*Modern, wooden,
leather, upholstered,
cane, lacquered, and
chrome-framed
furniture, lighting,
shelves and kitchen units*

Hangings for a fourposter
bed in a guest-room in
Ardgowan.

ARMOURY

Thistle Arms
Whitburn
West Lothian EH47 0LQ
(0501) 43426
*Targes, Broadswords,
Claymores, Lochaber
axes*

CHIMNEYPIECES

T. & J.W. Neilson Ltd
192 Morrison Street
Edinburgh EH3 8DS
031-229 5591
*Traditional mantels,
antiques and
reproduction chimney
pieces*

TILES

Margery Clinton
Ceramics
The Pottery
Newton Port
Haddington
East Lothian EH41 3NA
(062082) 3548
*Lustre wall tiles inspired
by Mackintosh and
Persian carpet designs*

POTTERY

The Adam Pottery
76, Henderson Row
Edinburgh EH3 5BJ
031-557 3978
*All Scottish pottery
products*

CONTEMPORARY FURNITURE AND LIGHTING

Tony Walker Interiors
35, Millar Crescent
Edinburgh EH10 5HQ
031-447 8763
*Modern furniture by
Cassina, Cor, Steiner,
Knoll International and
Interlubke. Lighting by
Flos, Arteluce. Artemide
and John French rugs*

Pine Country
14, Springvalley Gardens
Edinburgh EH10 4PY
031-447 5795
Stripped pine furniture

Tiling and mugs in the
kitchen at Bardrochat.

Detail of a guest bathroom in
Craighall.

CONTEMPORARY ART AND FURNITURE

The Prescote Gallery
369, High Street
Edinburgh EH1 1PW
031-225 2625
*Design furniture and
pictures*

The 369 Gallery
209, The Cowgate
Edinburgh EH1 1JQ
031-225 3013
Young Scottish artists

The Scottish Gallery
94, George Street
Edinburgh EH2 3DF
031-225 5955
*19th and 20th century
Scottish art*

The Malcolm Innes
Gallery
67, George Street
Edinburgh EH2 2JG
031-226 4151
*Sporting and 19th and
20th century fine art*

Inverbeg Galleries
Luss, Dumbartonshire
G83 8PD
(043 686) 277
*Mixed contemporary
paintings*

Shapes
6, West Mill Road
Colinton
Edinburgh EH13 0NX
031-441 7963
*Traditional furniture –
designers and
manufacturers*

In North America,
information on sources of
Scottish wares can be
obtained from the two
following organizations:

American Scottish
Foundation
P.O. Box 537
Lenox Hill Station
New York, N.Y. 10021
(212) 988-4468

Scottish Products Shop
133 East 55th Street
New York, N.Y. 10022
(212) 755-9656

INDEX

Page numbers in *italic* refer to illustrations and captions